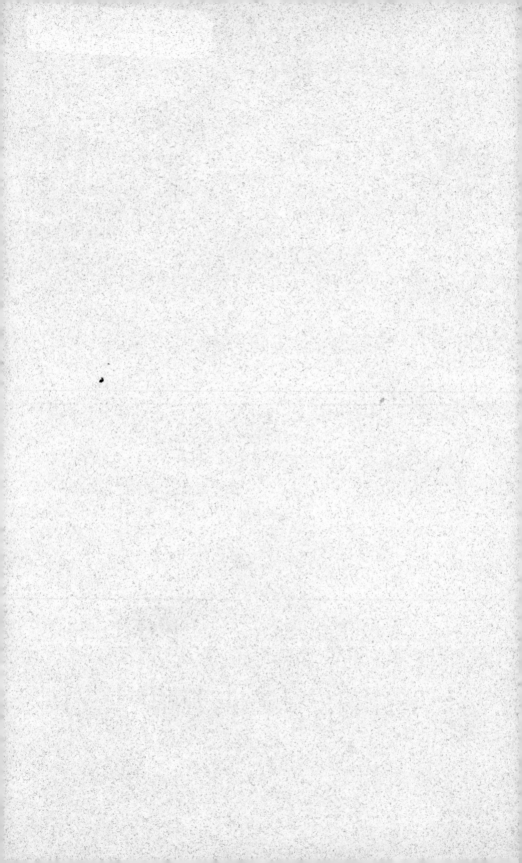

GIOTTO'S FATHER
AND THE
FAMILY OF VASARI'S *LIVES*

GIOTTO'S FATHER
AND THE
FAMILY OF VASARI'S *LIVES*

Paul Barolsky

THE PENNSYLVANIA STATE UNIVERSITY PRESS
University Park, Pennsylvania

ALSO BY PAUL BAROLSKY

Why Mona Lisa Smiles and Other Tales by Vasari
Michelangelo's Nose: A Myth and Its Maker
Walter Pater's Renaissance
Daniele da Volterra: A Catalogue Raisonné
Infinite Jest: Wit and Humor in Italian Renaissance Art

Library of Congress Cataloging-in-Publication Data

Barolsky, Paul
 Giotto's father and the family of Vasari's lives / Paul Barolsky.
 p. cm.
 Includes bibliographical references and index.
 ISBN 0-271-00762-1 (alk. paper)
 1. Artists—Italy—Family relationships. 2. Artists—Italy—
Biography. 3. Art, Renaissance—Italy. 4. Vasari, Giorgio,
1511–1574, Vite de' più eccellenti architetti, pittori et scultori
italiani. I. Title.
N6915.B28 1992
709'.2'245—dc20
[B] 90-21554
 CIP

It is the policy of The Pennsylvania State University Press to use acid-free
paper for the first printing of all clothbound books. Publications on uncoated
stock satisfy the minimum requirements of American National Standard for Infor-
mation Sciences—Permanence of Paper for Printed Library Materials, ANSI
Z39.48–1984.

For My Family and Friends

. . . filled with wonder at Giotto's work, Cimabue asked him if he wished to come and stay with him. The boy replied that he would willingly come with him, if it pleased his father.

Giorgio Vasari, "Life of Giotto"

CONTENTS

ACKNOWLEDGMENTS

I am deeply indebted to a number of friends and colleagues for their encouragement, suggestions, and assistance of various kinds. They include the following: Anne Barriault, Bruce Cole, Jessica Feldman, Sydney Freedberg, Cherene Holland, Joy Kenseth, Andy Ladis, Norman Land, Cecil Lang, Ralph Lieberman, James Mirollo, Gail Moore, Elizabeth Pilliod, Pat Rubin, Kathy Schrader, David Summers, Bill Wallace, and Philip Winsor. As ever, my family sustained my work in countless ways; in fact, they inspired this book. I also wish to express my gratitude to the John Simon Guggenheim Memorial Foundation and the University of Virginia for their generous support.

PREFACE

This book completes the trilogy begun with *Michelangelo's Nose* and *Why Mona Lisa Smiles*. All three books are concerned with Vasari's *Lives*, itself one of the great masterpieces of Renaissance art. If Michelangelo was the central subject of the first volume, Vasari was a very important part of that book. There I elucidated the biblical structure of the *Lives*, both the allegorical and typological principles that inform Vasari's sacred history of art, which culminates apocalyptically with the advent and judgment of the messiah-figure Michelangelo. In a similar vein, I explained how, building on the Bible, Vasari exploited Dante's *Comedy*, enriching the allegory of art as a story of the journey of the Dantesque artist-pilgrim from darkness to light and spiritual perfection.

In the second volume, *Why Mona Lisa Smiles*, I sought to broaden the understanding of Vasari's literary accomplishment. By focusing on Vasari's relations to the tradition of Boccaccio, I analyzed Vasari's role as storyteller, ultimately suggesting that his book can be read as a historical and autobiographical novel, an ancestor of Proust's great fiction. The second volume, like this one, was unillustrated—not because it did not refer to art, but because I wanted to concentrate the reader's attention on Vasari's own literary art. All the *Lives* are of course about art and artists, but this view has so completely dominated our consciousness of the book that we have failed to recognize the full play of the artifice that informs Vasari's work as literary artist.

The broad view of Vasari takes into account both his role as historian and critic, on one hand, and his role as imaginative writer, on the

other. As I have argued previously, however, Vasari's role as art historian and theorist has obscured his literary accomplishment. Moreover, our modern professional conception of art history has either prevented us from recognizing many of the fictions in Vasari or, even if we acknowledge them, from seeing their point. Vasari's tall tales, fables, parables, jokes, and anecdotes are themselves, like the artists and works of art to which they refer, grounded in history. They tell us much about the iconography and iconology of art, about the social, political, religious, and cultural contexts of Renaissance art, about the very reception of art—that is, about how Giorgio Vasari responded to works of art. In this latter respect, his vivid stories give us a sense of how art can be seen as part of living history; they give us a sense of history as it was lived by Vasari himself. If scholars of literature have ignored the literary art of the *Lives*, this is so, I suspect, because they believe, like art historians, that Vasari's book is primarily about art and artists, and therefore they do not delve deeply into the book's literary structures and devices. My view throughout this trilogy, brought to a conclusion in this volume, is that Vasari's great book is a work of immense literary sophistication far beyond what has previously been divined. I also believe that there is no incompatibility between seeing the *Lives* as both art history and fiction. Fiction after all is one of Vasari's principal means of recording history. Taking this wider view of Vasari allows us to learn even more about the past than we did when we read him merely as "art history," and it gives us access to the genius of one of the shrewdest observers of humanity who has ever written—whether of kings and prelates, of poets and pilgrims, of soldiers and statesmen, or of artists and artisans. At bottom, what is essential to our understanding of Vasari is his deep humanity, his sympathy for human character and suffering, which is rendered so vividly and with such great complexity and fullness that we return to the *Lives* again and again to see more deeply into the human condition.

At the conclusion of *Why Mona Lisa Smiles*, in the bibliographical essay, I suggested that Vasari's *Lives* is like a vast kingdom that has been visited often but which is still largely uncharted territory. There are indeed numerous aspects of the book that await discovery, and, in the spirit of exploration, I return to the *Lives* here to unearth and quarry even more of its buried treasures. Whereas in the first two volumes I proceeded typologically and thematically, I here present a

reading that approximately follows the sequence of the *Lives*. In this way, I hope to show readers of the *Lives* how they might explore Vasari more profitably on their own, as they read him sequentially.

In this study, I continue to investigate various themes introduced in the preceding two volumes, clarifying and elaborating on these topics: Vasari's love of language, his typology of the artist, his love of "patria," his piety, and his deep sympathy for his subjects. My title, however, alludes to one of the unifying themes of the *Lives* only touched on in the previous books: the role of the family in Renaissance society and the manner in which the idea of the family informs Vasari's very concept of history. Many artists are the fathers, sons, and brothers of artists and, building on this fact, Vasari conceives of the history of art and its genealogy as a family tree. He sees artists as paternal, filial, and fraternal in their love of their fellow artists, even when these artists are not in fact related consanguineously. His concept of the family of art is linked to the genealogies of noble families and, like theirs, Vasari's families in art have their deep roots in the genealogies of the great families of antiquity and the Bible. We often fail to notice the ways in which Vasari makes up family histories (even inventing imaginary noble genealogies while he is at it) to embellish his history poetically with Renaissance ideals of family piety and devotion. I trace these family histories and romances throughout this book, weaving them into a discussion of other aspects of Vasari's experience and culture. In particular, I have things to say here about the ways in which Vasari imagined his own family history and about the ways in which Vasari's family history is related to the family histories of his contemporaries Cellini, Bandinelli, and Michelangelo.

It is often said that art historians too easily sever art from its context, and the recent wave of contextualist studies (like the somewhat parallel phenomenon of the "new historicism" in literary scholarship) has reacted to the abstracting tendencies of formalism, iconography, and theoretical studies. Vasari offers us a full range of observations, extending from the technique and practice of the arts to their fullest social and political meaning or significance—all expressed as part of his interknit personal, family, communal, and religious experiences. No other writer on art—not Pliny and Ghiberti, not Bellori and Reynolds, not Diderot and Winckelmann, not the Goncourts and Pater, not even professional art historians, including the Marxists, who often ignore family history—offers us such a rich and manifold portrayal of

art as Vasari presents! All readings of the *Lives* are necessarily incomplete, but this reading, in conjunction with the previous two volumes, is offered in the hope of bringing the reader closer to an understanding of the cornucopian plenitude of Vasari.

Readers of the previous volumes in this trilogy will recognize that I refer, especially at the beginning of this book, but also throughout, to stories and details of the *Lives* that I have already discussed. It should be noted, however, that it was necessary to retell and elaborate upon these stories here in order to show how they relate to Vasari's history of family, which was otherwise unemphasized in the previous volumes.

Before we begin this excursion through the *Lives,* a word should be said about my decision, as in the two previous volumes, not to glut the text with footnotes. Too often in reading passages in Vasari out of context, we miss their fuller implications, and I hope to encourage students of the Renaissance and amateurs alike to read Vasari's book through in its entirety in order to discern and appreciate relations of the parts to the whole that otherwise escape notice. My trilogy points toward a fuller reading of the *Lives* than it has thus far received, and unless scholars of the Renaissance turn away from reading each other's quotations of Vasari out of context, the reading of the *Lives* will remain regrettably and unnecessarily restricted.

Although this book is not, strictly speaking, social history, I conceive of it as a contribution to the social history of the Renaissance, since Vasari's deep theme of family relations, both real and imaginary, explicated here tells us not only about Renaissance practices in general but also about a particular individual's specific experiences and views of the family. As such, it contains within itself an implicit treatise, a sort of "Della Famiglia," as copious in its exposition of familial ideals and values as Alberti's. Dwelling on the family in Vasari's pages, I have been stimulated by a whole generation of historians who have focused on this theme (although they were not concerned with Vasari's remarkably underused book). They include Marvin Becker, Gene Brucker, Richard Goldthwaite, David Herlihy, William Kent, Christiane Klapisch-Zuber, and Lauro Martines, among others too numerous to name here. If these scholars have dealt with the facts of family life, I have focused on the fictions of the family. It is my contention that these fictions tell us a great deal about the family. If the actual practices of families shaped Vasari's imagination, his book reveals the ways in which his imagination crystallized these

practices—in stories of father-son relations, of family finances, of funerals and tombs, of dowries and inheritances, of imaginary genealogies, which make up Vasari's larger story of artists who belong to the extended family that is the mirror image of both the state and church.

GIOTTO'S FATHER
AND THE
FAMILY OF VASARI'S *LIVES*

The Life of Cimabue

The biography of Cimabue is the first in Vasari's book. On an initial reading, this life appears to be unexceptional, but a closer look at its structure and allusions reveals a good deal both about the biography itself and about the *Lives* altogether that was unsuspected. I have previously made a number of observations about the life of Cimabue, but these are scattered through the first two books in my trilogy. By bringing these observations together and reviewing them here, I hope to give the reader a sense of how to read a single, typical biography in Vasari—one that sets the stage for the entire *Lives.*

We usually read Vasari's biographies for the historical information in them and also in order to correct the author's errors in the light of modern scholarship. Let us look at some of the works that Vasari tells us Cimabue painted. He speaks of the artist's well-known *Crucifix* at Santa Croce and of his *Madonna and Child* for Santa Trinita, focusing as well on his important contribution to the decoration of the Basilica of San Francesco in Assisi. He attributes to Cimabue more than the full extent of his work there, including some of the work of the anonymous Master of the San Francesco Legend and of the so-called Isaac Master. Vasari also gives to Cimabue the altarpiece of Santa Cecilia now attributed to the anonymous Master of Santa Cecilia, and he also supposes that Duccio's Rucellai *Madonna* for Santa Maria Novella was painted by Cimabue. These misattributions are in themselves interesting, for, despite their inaccuracy, they suggest stylistic affinities between diverse masters of the late Duecento.

We also read the life of Cimabue for its general commentary on the "maniera" or style of art in his day. Vasari speaks of Cimabue's training in the Byzantine style, that of the "Greci," which was still "goffa" or clumsy. Setting Cimabue against those from whom he learned, Vasari talks about his drawing from nature ("di natura"), his better invention

("migliore invenzione"), his improved drawing ("disegno") and color, notable for its freshness or "freschezza," especially in the rendering of flesh. He also praises Cimabue for the attitudes ("attitudini") of his figures and their "arie," and he dwells on the effect in his handling of draperies and their folds, the "pieghe de' panni," now more vivid or "vive," softer or "più morbide."

It is the framework of allegory, however, that gives deeper significance to Vasari's biography. He speaks of Cimabue's advent after a "flood of evils," evoking the biblical Flood. When he writes in the next sentence of Cimabue giving the "first lights" to painting, he alludes to the painter's name, Giovanni—thus linking him to the Baptist, a light in the wilderness, who foretold the coming of the True Light. He develops this theme further, saying of Cimabue's work at Assisi that it was a light or "lume" in darkness or "tenebre," when painting was still "blind." Cimabue was, however, a foil to Giotto, a greater light than his teacher, whose fame was a "splendore." Giotto ultimately obscured ("oscurò") Cimabue, putting him in shadow. At the very least, we should recognize that Vasari's concept of lights and darks, of "chiaro" and "scuro," is not merely aesthetic, for it is charged with theological significance, with the sense of spiritual light emerging from the darkness of sin or spiritual imperfection.

Vasari's sense of Giotto obscuring Cimabue is grounded in Dante's famous line in *Purgatorio* XI in which the one artist obscures the other. Vasari embellishes Dante by quoting from a commentary on the *Comedy* that speaks of Cimabue's "pride." Such sinfulness must be purged, Vasari suggests, in the manner of Dante, before the artist can attain perfection in his art. This perfection is achieved eventually by Michelangelo, who is appropriately humble, whose Sistine ceiling is, apocalyptically, a "lucerna" or lamp of painting. When Vasari says, however, that before Cimabue painting was "più tosto perduta che smarrita"—lost rather than bewildered—he writes in the language of Dante, himself "bewildered" when he descends into the realm of the lost souls, the "perduti."

Vasari develops the spiritual view of art's progress further by speaking of Cimabue's "renovation" of art as a spiritual renewal. Cimabue foretells the coming of Giotto, who, guided by heaven ("aiutato dal Cielo"), went higher ("più alto"), opening the door of truth, "la porta della verità," to those in Vasari's day who brought "grandeur" and

"perfection" to art. This perfected art was one of "marvels" and "miracles." Vasari's notion of art as an ascent to the gate of truth or paradise is at once Dantesque and biblical.

When Vasari writes of this journey heavenward, he not only thinks of Dante and the Bible, but he envisions this pilgrimage in terms of the *Triumph of the Church* in Santa Maria Novella. He identifies the fresco after his theological apostrophe by saying that the portrait of Cimabue appears here, in a work that he identifies as the work of Simone Martini (although modern scholars attribute it to Andrea da Firenze). This fresco makes visible the journey of the soul from the earthly city upward through an earthly garden or "paradiso" to the heavenly Jerusalem. We see here "beati" or blessed souls in the guise of children, those "reborn" as they pass through Saint Peter's gate, "la porta della verità." They are the "pueri" or children of the Bible who inherit the Kingdom of Heaven. The heavenly gate of the fresco was clearly in Vasari's mind when, a moment before, he spoke of the gate of truth opened by Giotto, who followed Cimabue.

What Vasari has done here is to use the large fresco at Santa Maria Novella as an icon of the spiritual journey of art—as a painted Bible or visual diagram of the ascent of the artist toward heaven. Although we call the fresco today the *Triumph of the Church*, Vasari spoke of it as the "storia della fede," the history of faith, directing our attention to the importance of devotion in the purification or renewal of art, what he calls its "rinovazione." We see that for Vasari the concept of "renaissance" depends primarily on the concept of spiritual renewal that he finds in the Bible, and he helps us to visualize it by contemplating the allegory of the fresco, in which Cimabue is said to appear. The souls passing through Saint Peter's gate, vestured in white, the color of purity, are dwarfed by Saint Peter because, as we have already observed, the painter sought to emphasize or render visible their childlike character. The painter makes visible the metaphor of the Gospels of the faithful as children reborn in Christ. Contemplating Vasari's sense of the spiritual meaning of the fresco, we not only come to understand the allegorical purpose to which he puts it, but we also grasp the painter's meaning when he paints the blessed souls entering heaven in diminutive form or as the "pueri" who inherit the Kingdom of Heaven. For Vasari this fresco of faith, based on the Bible, is a micro-map charting the vast and awesome

journey of the artist-pilgrim from Cimabue to Michelangelo, the soul's progress to perfection.

Cimabue's Family

By making the fresco in Santa Maria Novella the icon of the spiritual history that informs the very history of art, and by imagining Cimabue as portrayed in the fresco, Vasari alludes to a theme introduced at the beginning of the painter's life as part of the artist's family romance. He tells us that Cimabue, born of the "noble family" of the Cimabui, was adjudged by his father to be of such intelligence that he was sent to study grammar with a master, a "relative," at Santa Maria Novella— the very location of the fresco in which the painter supposedly would later be portrayed. The school of Santa Maria Novella was a distinguished center of theological learning, and the fresco directly across from the one in which Cimabue is said to appear represents a "summa" of Christian doctrine. Vasari thus absorbs Cimabue into a notable center of theology, introducing a major Dominican church, whose decorations by the Cione, Masaccio, Ghirlandaio, Filippino Lippi, among others, make of it one of the centers of devotional art in Florence.

But let us not lose sight of Vasari's family fiction. He pretends that while at Santa Maria Novella Cimabue fled from his studies to assist the "Greek" artists at work there. Vasari then insists that Cimabue's father soon judged ("giudicato dal padre") that it would be best for Cimabue to train with those artists. Cimabue's imaginary father is an ideal father who recognizes the importance of his son's natural inclination to art. He is the ancestor of all those fathers whom Vasari subsequently praises for their loving understanding of their sons' talents in art, including Vasari's own father. Cimabue's father thus stands apart from Michelangelo's father, who beat him as a boy when he pursued his drawing, and from Cellini's father, who tormented Benvenuto by trying to dissuade him from practicing his art. Cimabue brought honor both to his father and to his fatherland, "onorò la sua patria." With splendid alliteration Vasari says that his paintings are testimony of his honor: "fanno fede in Fiorenza."

When Vasari says that Cimabue's works bear witness to his glory,

his use of the word "fede" or faith foretells his claim that Cimabue's portrait appears in the fresco illustrating the story of "fede." The "profession" of painting is for Vasari a profession of faith, and it is therefore notable that Vasari sets its origin in a theological center of Florence. Family history, civic history, and religious history are thus all intertwined with biography.

Vasari exploits Santa Maria Novella in another regard in his account of the splendid altarpiece placed there between the Rucellai Chapel and that of the Bardi di Vernio. The Rucellai *Madonna* is today universally attributed to Duccio, but, given the relations of Duccio's style to Cimabue's, Vasari's attribution is remarkably apt. It is less the attribution, however, than the meaning of the subject and the significance Vasari gives to its subject that should command our attention.

Developing the theme of the Madonna and Child, Vasari writes a fable concerning the original reception of the painting. He pretends that the holy picture created such wonder or "maraviglia" in the people of Florence that it was carried to the church to the sound of trumpets, with much festivity "in most solemn procession." The story has the ring of truth to it, since Duccio's *Maestà* was carried to the Cathedral of Siena in such a procession as a famous document reveals: "And they accompanied the said picture up to the Duomo, making the procession around the Campo, as is the custom, all the bells ringing joyously, out of reverence for so noble a picture as is this." Vasari adds pseudohistorical authority to his account by forging documentation when he claims that "it is said in certain old records of the painters" that Charles of Anjou was passing through Florence at the time before the painting was seen by anybody ("per non essere ancora stata veduta da nessuno") and that the painting was shown to the king. All the men and women of Florence then came forth to behold it with him and with great festivity.

In Vasari's fiction, the image of Madonna and Child is part of the reenactment of the Epiphany of Jesus to the Three Kings, in which a contemporary monarch appears before the image of Jesus in a modern epiphany. The fable is given further significance by Vasari, who pretends that the joy or "allegrezza" of the Florentines was so great that the place where Cimabue's painting was beheld came to be called Borgo Allegri. Vasari paints a word picture of an aesthetic epiphany no doubt inspired by paintings of the Epiphany—thereby blurring the boundaries between aesthetic and religious experience, as he does

when he speaks of the way in which the works of Cimabue and others were beheld "in reverence." He thus contributes to the history of the city, and his knowing readers will recognize that by linking Cimabue's painting to one of the city's streets, Borgo Allegri, he associates it with the neighborhood of the greatest artist in Vasari's history, Michelangelo. Vasari's history, as he first indicated, extends "da Cimabue insino a' tempi nostri"—that is, to the age of Michelangelo. The joy of those beholding Cimabue's "Epiphany" foretells the "felicità" of those who, later contemplating Michelangelo's greatest works, were "beati" or blessed.

What is particularly notable about Vasari's account of the Rucellai *Madonna* for Santa Maria Novella and of the "storia della fede" there, in which Cimabue's portrait is said to appear, is the way in which he uses works of art, indeed their very iconography and location, to portray the subject of his biography. Through the fresco of the "story of faith," Vasari broadens Cimabue's role in the history of Florentine art, and it is again to this fresco that we must now once more turn.

Cimabue as Civic Architect

If Cimabue's beginnings are to be found at Santa Maria Novella, as Vasari fantasizes, his end is at Santa Maria del Fiore, where, Vasari further claims, he was buried. The Cathedral was the burial place of many notable Florentines, including Giotto and Brunelleschi, and Vasari fills out this picture of it as a sort of Florentine Pantheon by imagining Cimabue's burial there. Vasari also makes up an epitaph for this make-believe tomb—saying that one of the Nini composed it, using a Latin translation of Dante's line about Cimabue, who believed that in painting he held the field: "Credidit ut Cimabos picturae castra tenere." The reference to Dante here is pointed, since Vasari pretends that Cimabue (who was still alive in 1302, according to the documentation) died in 1300. This date is significant as a Jubilee year, but to Florentines it is also significant as the year of Dante, the year of the journey of his *Comedy*. We know that Vasari associated Santa Maria del Fiore with Dante's poem, since he quotes a poem, in the language of Dante's *Paradiso*, which describes the dome rising "di giro in giro"—circle by circle. The dome of Brunelleschi, as Vasari

also claims, was based on that of Arnolfo di Cambio, who, he pretends, was an ancestor of Brunelleschi's. Vasari further ties Cimabue to Arnolfo (and to Dante) by saying in Arnolfo's biography that the architect, too, like Cimabue, died in 1300—whereas we know that he died in March 1302. Vasari does not stop there. He also makes believe that on account of his "very great name" Cimabue went to work with Arnolfo at the very cathedral in which he was supposedly buried, at that structure associated both with Dante's paradise and with the glory of the commune.

Vasari links Cimabue with Arnolfo for various reasons—above all because he imagines Cimabue's place in the spiritual and civic history of art that he connects to the "story of faith." The image of the Church in this fresco, what Vasari calls the "universal church," is rendered, as he stresses, in accord with Arnolfo's design for the Cathedral, which included the dome later imitated by his descendant Brunelleschi. In Vasari's fiction, Cimabue the architect, working with Arnolfo, helps to build the central church of Florence, which is the model for the "universal church," next to which he appears in the fresco. Not surprisingly, Vasari later tells us in the life of Simone Martini that Arnolfo's portrait appears in the fresco in which Cimabue is portrayed. Vasari is gradually building his story of the relations of artists who participate in the larger community of the Florentine commune, of artists related to each other by bloodline (Arnolfo and Brunelleschi) or by training and cooperative endeavor (Arnolfo and Cimabue).

The Florentine Commune in 1300

When Vasari says that Arnolfo died in 1300, he adds that this was the period of Giovanni Villani. He likely recalls Villani's own symbolic claim that he was inspired in 1300, the Jubilee year, to write his chronicle, whereas the bulk of his book is believed to have been put in its final form some decades later. Vasari weaves together various major figures whose accomplishments are symbolized by the date 1300: Cimabue, Giotto, Arnolfo, Dante, and Villani.

Vasari elaborates on this history, writing his own universal history, by imagining various portraits, besides those of Arnolfo and Cimabue, in the fresco of the "story of faith," which makes visible the moment of

1300. He tells us that Simone Martini, to whom he attributes the fresco, portrayed himself there, and he insists that Martini also portrayed his friend Petrarch in the fresco as well as Petrarch's beloved Laura. He further imagines in this fresco the pope Benedetto X da Treviso and sees the figure next to him as Cardinal Nicola da Prato. Vasari also claims that the Lord of Poppi, Count Guido Novello, is portrayed in this proud assembly. Such imaginary portraits are typical of Vasari's descriptions of paintings. In this way, he finds the origins for many of his own portraits of artists included in the *Vite*, and he furnishes us with vivid images of illustrious citizens from the Florentine past. By claiming that all of these distinguished figures from around 1300 are shown in relation to the "universal church," Vasari writes his own "universal history," accommodating his subjects from a particular moment in history to eternity. As an allegory of faith, the fresco in Santa Maria Novella, in which all of these imaginary portraits appear, is also an idealized portrait of the commune—symbolized by both the ecclesiastical and civic authorities there. In Vasari's vision of the body politic harmoniously bonded to the Church Visible, artists and poets take their places in the larger community of civic leaders and church authorities.

The Family Tree of Art

The history of Florence, as historians teach us so vividly, is the history of families—of the Alberti, Strozzi, Pandolfini, Gondi, Martelli, Albizzi, Sassetti, and, above all, of the Medici. The story of the commune is the story of intermarriage between families, of patronage, patrimony, and power. In the pages of Vasari the language of family, reflecting this reality, plays a prominent role. He speaks of patrons or "padroni," whom he likens to the "patriarchi" of the Hebrew Bible, the patriarchs of the "patria." The terminology of family is everywhere apparent in descriptions of the church—of the "frati," "suore," and "padri," of the superintending "Holy Father" or Papa. This vocabulary is perhaps most commonly found in Vasari's descriptions of the most hallowed of households, the Holy Family: "Dio Padre," "Vergine Madre," and "Figliuolo."

Vasari's concept of the artist's own family is closely tied to his vision

of the noble families, who make up the commune, who are the patrons of artists. No less is it informed by the ideals of biblical families and by the ecclesiastical metaphors of family. If Vasari's vision of the commune, linking "chiesa" and "stato," is informed by the ideals of family, what Dante calls the "umana famiglia," his view of artists, as part of this community, is similarly inspired by such familial ideals. The genealogies of noble Florentine houses, modeled on the patriarchy of the Hebrew Bible, are an important model for Vasari's very concept of art history—which is a genealogy of artists both real and imaginary. These families of artists are part of the larger family of the Florentine state. Hence, it is appropriate that Arnolfo and Cimabue should appear with noble lords and clerics in the "story of faith," which is an ideal portrait of the Florentine Republic.

When Vasari says that Arnolfo's portrait appears in the "story of faith," he also mentions that the portrait of Arnolfo's father, Lapo, is seen there as well. Who is Lapo? In Vasari's biography of Arnolfo, Lapo is essentially an imaginary figure said to have made various works in Tuscany and elsewhere in Italy. He worked for popes, cardinals, and princes, for the various great personages of his day. The fictitious Lapo is a character whose career is imagined to explain the works antecedent to the advent of Arnolfo.

Vasari says that Lapo "always lived with his whole family" in Florence, leaving upon his death "Arnolfo, his son and heir" to his "paternal faculties" and "virtue." After his father's death, Vasari adds, Arnolfo was held in "very great esteem" and was believed to be "the greatest architect in Tuscany." Just as the greatness of Florentine architecture was laid on the foundations of Arnolfo's accomplishment, Arnolfo's distinction, Vasari urges, was based on the accomplishment of his father. The mythic Lapo is the great patriarch or forefather of Florentine architecture.

Although Arnolfo was in fact Arnolfo di Cambio, Arnolfo the son of Cambio, Vasari wants him to be the son of the imaginary Lapo so that he can, if fictitiously, link him, through Lapo, to the noble house of the Lapi Ficozzi. "It is said" ("Dicesi"), Vasari writes, that Arnolfo made a frieze of some fig leaves ("foglie di fico"), which, he claims, were the "arms of his father, master Lapo" and, to the extent that one can believe this ("perciò si può credere"), he had his origins in the family of the Lapi, "today a noble house of Florence." The fig leaves are the emblem of the Lapi, who are the Lapi Ficozzi.

Vasari elaborates the fiction of Arnolfo's family history by saying that, according to some, Filippo di Ser Brunelleschi was a descendant of Arnolfo's. Vasari wants to link Brunelleschi to Arnolfo, since Filippo completed the dome of the Cathedral, originally designed by Arnolfo. The genesis of a work of art becomes the basis of a family genealogy or family tree. In this case the tree is a fig. Although he does not say so, Vasari is exploiting the biography of Brunelleschi by Antonio Manetti, in which it is said that Filippo descended from both the Lapi and the Figherolo family, originally from the Po Valley. We know that Vasari has Manetti in mind here because he adds that "others believe" that the Lapi descend from those who come from Figaruolo, "castle on the mouth of the Po." Vasari simply reads Brunelleschi's genealogy back into Arnolfo's life.

What Vasari does is rework Figherolo into Ficozzi and make Lapi into the basis for the name of Arnolfo's father, Lapo—thus tying the two artists, Arnolfo and Brunelleschi, together in a unified family history. Vasari even returns to this genealogy in the life of Brunelleschi when he says that Filippo was registered in the city government in 1423 as Ser Brunellescho Lippi, named after his "avolo" or forefather "Lippo" rather than after the Lapi, "as he should have been." We might well chuckle at Vasari's fancy here in the service of his genealogy of art, but is this not the kind of fantasy exhibited in the genealogies of noble or royal families who traced their origins back to ancient Troy or who associated themselves with the patriarchs of the Bible? Before we bid farewell to Arnolfo's father, however, we should take a closer look at his name and therefore at its biblical implications.

The Story of Jacob

Vasari tells us—and we should not pass by this detail too quickly—that Lapo was really Iacopo. In other words, Vasari is saying, according to the ancient usage of the Florentines, who abbreviated names, Lapo was a shortened form of Iacopo. This Iacopo, Vasari imagines, built the great basilica of San Francesco at Assisi, which is described in great detail. When Vasari says that Iacopo's full name was Iacopo Tedesco, he plays on the fact that the basilica was built on a hill near the river Tescio—thereby making the rhyme between "Tedesco" and

"Tescio." His use of Tedesco (German) also aptly suggests the still-Gothic style of the basilica, reflecting a northern or Germanic influence. In any event, it is here in the basilica of San Francesco that Iacopo's (that is, Lapo's) son's associate Cimabue painted and that Giotto is said to have painted the glorious frescoes in honor of the saint. We come to see some of the ramifications of the genealogical tree of art.

Let us not, however, lose sight of Iacopo's name and its deeper significance. Iacopo is the Italian form of Jacob and, as I suggested in *Why Mona Lisa Smiles*, Vasari exploits this name in order to establish the patriarchal identity of his artists—notably of Iacopo Pontormo and Iacopo Bellini, both great father figures in the history of art. Since Vasari's protean Iacopo had the name Tedesco, he has to insist that his family always lived in Florence. Doing so, he makes this Florentine Jacob a patriarch, like the biblical Jacob, presiding over a family whose virtues are closely identified with the fortunes of the "stato," reminding us that the sons of Jacob were the nation of Israel. Iacopo begat Arnolfo, from whom Brunelleschi was descended by bloodline, just as Michelangelo was descended from Brunelleschi through his "virtù." Iacopo, father of Arnolfo, is the Jacob figure in the history of Florentine architecture, presiding over the great family of master builders culminating in Michelangelo—himself a great patriarch in Vasari's eyes.

Let us review the significance of Arnolfo's father's name—or rather Vasari's invention of it. As Lapo, he belongs to the Lapi, the family of Brunelleschi, sharing the imaginary family emblem, the fig. As Iacopo, he is a Jacob figure. As Iacopo Tedesco, his name resonates with the place and style of his greatest work. We might almost say that Lapo's or Iacopo Tedesco's name contains so much meaning for Vasari that it is in itself a poem. This poem is not, however, poetry for poetry's sake since, in its fictions, it tells us a great deal about the ways in which Florentine familial ideals inform Vasari's history of art. We need to pay homage to Vasari for inventing his Jacob, the master-builder who founded the house of Florentine architecture and its glorious family.

The Pisani: Father and Son

Having introduced Cimabue and linked him to Arnolfo, Vasari extends the family of art by placing Nicola and his son Giovanni in relation to both of these artists. More specifically, he ties these Pisan artists to the distinguished architectural clan of Arnolfo by pretending that the Pisani were not only sculptors but, like Arnolfo, builders. Nicola, he imagines, built many palaces and churches in Pisa, and he further imagines that Nicola's designs were used for buildings in Ferrara, Padua, and Venice. Vasari speaks suggestively of the great cathedral of Milan in relation to Nicola, although he does not actually say that the Pisan architect was involved in this project. Rather, the building is associated with Nicola in order to suggest the architectural splendor of his time. All of this is fiction of course, since there is no evidence of Nicola's activity as a builder. Nevertheless, Vasari speaks of the architectural works of Arnolfo and of Nicola—just as he speaks of Cimabue as architect with Arnolfo.

Having invented in Nicola a prodigious architect, responsible for countless works, Vasari then introduces his son or "figliuolo," Giovanni, who "always followed the example of his father." He imagines that when Nicola was "very old," he retired to Pisa, living there quietly and leaving the handling of his affairs to his son. Vasari speaks of Giovanni's work in Perugia before pretending that he now left for Pisa, desiring "to see his old and indisposed father again." Giovanni stopped off in Florence, but, hearing "that his father had died," he returned to Pisa, where he was much honored—rejoiced in by all, since, after the death of Nicola, he was regarded as the "heir" to his father's virtue and skill. His story recapitulates that of Arnolfo, "heir" to the virtue of Lapo. Vasari goes on to imagine that Giovanni did not let the Pisans down, working in Santa Maria della Spina, where (Vasari makes believe) Giovanni made a portrait of his father, Nicola. He is the embodiment of filial piety.

Embellishing this fictionalized account of Giovanni's career, Vasari pretends that Giovanni built the Campo Santo—one of the great monuments of his "patria." There is no evidence, however, that Giovanni was an architect—much less that he was the builder of this glorious Pisan monument. Filling in this largely fictional life of Giovanni by cataloguing his works all over Italy, Vasari also extends his

family in art by pretending that he was assisted by the Sienese brothers Agostino and Agnolo. Giovanni's itinerary includes Rome, Orvieto, and Arezzo, before a supposed trip to Florence made "in order to see Arnolfo's work at Santa Maria del Fiore."

Vasari next interjects into his account the singular date of 1300— the date of Dante, Villani, Cimabue, and Arnolfo—saying that in that year Nicola da Prato built a convent in Prato, named after him and thus called San Nicola. In the following sentence Vasari adds that because the citizens of Pistoia "held in veneration the name of Nicola," father of Giovanni, they commissioned Giovanni to make the pulpit of San Andrea in their city. The conjunction of these two unrelated, fictionalized events is made (in an apparent non sequitur) to celebrate the "name" of Nicola—Nicola the patron, Nicola the saint, and, finally, Nicola the honored artist and father of Giovanni.

After listing more of Giovanni's works, Vasari concludes by saying that after these many works the artist was "now very old." Vasari is forever stressing the old age of his artists, often exaggerating age as he creates the image of the artist as venerable patriarch in the biblical mold. Upon his death, Vasari says, Giovanni was buried in the Campo Santo, where he had earlier buried "Nicola his father." When Vasari says toward the end of the biographies of father and son that they brought "light" after "so much darkness," he plays on Giovanni's name, since Giovanni is, like Giovanni Cimabue and ultimately Saint John the Baptist, a light in darkness. Thus end the lives of a great father in art and his great and devoted son in art—both of whom brought honor to their "patria."

The Rise and Fall of the Gaddi

The glory that artists bring to their "patria" is one of the deep themes of the *Lives*. Such honor is achieved by one of the leading families of Florentine art, the Gaddi. Gaddo di Zanobi Gaddi was the founder of this glorious house of art. He was matriculated in the Arte de' Medici and degli Speziali in 1312, and it appears that he was still alive in 1333. Besides these simple facts, we know essentially nothing about Gaddo. With this "nothing" in mind, let us consider how Vasari fabricates Gaddo's life and the fortunes of his family.

Vasari makes Gaddo into a mosaicist who worked at Santa Maria del Fiore and later at Santa Maria Novella. Like all distinguished or important artists, Gaddo traveled to Rome, supposedly completing works left unfinished by Iacopo Torriti, before returning to Tuscany, where he worked in Pisa and Arezzo. The main point of Vasari's biography of Gaddo is that he is a loving friend of Cimabue and also of Andrea Tafi. These "gentle spirits" are part of the brotherhood of art—the theme that Vasari develops as part of his story of the family of art. He later speaks of the painter's guild as a "fraternità," the fraternity uniting artists in what he often calls "fratellanza" or brotherhood.

Vasari introduces the specific theme of Gaddo's family when he imagines that Gaddo was "buried honorably by his son Taddeo in Santa Croce." (Presumably, he knew nothing about the circumstances of this funeral or about the location of Gaddo's tomb.) Vasari then extends this family history, following the report of Cennino Cennini, by saying that Taddeo was held by Giotto at his baptism—as if Giotto were his godfather. Vasari fills out this family history when he claims that Taddeo portrayed his father, Gaddo, in the fresco of the Marriage of the Virgin in Santa Croce. Like Giovanni Pisano supposedly portraying his father, Taddeo is the very paradigm of filial piety. These forefathers of art are the ancestors or "avoli" in art of Vasari, who would similarly portray his own father.

Vasari also ornaments his history of artistic brotherhood by saying that Taddeo portrayed Gaddo along with Tafi, further memorializing their devotion to each other. In Vasari's pages the ideal community of artists mirrors the vision of a perfect, harmonious commune (like that in the "story of faith"), this perfect community being an extension of the ideal, perfect family. By imagining artists painting their fathers and brotherly friends, Vasari embellishes the interwoven familial and communal ideals of "concordia." He continuously links Gaddo and Tafi, even though he in fact knows nothing about either. In the life of Tafi, Vasari also pretends that Tafi and Gaddo worked together, and he associates Tafi and Cimabue by setting them apart from Giotto. All of these artists belong to the community of artists established in the biography of Cimabue, and the claim that Gaddo worked prominently at Santa Maria Novella reminds us of the pivotal role of this church in the career of Cimabue and, thus, in the rebirth of art.

Vasari next continues his history of the Gaddi family in the life of Gaddo's son, Taddeo. The "proemio" to this biography is a celebration

of the "honor" Taddeo brought to his "patria" and of the "glory" and "wealth" he brought to his family. Taddeo's descendants, Vasari is pleased to tell us, became "very rich" and "noble." The story of the Gaddi is therefore part of Vasari's larger history of the nobility of art, which includes the noble family histories of Cimabue and Arnolfo. Taddeo's life is also part of the history of artistic brotherhood. Just as his father, Gaddo, was a friend of Tafi and Cimabue, so is Taddeo a friend of Simone Martini, each loving the other like a brother, "fraternamente," as Vasari says. The metaphorical family of art is, we have seen, woven through actual family history, which here reaches its apogee, if in imagination, in another moment of filial piety: "Taddeo was buried," Vasari imagines, "by his sons Agnolo and Giovanni in the first cloister of Santa Croce in the tomb that he had himself made for his father Gaddo." Or so Vasari imagines—no doubt recalling the family tomb of his fathers, which he proudly rebuilt and extended in the Pieve of his native Arezzo.

If Taddeo brought his family to prominence in Florence, his son Agnolo did not exactly maintain his family's status. As a type of sixteenth-century Thomas Mann, Vasari recounts the decline of a Florentine burgher family. Agnolo did not pursue his studies in art assiduously enough; instead, the very personification of "avarice," he gave himself over to trade and commerce. Although Vasari hopes that artists will acquire wealth and prosper, he sees this goal in tension with the ideal of living in accord with the principles of "povertà." For Vasari, Michelangelo embodies the reconciliation of these two ideals since Michelangelo, although "rich," as Vasari boldly asserts, did not live like a rich man. Vasari paints a picture of the avaricious Agnolo, however, as dedicated too much to commerce (at the expense of his art), hence the decline of art in his family.

Vasari rounds out this story by saying that Agnolo went to live in a house established by his father in Venice and there he dedicated himself to "pleasure" instead of work. (This fiction is part of the larger story of Venice as a center of luxury found, for example, in the lives of Antonello da Messina and Giorgione.) And so the house of Gaddi went into decline, given over to luxury and sloth. It is an old story. The first generation works hard, establishing the family's foundation. The next generation, exploiting this base, achieves status and wealth. The final generation is too self-indulgent and thus the family declines. Vasari adorns this family history by pretending that Agnolo received as an

"inheritance" from his grandfather Gaddo knowledge of the "secret" of how to work in mosaics. He therefore heightens, almost poignantly, the sense of family decline, the story of a prodigal son, squandering his patrimony by turning away from art to a life of pleasure.

Vasari's fictional or novelistic account of the rise and fall of the Gaddi family cuts even deeper. It is, if metaphorically, a commentary on the history of art in general. Today we see the art of the late Trecento, the period of Agnolo, as one of decline after the work of Giotto and his immediate followers. So did Vasari. Whereas we fictionalize this history by relating such decline to social, economic, and political crises, Vasari sees this decline, in a moral and theological allegory, as the result of greed, sloth, and luxury. His make-believe history of the Gaddi family is a sort of parable, a cautionary tale that warns all artists to continue to work hard and, when they prosper, not to let their wealth lure them away from their profession.

One final observation about the family history of the Gaddi. Vasari tells us that Agnolo was buried by his sons in the sepulcher that he made for himself and his descendants—recalling the account of Agnolo burying his father, Taddeo. He adds that Agnolo left fifty thousand "fiorini" to his sons, a huge sum of money. Let us be clear about one thing: Vasari condemns avarice, but he intends all his artists, both real and imaginary, to prosper. I say "imaginary" because Vasari's portrayal of Agnolo is largely just that. Although he might have assumed that Agnolo made a good living as a prolific artist, Vasari surely knew nothing of Agnolo's exact financial status. Vasari wants to leave us an image of an artist who, if flawed, was notable for his "ricchezze." Such wealth is the goal of Vasari and his contemporaries (of Michelangelo, Bandinelli, and Cellini), who, like Vasari himself, prospered and invested their capital in real estate, as the Gaddi family supposedly did. The prosperity of the artist is part of the larger story of his family's wealth and prominence.

Biography as Family and Civic History

It should be more than clear by now that, writing "vite" or biographies of artists, Vasari is writing a family history of art, both literary and metaphorically, and that this history is a moral history as well. Artists are linked in moral terms, and it is therefore no accident that Giovanni da Ponte is presented right before Agnolo Gaddi, since da Ponte is said to have "consumed his patrimony." It cannot escape our attention that he is like Agnolo, who similarly wasted his patrimony— that is, the patrimony of art. When Vasari pretends that Giovanni— who in fact lived much later—was a protégé of Buffalmacco, he associates Giovanni's "mal governo" or poor handling of his personal affairs with that of Buffalmacco, who, spending all that he earned, died in poverty. Vasari insists, let us recall, that artists should live in accord with the ideal of "povertas"—not that they should live and die in fact in poverty!

Vasari's use of the word "governo" for an individual's management of his affairs is a reminder of the close links between personal governance and communal government. In the life of Antonio Veneziano, Vasari speaks of "envy" and "tyranny," saying that although Antonio, who worked with Agnolo Gaddi, was loved by the Florentines, he was envied and persecuted by Venetian artists when he returned to Venice. For this reason Antonio made Florence his "patria." We read this story of envy, recalling all of Vasari's examples of loving artists, free of such envy, who love each other like brothers. Perhaps it is no accident that Vasari chooses to describe as the first work by Antonio in Florence one in which Christ appears in "the ardor of charity." For Vasari "carità" is interchangeable with "amore," which is antithetical to the blindness of "envy."

Vasari ties to the story of Antonio Veneziano that of Gherardo Starnina, saying that after studying in Spain, Gherardo worked with Antonio. Whereas Gherardo's work was originally "rough and crude," he learned in Spain to be more "gentle and courteous," so that whereas he was hated before his departure, he was now loved by his fellow Florentines. We cannot fail to see the contrast between the Venetians, who do not recognize Antonio's virtue after his return to

Venice, and the Florentines, who come to love Starnina for his cour-
tesy and grace. The stories of Antonio and Starnina are part of the
larger history that Vasari writes of their "patrie" or adopted "patrie."
In Vasari's idealized fiction the Florentine commune or "patria" is
inspired by love. Such love is closely related to that between family
members—between fathers and sons, between brothers.

Although Vasari is forever idealizing Florence, he also realizes that
the city is imperfect. Thus it is no accident that he places the life of
Lippo Fiorentino after that of Starnina. Whereas Gherardo is "gentle
and courteous," overcoming "hatred," Lippo is litigious and aggres-
sive, loving "discord" rather than peace. As a result he provokes a fight,
Vasari pretends, which results in his death. Lippo stands here as the
antitype not only of Gherardo but of all those saintly artists whom
Vasari exalts for their loving ways. Litigious Lippo is a reminder, for all
of Vasari's dreams of brotherly love and civic harmony, that hatred and
"discordia" exist and must be expelled from the perfect commune.

Giotto's Father

In the community of artists that Vasari writes about in the first part of
the *Lives*, Giotto is the central figure. All artists are defined as either
coming before Giotto and thus lacking his virtue or following him as
"disciples" and thus absorbing it. It is not surprising that Giotto is
linked to numerous artists in various ways—often as a kind of father
figure. Before we turn to his paternal role, however, we should not
fail to remark on Vasari's fiction of Giotto's own father.

The story of how Cimabue discovered the young Giotto drawing
sheep in the sand is told over and over again. Vasari took this tale from
Ghiberti's *Commentarii*, but he adds a detail to it that otherwise
escapes notice. According to Vasari, when Cimabue asked Giotto if he
wished to come study with him, Giotto replied that "he would go with
him willingly, if it pleased his father." Cimabue then asked Giotto's
father, the ideal father of an artist, who then offered his son lovingly to
Cimabue. Or so the story goes. Cimabue's imaginary father, we saw,
stands for all those fathers who encourage their sons in art, including
Vasari's father, who lovingly leads his son down the path of art, as
Vasari reports in his autobiography. Giotto's ideal father stands in

opposition to all those fathers, real or imaginary, who oppose their sons' study of art—for example, as we have noted, Michelangelo's father. Michelangelo told Vasari that his father beat him for pursuing his art, since it was a "low thing" not worthy of their "ancient house." Art was thought by Michelangelo's father to be ignoble.

Giotto's low social status as a shepherd is the very basis of the story of his rise to a form of nobility—that is, the nobility of art. Giotto begins his life in humble circumstances, tending sheep on a farm ("nella villa") in the countryside. His ascendancy to artistic greatness is to be seen not merely in theological terms as the rise to spiritual perfection through artistic virtue, observed in the allegorical life of Cimabue, but as the exaltation of the artist's station in society. Vasari quotes Giotto's imaginary quips, reported by Sacchetti, in which the painter teases none other than the King of Naples—showing, in a sense, that he has achieved an elevated position in society. The overall image of Giotto that emerges in Vasari is that of a princely figure, foretelling Leonardo, Raphael, and Michelangelo.

We fail to measure fully Vasari's portrayal of Giotto's climb in society if we do not observe the way in which he chooses to retell a particular tale about Giotto from Sacchetti at the end of the artist's life. According to this tale, which can be seen as a summing up of Giotto's social attainment, a clod with social aspirations of his own, "un grossolano," presumptuously asks Giotto to paint his family arms. The painter responds to this commission mockingly by painting not the requested emblematic arms but actual arms, that is, a sword, a knife, a lance, and armor. When his patron protests, Giotto asks: Who do you think you are, a Bardi? Who are your ancestors anyway? Mortified, the booby objects, protesting to Giotto that the painter says a "villainous thing." The term "villania" is used here pointedly, indeed ironically, since it is the presumptuous patron who is villainous. The word "villainous" echoes Vasari's opening story of Giotto's youth on a farm or "villa," as himself a farm servant or "villanus." Now, having worked for the Bardi and other lords and nobles, for popes and kings, he has become himself a great man—by contrast to his lowly patron, a lesser man, who is vile, "vilus" or base. Giotto's father surely made the right—the wise and noble—decision when he willingly sent his son to school with Cimabue. The result of that education was the fulfillment of Giotto's virtue in art, his attainment of a noble status in and through art.

Giottesque Affiliations

Recalling that Vasari links the Pisani with Arnolfo, we should also see that he links Giotto with both. He tells us that the painter made frescoes in the Campo Santo of Pisa, which he imagines to be of Giovanni Pisano's design, and, building this edifice of artistic interrelations, he also tells us that Giotto is (like the Pisani) associated with Arnolfo, since he worked on the Cathedral bell tower, following Arnolfo's design. Observing that this design was in the "maniera tedesca," Vasari reminds us that Arnolfo's father was Iacopo Tedesco. Iacopo begat Arnolfo, who, in a sense, begat Giotto. It was perhaps in part on account of Giotto's activity at the Cathedral that Vasari earlier sought to connect his teacher Cimabue with Arnolfo's work there. Doing so, he brought all these artists into relation to each other, united in the central church, just as all the illustrious men, including artists, were said to appear, united, in the fresco that showed the universal church in the guise of the Cathedral. Vasari embellishes these relations by making believe that his disciple and "godson" Taddeo Gaddi worked on the "campanile," completing Giotto's work after his death. Vasari also follows Ghiberti, who attributed the design of the "campanile" reliefs to Giotto, saying that Andrea Pisano made these sculptural reliefs from Giotto's designs. Vasari wants to show that Giotto is universal in the arts—in painting, sculpture, and architecture, all based on "disegno"—which, he says on more than one occasion, is the "padre" or father of art (as "invenzione" is the "madre" of art). The very master of "disegno," whose "disegno" is imitated by others, Giotto is the father figure of art, who embodies the paternity of "disegno" itself. Remembered by Vasari as a great forefather of art, Giotto is a patriarch of art, like the great patriarchs of the Bible, who rose from humble beginnings as shepherds to become the kings of Israel.

Having associated Giotto with sculpture, Vasari attributes to him the design, or paternity, if you will, of the major tomb of Bishop Guido Tarlati di Pietra Mala in Arezzo. Vasari in this way associates the great patriarch of art with one of the major monuments in his hometown, thus exalting its history. He describes the tomb in great detail in the lives of two brothers, the sculptors Agostino and Agnolo Sanesi, saying that these artists made the tomb after Giotto's designs.

In fact, Vasari knows nothing about these two artists, who, he imagines, were protégés of the Pisano; he thus links two families in art. He multiplies the ramifications of the family tree of art by saying that "their ancestors were architects." If this claim is not true, as the Italians say, it could be, since art, like other professions, trades, and crafts, often remained in the family from generation to generation. For this reason we do not pause to consider that Vasari is making up this not implausible but unfounded detail of his story. He rounds out the lives of these brother sculptors by saying that they had as protégés Pietro and Paolo Aretini and Iacobello and Pietro Paolo Veneziani. Although he does not say so, he suggests that these pairs of artists, like Agostino and Agnolo, are brothers in art. Although not in fact brothers, these are implicitly associated in friendship with Stefano Fiorentino and Ugolino Sanese, whose paired lives come immediately after the biographies of the two Sienese brothers. Vasari adds to this story of the family of art by saying that, although the records show that Stefano had a son named Maso, this artist, also called Giottino, was held by some to be the "son" of Giotto. Even if Giottino was not Giotto's son, his name suggests, in the root sense of "affiliation," his filial relation to Giotto, the great patriarch of Trecento art. The story of Giotto's affiliations with Arnolfo, Cimabue, and the Pisani and the history of the affiliations of Taddeo Gaddi and Giottino to Giotto are permeated by the real family relations that exist within the broader imaginary family of art.

Vasari quite poetically and marvelously generates a real family out of the extended family of art united in Giotto, pretending to trace the family of his disciple Puccio Capanna. He claims that Puccio, who worked assisting Giotto in Assisi, died there on the job, adding that he has found evidence that they "regard him as a citizen of Assisi." Why? Because in that city there is a family named Capanni, and from this fact Vasari concludes that "one can believe" that, although Puccio came from Florence, he took a wife in Assisi and had children whose descendants still live there. If we read Vasari carefully, we discover that he betrays to us that all of this is conjectural, if not altogether fanciful—what he might himself call a "fantasia"—because he ends by saying that it does not matter ("non importa") that one cannot know this for sure. We see how Vasari creates the family romance of Giotto's disciple or "son" in art, Puccio, imagining how he went from Florence to Assisi, where he established his household. In a metaphorical

sense, just as Giotto was affiliated with Cimabue, who stood "in loco parentis" to him after receiving him from Giotto's father, Puccio was now affiliated with Giotto. In Vasari's fiction, Giotto begat Puccio, who begat the Capanni of Assisi. The Capanni, Vasari might almost be saying, are descendants of the house of Giotto.

The Mythic Memmi Family

We have by no means exhausted the family relations of art, both real and imaginary, in the age of Giotto. In some cases Vasari does not exploit these relations, writing in a straightforward way about the three Cione brothers, Andrea, Nardo, and Iacopo. More often than not he writes imaginatively about artists' families. He imagines, for example, that Taddeo di Bartolo was the son of Bartolo di Fredi, who did major work in San Gimignano, whereas in fact Taddeo was the son of Bartolo di Mino. At the end of Taddeo's life Vasari introduces Domenico Bartoli as his "nipote" or nephew, although Bartoli was from another town and family, being born in Asciano, the son of a certain Bartolo di Gherzo. Vasari creates family ties of three generations—from Bartolo di Fredi to Taddeo di Bartolo to Domenico Bartoli—and this genealogy is entirely a fiction, but as a fiction it unites artists in the fanciful family of art.

Sometimes Vasari's familial ties compound fiction and error. He speaks mistakenly of Lorenzo di Bicci having two sons, Bicci di Lorenzo and Neri di Bicci, whereas Neri was the son of Bicci. He pretends that in painting the Capella Lenzi of Ognissanti Neri portrayed his father, Lorenzo—a fiction that further articulates Vasari's deep theme of filial piety. Speaking of Andrea Pisano and his son Nino (a parallel to the Pisani, Nicola and Giovanni), Vasari says that Nino signed an altarpiece in Santa Caterina in Pisa: "On the first day of February 1370 . . . Nino, son of Andrea Pisano, made these figures." Nino was dead before this date and since the documents indicate that the altarpiece was completed earlier, by 1368, we might conclude that this purported signature is a fiction—but a telling fiction, because Vasari, by identifying Nino as the son of Andrea, returns once again to his theme of filial devotion. Similarly, Vasari makes believe that Nino buried Andrea in Santa Maria del Fiore with

a Latin epitaph. Of Vasari's own invention, this imaginary epitaph further sustains the story of the son's devotion to his father. All these instances of filial piety in Vasari are linked to all the related tales of paternal blessing.

Throughout the Trecento we have encountered imaginary cases of familial piety, and these are to be measured against Vasari's own dedication to the memory of his family, which intrudes in the life of Pietro Lorenzetti when Vasari speaks of his restorations in the Pieve of Arezzo. It was here that he learned his first lessons, and the church contained the remains of his ancestors—"le reliquie de' miei passati." Not surprisingly, this is not the last we hear of this family tomb, of Vasari's own filial piety, which has its idealized mirror image in the Trecento, in the lives of the Pisani and the Gaddi sons, who honor their fathers' memories.

Almost amazing is just how susceptible we are to Vasari's family fictions, especially since art historians are quick to dismiss his "errors." Consider the case of an overlooked family fiction in the life of Simone Martini. Vasari begins by saying how happy or "felici" are those whose "names" are rendered immortal by poets, whose "memory" is preserved by writers. Simone Martini is such a figure, whose "memoria" is preserved in two sonnets about the painter by his friend Petrarch. In the course of his biography of Simone, Vasari introduces his brother-in-law Lippo Memmi. Echoing Ghiberti, he says that Lippo is Simone's brother. He calls the two painters the "due Memmi," although Lippo was of another family, the son of Memmo di Filippuccio, and Simone was not of the Memmi family, which is fictitious, invented from Memmo's name. Vasari goes on to say that the styles of these two brothers resembled each other so much that Simone put his signature, "Simonis Memmi Senesis opus," on his works to distinguish them from those of Lippo's, and that Lippo signed his works "Opus Memmi de Senis me fecit" to distinguish them from Simone's. Since Simone is not from the family of Memmi, the signature reported by Vasari, "Simonis Memmi," is imaginary. But by making him a Memmi, through his association with Lippo, Vasari uses Simone Memmi's fictional name as a memorial, playing alliteratively on the relation of "Memmi" to "memoria" (or "memini" in the Latin). Vasari thus poetically elaborates Petrarch's "memoria" of Martini's "name." Only now he invests Simone's new name, "Memmi," with the very resonance of "memoria." Characteristically, Vasari orna-

ments this fiction and its play on the "memoria" of Memmi by invent-
ing a Latin epitaph for Martini's tomb that begins: "Simoni Memmio
picturum omnium omnis aetatis celeberrimo."

Although this epitaph and Martini's signature are make-believe,
they are usually unquestioned by art historians whom, as we have
observed, we otherwise expect to correct Vasari's "errors." Scholars
read Vasari ignoring such fictions, accepting them at face value be-
cause they are "true to life." Vasari's fictitious signatures, like his
make-believe tombs and epitaphs, like his imaginary artists and
works, and like the fabricated events in their lives, are accepted on
account of their verisimilitude. Such resemblance to the truth is a
principal attribute of great painting, according to Vasari, and it is no
less a characteristic of Vasari's "art," which, although not strictly
"true," is similar to the truth. Suspending disbelief, we yield to the
fictitious fraternity between Simone and Lippo and its deeper memo-
rializing meaning in their mythologized Memmi origins.

Saintly and Communal Brotherhood

So subtly woven into the fabric of the *Lives* are the ideals of
fraternity—saintly, civic, and artistic—that we often fail to recognize
them. They appear, for example, in the life of Nanni di Banco, where
Vasari tells the wonderful tale of the artist's famous sculpture of the
Quattro Coronati, the four martyr saints made for the niche of the
Guild of the Smiths, Carpenters, and Masons at Orsanmichele. "Si
dice," Vasari writes, it is said, that having finished this work and
having detached the figures from each other, it was with great diffi-
culty that Nanni could get even three figures back into the niche,
since he made some with arms extended. Desperate and overcome
with melancholy, he begged Donatello to help him repair this
"disgrazia."

Laughing good-naturedly, Donatello tells Nanni that he will be
happy to help him, provided that Nanni buys dinner for him and all
the "garzoni" in his shop. Then, with "excellent" judgment, Don-
atello, helped by his assistants, arranges the figures in the niche, in

one case placing the extended arm of a saint on the shoulder of another. Joined harmoniously ("unitamente commesse" or literally "put together in unity"), the saints manifest, Vasari says, "concord and brotherhood"—"concordia" and "fratellanza." We miss part of the point of the story if we fail to see that Donatello successfully joins together figures commissioned by the guild of carpenters. In other words, as a joiner of sorts, Donatello exhibits a skill worthy of the patrons, who are joiners.

The larger point of Vasari's story is not that Donatello helps Nanni, but that in doing so he demonstrates "fratellanza" toward his fellow artist. In other words, Donatello's "fratellanza" is manifest in the "fratellanza" of the saints he arranges. Such saintly fraternity evokes the very ideal of "fraternitas," of which Saint Paul speaks in the Epistles. Vasari finds this ideal in both the saints and in his saintly artist. The anecdote accords with other episodes in the life of Donatello, where he is saintly in his giving or charity, as his name—from "donare" or "give"—suggests. Repairing the "disgrace" of Nanni's work, Donatello gives grace to the work, suggesting the connection between "giving" and "grace," for grace is the "gift of gifts." Donatello's goodness is not only saintly, it is also civic. He helps Nanni with a work for one of the city's guilds, and elsewhere he demonstrates civic spirit when, along with Brunelleschi, he withdraws from the competition for the Baptistry door for the "public" good. Fraternity is both religious and civic. Brotherhood extends outward from the family to the commonwealth and the Church. One might almost say that the accord between Nanni's saints in their niche is reflected in the "concordia" between the fraternal Donatello and Nanni and that these saints make visible the "concordia" between citizens in an ideal city, which mirrors that of heaven.

Aretine Families

Like Petrarch, Vasari was born in Arezzo and, although we are less interested today in his native city than in his adopted Florence, we should see that Vasari dwells on the art of his hometown. If it would be tedious to list all the works—the buildings, sculptures, and paintings of Arezzo—we can say that from all these descriptions one could

easily fashion a substantial guidebook to the town. Any index to the *Lives* that lists the locations of works of art cited by Vasari will show that this is so. The disproportionate attention to Arezzo—far more extensively treated perhaps than any other Tuscan town besides Florence—is testimony to Vasari's civic pride. It is not surprising, therefore, that Vasari celebrates Aretine artists and, in doing so, describes and celebrates their families.

Vasari's patriotic zeal is reflected in one of his quasi-fictitious biographies, that of Niccolò Aretino. I say "quasi-fictitious" because although there was a Niccolò from Arezzo, Niccolò di Luca Spinelli, Vasari conflates this shadowy, minor figure with Niccolò Lamberti of Florence. He thus fabricates an artist who moves between Arezzo and Florence—a shadow figure to Giorgio himself. Vasari makes capital of this make-believe artist by pretending that he labored in poverty, and that after receiving some mysterious insult he left Arezzo for Florence. Although he remained very poor, "murdered by poverty," he worked with virtuosity or "virtuosamente." Celebrating artistic dedication, Vasari fleshes out his imaginary character by saying that he left Florence for Arezzo when the plague came and later returned to Florence when there was war in Arezzo—war being "a main enemy of the arts." Vasari pretends that Niccolò achieved a certain measure of success, becoming chief architect of the Cathedral of Milan, but he sees Niccolò's career as essentially marked by poverty, plague, and war, as the result of ill-fortune. Dame Fortune, "la fortuna," was "avaricious with her goods," limiting Niccolò's success, despite his "ingegno" and "vivacity of soul." Whatever the facts of the lives of the real Niccolòs, Vasari's "Niccolò" is a figure of great pathos and exemplary dedication. Although Niccolò is an imaginary character, his life a fiction, he and his life are plausible because they suggest the conditions of poverty, plague, and warfare and the suffering that these conditions cause in the "real lives" of artists in Vasari's own time.

Far more prominent in Vasari's Aretine Hall of Fame is Spinello Aretino, whose life is part of the family history of Aretine art. Like Vasari himself, Spinello was a prolific artist, especially as a muralist, who traveled between Arezzo and Florence. His biography becomes an opportunity for Vasari to speak of the painter's civic patrons and their importance—for example, of the governing Council of Sixty, which, having heard of Spinello's good work, called him home to work

for the commune. Elsewhere Vasari writes of the Confraternity of Arezzo, which aided the poor during the plague year of 1348 by helping the sick and burying the dead. For such good works the Confraternity received so many donations that it inherited one-third of the wealth of the town. Vasari adds that in the plague year Spinello himself visited the sick, buried the dead, and undertook other pious acts. In doing these things Spinello was like the "best citizens," who always have and still undertake such acts. Vasari concludes this imaginary account of Spinello's participation in the Confraternity—really an oration on the "virtue" of Aretines—by saying that Spinello memorialized his own deeds by painting a Madonna with her mantle open and under it all the people of Arezzo. The painting is thus an expression of both religious and civic zeal. Its subject reminds us that Mary is the "Vergine Madre" and that the commune is implicitly likened to an extended family united under her maternal protection. In the patriarchy of politics and religion there is still some room for the civic and heavenly matriarch.

As in the life of Niccolò Aretino, Vasari colors the painter's life with dramatic events, saying that at one point Spinello left Arezzo because there was great strife between the Guelphs and Ghibellines. This is an opportunity for Vasari also to portray the artist's family, introducing his painter-son, Parri. As a result of this political strife (so different from the image of the commune united in Mary), Spinello took "his family and his son Parri" to Florence, where, Vasari imagines, he had "many friends and relatives." Vasari goes on to say that in 1400 (and this date begins to crop up as 1300 had earlier) Spinello, who was now in Pisa, desired to return to Arezzo, his "patria." At the age of seventy-seven, he was lovingly received by relatives and was honored by them until the end of his life, at the age of ninety-two. In the earlier, first edition of the *Lives,* Vasari, who had no idea how old Spinello was at his death, said that he died at the age of seventy-seven. So we see that in the revised edition he adds fifteen years to Spinello's life—no doubt to make him even more venerable. I have previously noted that Vasari is forever making his artists older than they were when they died, because in his vision they are modern equivalents of the biblical patriarchs. Spinello Aretino, citizen par excellence, who was honored by the commune when he was "very old," is such a patriarch—a patriarch of Arezzo in particular and of the history of art in general.

Spinello Aretino, His Family and "Patria"

As a patriarchal figure, Spinello Aretino presides over a family of artists, real and imaginary. Before turning to his progeny, however, let us consider his extraordinary death as imagined by Vasari. In old age, Spinello painted a fresco of Saint Michael's triumph over Lucifer in the manner of the "old artists," as Vasari says, playing on Spinello's identity as one of the forefathers of art, as one of the painters of old. According to Vasari's fiction, the terrifying Lucifer was so ugly that, in revenge, he visited the painter in a dream, from which the artist awoke in a state of fear. Although his wife succored him, Spinello never recovered from this horrible apparition and he died from the shock a short time later. Vasari repeats here that at the time of this horrible death Spinello was ninety-two years old, shrewdly leaving us with a grim, vivid, unforgettable image of the venerable artist succumbing in old age.

Vasari tells us that Spinello left two sons, the above-mentioned Parri and Forzore. Forzore was in fact a nephew of Spinello's, the son of his brother Niccolò. The life of Parri di Spinello Spinelli or Parri Spinelli, as he is called, is similar to that of his father in its basic themes. Vasari uses it as another opportunity to speak of Arezzo. He picks up the story of the Spinelli family by saying that Parri, having been absent from Arezzo for many years, was called back by relatives after the death of his father. There he paints a fresco of Beato Tommasuolo, and mention of this work becomes an excuse for Vasari to tell a story of what the saint once did in Arezzo. After preaching to the Aretines, trying to induce them to live in peace and warning them to desist from their discordant ways, the saint decided finally that he was wasting his time. One day, entering the Palace of the Sixty, the saint, who saw them deliberating but reaching no resolutions save those that harmed the city, devised a plan. Observing that the hall was full of magistrates, he concealed some burning coals in his robes and, approaching boldly, he threw these coals at their feet, saying: "My Lords, the fire is among you; take heed lest ruin be upon you." With this he left, but such was the effect of his advice, in accord with God's wishes, that his action achieved what his preaching and threats had previously failed to accomplish, and the

magistrates, now finally united, governed the city for many years with much peace and quietude.

After this story, we are pulled up short by Vasari's next words, "But to return to Parri," for so absorbed are we by the story of the saint that we realize Vasari has digressed from the artist's life. In fact, Vasari has not digressed at all, since his interpolated tale, itself a vivid fresco in words, relates the artist's life to the history of his "patria." The account of the saint's words to the Aretines recalls Vasari's tale of the civic strife that caused Parri's father to move his family from Arezzo. In the broader scheme of things Beato Tommasuolo's fiery denunciation of the Aretines is reminiscent of the preachings of San Bernardino, Savonarola, and the other holy men who warned the Florentines and the Aretines to repent, since their damnation was near, and in the story of Beato Tommasuolo we see that Vasari had learned well the rhetorical skill of such zealous preachers.

In the saint-filled life of Parri Spinelli, another holy man, San Bernardino, emerges prominently as one of the central characters. "It is said," Vasari writes, that Bernardino came to Arezzo with his "brothers" or "frati" and, having converted many, he had Parri make a model for a church at Sargiano. He then says that the saint led the people of Arezzo in procession to this place and delivered a sermon. Later the saint had a chapel built there, namely Santa Maria delle Grazie. Bernardino also supposedly asked Parri to paint the Virgin in Glory, who covered the whole population of Arezzo with her mantle—an image that worked miracles. The commune later built a church, Vasari adds, that accommodated Parri's *Madonna*. Vasari adds that Parri painted an image of San Bernardino in the Duomo; under her feet he rendered a portrait of Arezzo. Vasari thus weaves the artist's biography into the holy biography of the saint, interweaving into both the civic and religious life of Arezzo. Parri's life, we might say, takes place within the lives of the saints. The biography of the artist is absorbed into the larger sphere of hagiography.

The stories of saints who bring harmony to Arezzo, where discord had previously reigned, set the stage for two fictional episodes in the life of Parri. In the first of these, Parri is supposedly attacked by armed relatives in a dispute over a dowry. Vasari claims that the figures Parri painted afterward reflect the fright he experienced during the attack. In the other episode, Parri is verbally abused by those who are envious of him. Both of these fictions echo the theme of civic

discord that is part of the larger history of Arezzo as Vasari writes it. Parri replies to this abuse by painting an infernal scene of burning tongues with Christ above cursing them. The attacks on Parri, both physical and verbal, are part of the "discordia" that the holy Tommasuolo and Bernardino sought to purge from Arezzo, and Parri's painting of burning tongues in hell is implicitly linked to Vasari's story of Tommasuolo, who sees the Aretines within the fires of hell before they change their ways. Not only is Parri's life tied to those of the saints, but the pathos of his biography is like that experienced by suffering saints.

We miss the full force of Vasari's fictions if we miss their familial connections. Parri's terror after he is attacked and the terror of his painted figures are linked to the terror of Spinello terrified by his own painted figure. Spinello is attacked by Lucifer, the epitome of fraud, and Parri is similarly abused by those whom he accuses in his painted malediction of such fraud—for in this painting Parri writes to those who accuse him, "a lingua dolosa" ("to the fraudulent tongues"); "dolosa" is derived from "dolus" for fraudulent.

Woven through these fictions of Spinello and Parri are details of their family life that I have mentioned previously—for example, Spinello's reception by his family when he returns to Arezzo or Parri's return to Arezzo, when he is called back after Spinello's death. To these we must add the account of the works by Forzore, whom Vasari presents as Parri's brother. Vasari even imagines that Parri had a sister who embroidered scenes of San Donato after Parri's designs. Vasari finally brings Spinello and his son Parri together when he imagines that Parri was buried with his father in San Agostino, even though there is no evidence that they were in fact buried in the same place. Vasari's image of the united remains of father and son is a fitting conclusion to two lives united in a fictionalized family romance reflecting the glory of the commune that aspires to peace and unity. By linking Spinello and Parri so vividly to the religious and political life of the Arezzo, Vasari tells us just how intimately the life of the family was tied to the story of the commune—in this case, Vasari's own "patria."

The Fame and Glory of the Della Robbia Family

If the lives of families are similar, they are also different in various ways. Each of Vasari's family histories has its own particular characteristics, themes, or images. Take the case of the life of Luca della Robbia, which is both the biography of an extraordinary artist and the history of a remarkable family of artists, legendary for their terracottas made with a special glaze.

At the outset of his biography of Luca, Vasari provides us with a graphic, unforgettable image of the artist, who plied his chisel all day and all night, suffering the extremes of discomfort. This portrait of the ideal artist, who exemplifies "industria," puts us in mind of another such vivid portrait of the industrious artist, that of the aged Michelangelo working on his *Pietà* into the night by candlelight. What distinguishes the image of Luca from that of others who belong to the type of "industria" is the precise, almost plastic image of him freezing at night as he worked, taking the shavings of wood to make a fire to warm his feet. The personification of dedication, of profession, Luca stands for all artists prepared to endure cold, heat, and thirst, as Vasari says, and all other discomforts in their efforts. Such asceticism is nearly saintly. The image of Luca, both particular and typical, is also familial. The eventual "gloria" of the Della Robbia depends on their forefather's overcoming adversity. Luca's suffering is inseparable from the story of his founding of this glorious house of art.

Vasari fictionalizes Luca's biography by imagining that he undertook one of his most important projects—the "Cantoria" for the Cathedral—at the behest of Vieri de' Medici, a "great and popular citizen," who loved Luca very much. This is one of the first instances in the *Lives* in which Vasari connects artistic glory with the name of the glorious house of the Medici. No matter that Vieri de' Medici had nothing to do with Luca's work. The fact that so much art was subsequently made to glorify the Medici—indeed Vasari's own—enables us to read Vasari's fiction acceptingly. His tale of make-believe patronage once again rings true.

The central event in Luca's life that contributes to his family's glory and fame is his invention of a special glaze for majolica ware. Made

with various minerals and mixtures of clay baked in a furnace, Della Robbia's terracottas were remarkably durable, indeed "nearly eternal." For this invention, based on considerable "experimentation," all the ages to come, Vasari proclaims, will owe Luca an obligation. Vasari dwells on Luca's inimitable ceramic work for the Medici—his tiles for Piero de' Medici in the palace built by Cosimo, "his father," and the work commissioned by Piero in San Miniato. Vasari thus rounds out the story of an artist whose glory is tied to that of an august family. We sense too that the warmth of Vasari's feeling for Luca depends not only on his own ties to the Medici but on the fact that he descends from a family of potters or "vasai" who, similarly, worked in terracotta. Luca's perseverance in art might well stand in Vasari's imagination for that of his own forefathers.

The second part of Luca's biography modulates into a partially fictionalized family history. Vasari imagines or pretends that Agostino di Duccio and Ottaviano d'Antonio di Duccio were brothers of Luca's, thereby absorbing their works into Luca's family history. He writes further of Luca's nephew, also named Luca, who was a man of letters, and he writes of Andrea's two sons, who were "frati" at San Marco and who supposedly received the habit from Savonarola himself. Andrea had other sons: Giovanni, who devoted himself to art (and who had three sons, Marco, Lucantonio, and Simone), Luca, and Girolamo. This younger Luca made glazed works in the Vatican for Pope Leo X under Raphael, and Girolamo is said to have undertaken works for the king of France, acquiring both great wealth and fame.

Vasari tells us of the last days of Luca and Girolamo before concluding that the "house" of the Della Robbia was finally "closed," the family "extinct." Thanks, however, to Luca and his family—the Della Robbia clan, we might say—the world was enriched, "arricchito." Despite the extinction of the house of the Della Robbia, Luca, the great patriarch of his house, brought his family everlasting "glory and praise." When Vasari concludes the biography by saying that Luca was not "lazy" in shifting from work in marble to work in bronze and, finally, in clay, he reminds us of his opening image of the industrious Luca working in extreme discomfort. It was, Vasari affirms, on account of Luca's perseverance in the face of adversity that his family achieved eternal glory forever. The picture of the freezing Luca warming his feet as he worked into the night is the central, exemplary icon

in Vasari's account of the Della Robbia family's ascent to eternal "glory."

Ghiberti's Father as Patriarch

Vasari's portrayal of distinguished artistic families reflects the thinking of artists themselves about their family glory. Ghiberti, for example, portrayed himself and his son Vittorio on the celebrated Gates of Paradise, suggesting, as it has been said, his role as paterfamilias. By portraying himself and his son in relation to Isaac and his son Jacob and Jacob's son Joseph, he emerges as a patriarch among patriarchs. Jacob's sons are the tribes of Israel; family and state are one. With his likeness on the door of the building where all Florentines were baptized, Ghiberti similarly links his family identity with his place in the commune.

In the biography of Ghiberti, Vasari embellishes Ghiberti's image of himself. However, Vasari, who is always in search of artists' fathers and forefathers, dwells on the role of Ghiberti's father, Bartolo, or Bartoluccio, as he calls him. He says that Ghiberti first learned his art from Bartoluccio, himself an excellent master, but that Lorenzo finally did better than his father. It is unlikely that Vasari in fact knew anything about Bartoluccio's work. In 1400, a period of "civic discord," Ghiberti left Florence, Vasari tells us, following Ghiberti's own account in his *Commentarii*. Bartoluccio supposedly wrote to Lorenzo, telling him about the project for the door of the Baptistry, urging his son to return to Florence. Lorenzo was sufficiently moved by "the words of Bartoluccio" that he returned and made a competition panel, guided, as Vasari imagines it, by his father. With Bartoluccio, who helped him, Lorenzo cast the bronze and won the competition. Once again Vasari is writing the twin stories of the father who guides his son in art, giving his blessing, and of the son who follows his father's will in his art, manifesting filial piety. When Vasari writes that Brunelleschi and Donatello, after seeing Ghiberti's panel, withdrew from the competition for the "public" good, he concludes a chapter in the life of Ghiberti that began with "civic discord" and ends with "concordia"—artists united in their service to the commune. In this

chapter Bartoluccio, the patriarch of Ghiberti's family, plays the principal role, training his son, encouraging, guiding, and then helping him. It does not matter that Bartolo was Ghiberti's foster father, that his true father was Cione, or that Vasari in fact does not know the details of Lorenzo's exact relations to Bartoluccio. What is important here is the fact that for Vasari Bartoluccio is Ghiberti's father.

Vasari emphasizes Bartoluccio's role in Ghiberti's life, magnifying it by imagining that Ghiberti's self-portrait on the Gates of Paradise is the portrait of Bartoluccio and that the portrait there of Ghiberti's son Vittorio is a portrait of Ghiberti. The point is the same, except that Vasari chooses to stress Bartoluccio's preeminence in Lorenzo's life. If Ghiberti had celebrated himself as a patriarch, Vasari, filling out his family history, focuses on the artist's father.

Vasari elaborates the Ghiberti genealogy by writing about the artist's son Vittorio (misidentifying him as Buonaccorso, Ghiberti's grandson). Then, after mentioning Ghiberti's death in old age, he again mentions the presumed portraits of Lorenzo and of his father Bartoluccio on the Gates of Paradise. It is with considerable fantasy that Vasari keeps Bartoluccio before our eyes. He even claims that Ghiberti's great grandson, also named Vittorio (the son of Buonaccorso) gave him very good drawings by Bartoluccio and others, which are part of his book of drawings. Thus Bartoluccio, a shadowy figure in the history of art, about whom we know almost nothing, maintains his central place in Vasari's fictionalized biography of Ghiberti from beginning to end. We see him teaching and guiding his son, we see him on the Doors of Paradise, and, finally, we see his exemplary art preserved in Vasari's book of drawings.

One final word about Ghiberti's family. Receiving the drawings from Vittorio in 1528, when he was "very young," Vasari says that he held them "in veneration"—not only because they were beautiful but because they were a "memoria" of these men. Bartoluccio stands among the forefathers of art, and Vasari holds these forefathers in reverence just as he reveres his own forefathers. Proud to have a "close friendship" with Vittorio, he is thus proud to be in a sense a "familiare" of Vittorio, son of Buonaccorso, son of Vittorio, son of Lorenzo, son of Bartoluccio, the great patriarch of the Ghiberti family, whose effigy he beholds on the Gates of Paradise. Vasari is proud to be on terms of "familiarità" with Ghiberti, just as he is proud to be closely affiliated

with the Medici, for in both cases—one artistic, the other political—he identifies himself with the "gloria" of a great family.

Uccello's Domestic Difficulty

Vasari does not always dwell on the artist's family, as he does in the lives of Spinello, Della Robbia, and Ghiberti. For example, he says almost nothing about the family of Ghiberti's protégé, Paolo Uccello. I say "almost" because the brief, concluding passage in Vasari's life of Uccello is about his family and, although brief, it has become legendary.

Writing that upon Uccello's death the artist left a daughter who knew how to draw and a wife, Vasari adds that when Uccello was working at night, his wife would call him to bed and he would reply: "Oh, what a sweet thing is this perspective"—"Oh che dolce cosa è questa prospettiva." Like Michelangelo, Uccello works into the night, dedicated to his art. One might almost say, in the language of Michelangelo, that Uccello was married to his art, that his works of art were his progeny.

Of course this image of Uccello ignoring his wife's calls is a fiction, but it is a deeply revealing one because it comments truthfully on Uccello's deep study of perspective. So powerful is this fiction, however, that it is taken at face value. In his distinguished *History of Italian Renaissance Art*, Frederick Hartt quotes Vasari, who said that Uccello "refused to follow his wife into the bedchamber." Hartt does not observe that here, as elsewhere, Vasari is writing fiction. Suspending disbelief, he yields to Vasari's tale. Actually, he does more than this. He rewrites it, elaborating it poetically and bringing out its implications by quoting Vasari freely. Whereas Vasari has Uccello proclaim, "Oh, what a sweet thing is this perspective," the modern scholar has Vasari's Uccello say, "Oh what a sweet mistress is this perspective." This free translation plays on the fact that, like a mistress, perspective draws the artist away from his marriage bed. The identity of perspective as a mistress is grounded in the gender of "la prospettiva," which is feminine. "La prospettiva," as is well known, appears as a woman in Pollaiuolo's tomb for Pope Sixtus IV.

The sweetness of Paolo's beloved perspective is highly resonant. In

Tuscan poetry "dolcezza" is a word the poets use over and over again to describe their beloved—as when Petrarch speaks of the "sweet words" of Laura or when Poliziano speaks of the "sweet smile" of a nymph. In Dante's words love is itself "sweet" or "dolce." The "dolcezza" of perspective is similarly the "sweetness" of Uccello's beloved. Artists, Vasari says repeatedly, study "con amore," with love, and Vasari's image is that of an artist in love. Only it is a love in conflict with that for his wife. Like the sweet "unheard melodies" that endure forever on Keats's Grecian urn, the image of Uccello extolling his beloved sweet perspective "cannot fade." It endures in imagination thanks to the art of Vasari, as does the image of Uccello's wife, forever calling to him, all alone in bed—a reminder that if love is sweet it is also bitter: "amari aliquid."

Community in Masaccio

If Vasari knows almost nothing about Uccello's family, only mentioning his wife and daughter, he knows even less about Masaccio's. He knows merely that the artist came from San Giovanni di Valdarno. The center of Masaccio's career and the focal point of Vasari's biography of the painter are his extensive decorations in the church of Santa Maria del Carmine. Among these decorations was the chiaroscuro fresco of the consecration of the church, 19 April 1422, destroyed at the end of the sixteenth century. Vasari sees in the procession of this fresco the portraits of numerous citizens—among them Brunelleschi, Donatello, and Masolino, but also Niccolò da Uzzano, Giovanni di Bicci de' Medici, and Bartolomeo Valori. He adds that all these portraits were preserved in related effigies in the house of Simone Corsi.

But were all the citizens said to be portrayed in Masaccio's fresco the very men whom Vasari identifies? As a general rule when reading Vasari, we are obliged to accept many of his observations as "fantasia" until we can demonstrate from other evidence that the contrary is so. Vasari uses Masaccio's fresco as the opportunity to memorialize the illustrious men of Florence, both artists and patricians. As an idealized image of the commune consisting of fictitious portraits, Masaccio's fresco takes its place in Vasari's pages along with Andrea da Firenze's earlier fresco of Florence as the universal church. Vasari no

doubt projects imaginary portraits of famous citizens into Masaccio's work, as he had into the earlier fresco. As famous citizens, Niccolò da Uzzano, Giovanni di Bicci de' Medici, and the others represent the illustrious families or houses of Florence, and although Donatello and Masolino, said to appear here, do not represent such families, they are glorified by association with these families. Although not "relatives" of great citizens, artists are shown as in a sense related to them.

The glory of artists' names is like that of the names of the patricians who were their patrons. Vasari also glorifies Masaccio's frescoes in the Brancacci Chapel by observing that they were studied by all the great artists in Florence. The list includes Fra Angelico, Lippo Lippi, his son Filippino (who finished the frescoes), Baldovinetti, Castagno, Verrocchio, Ghirlandaio, Botticelli, Leonardo, Perugino, Fra Bartolommeo, Albertinelli, Raphael, Granacci, Lorenzo di Credi, Ridolfo Ghirlandaio, Andrea del Sarto, Rosso, Franciabigio, Bandinelli, Berruguete, Pontormo, Perino del Vaga, Nunziata, and, most important of all, Michelangelo.

All the artists united in Masaccio are, we might say, part of the "order" of his disciples, united as followers of a saint. This notion is appropriate since Vasari portrays Masaccio's asceticism and otherworldly ways, his indifference to money and material things, as saintly. The followers of Masaccio are also part of the family of art in which Masaccio is a great patriarch. Referring to Masaccio as one of the "capi" of art, Vasari evokes the notion of the head of family or state. As a great patriarch in the family of art, Masaccio is a great citizen—despite the obscurity of his family's origins.

As if writing about a great citizen, about a "pater patriae," Vasari, following the *Libro di Antonio Billi,* has Brunelleschi say of Masaccio's death: "We have suffered a great loss." Vasari concludes the biography by observing that Masaccio, who died in Rome, was buried in the church of the Carmine—the very church where his works attest his glory, along with the glory of the illustrious citizens he is said to have depicted there. Saying that he died in the "flower" of youth, Vasari echoes Fabio Segni's epitaph on Masaccio's death "sub flore," which he reports at the very end of the life. Vasari is using "fiorire" and "flore" to link Masaccio to the glory of Fiorenza, the city of Flora. His description is almost an implicit emblem of the artist who, despite his humble ways and his presumably humble origins, is the personification of artistic nobility—an artist who takes his place in

the history of Florence along with the very illustrious citizens, the sons of great families, whom he depicted.

Familiarity Between Artist and Patron

When Vasari sees the portraits of artists in the same scenes in which illustrious citizens are portrayed, he in a sense assimilates these artists to the patriciate, placing them on terms of familiarity with their patrons. Such familiarity becomes a central theme in the lives of Michelozzo and Donatello, whose stories, like Della Robbia's, but to a greater degree, are wed to those of their Medici patrons.

Michelozzo is the architect who built the prestigious Medici Palace for Cosimo de' Medici, as Vasari stresses. He was a "familiare" of Cosimo, and Vasari elaborates this relationship by saying that because "he loved him infinitely" Michelozzo accompanied Cosimo into exile in Venice. There is no documentation for such a trip by the artist, which can be seen as fiction. Vasari further ornaments this tale by speaking, on the authority of Michelangelo, of Michelozzo's work in Venice. Vasari continues his story of intertwined lives by adding that when Cosimo returned to his "patria" in 1434, "he returned nearly triumphant and Michelozzo was with him." We are almost encouraged to imagine Cosimo as an emperor, as a modern Augustus, who was "pater patriae," passing, like a "king" into the city, under triumphal arches, riding side by side with his "familare" Michelozzo. The rest of the biography continues with an elaborate catalogue of works made by Michelozzo under the sponsorship of Cosimo and his sons— including ecclesiastical work at San Marco, Santa Croce, and San Miniato, villas outside Florence, and the emblems and arms of the Medici. Cosimo is likened to a modern Augustus, creating a modern Rome, extending his vast building project into the "impero" of Tuscany. This image is magnified by virtue of Cosimo's association with Vasari's imperial patron, Cosimo il Vecchio's namesake, Duke Cosimo de' Medici. Michelozzo made major additions to the Palazzo Vecchio, which later became the residence of Duke Cosimo. His story is thus gradually absorbed into the stories of both Cosimos.

It is only fitting that toward the end of the biography of Michelozzo Vasari should speak of a decoration by Michelozzo that included the portraits of eight emperors, to which the artist added the portrait of Cosimo, as if he too were an emperor. It is as if Vasari read his patron Duke Cosimo's identity as a modern Augustus back into the image of Michelozzo's patron, Cosimo il Vecchio. Cosimo's glory is Michelozzo's because, as Vasari says, Cosimo loved Michelozzo, "as much as one can love a dear friend." As a builder of the Medici palace and villas, he is conceived by Vasari to be very nearly of their quasi-imperial house, as if of their family.

No less was Michelozzo's more distinguished associate Donatello connected with the Medici. Vasari begins the fictional biography of Donatello by saying that he was raised by the Martelli. Vasari is able to imagine Donatello's boyhood in the Martelli household on the basis of the statue of David that he saw in their palace and attributed to the sculptor. Vasari thus links Donatello to a "noble family," who were partisans of the Medici. They were one of the "seven houses" (along with the Rondinelli, Ginori, Della Stufa, Neroni, Ciai, and Marignolli) who, Vasari says, had chapels in the Medici parish church of San Lorenzo. Just as these families were united to the Medici, so, through the Martelli, was Donatello already linked to them in his fictionalized youth.

Vasari goes on to speak of Donatello's various works made for Cosimo de' Medici, especially those in his palace, including the classical roundels in the courtyard. He says that "such was the love of Cosimo toward the virtue of Donatello" that he continuously hired the artist; similarly, Donatello had so much love for Cosimo that at every sign he guessed what Cosimo wanted. The artist is thus the perfect son to his "padrone," just as his patron is the perfect "padrone" to his son. Once again we encounter the stories of paternal blessing and filial piety, only in this case the patron is the substitute father.

Vasari fills out the imaginary story of Cosimo and Donatello by linking both men in old age. He pretends that when both were very old Cosimo recommended to his son Piero that a farm at Caffagiolo be left to Donatello, who could live there in peace. Cosimo leaves part of his inheritance or estate to his adopted son, we might say, providing the artist with a farm at the same place where the Medici had a villa of their own. Like his patrons, Donatello could now retire to a villa in the country. (It does not matter that, according to Vasari, Donatello

did not like country life, and that he sold the villa and moved back to the city.)

Donatello's close attachment to the Medici, his participation in their family life, is brought into relief in the very conclusion to the biography, where Vasari says that Donatello was buried in San Lorenzo near the tomb of Cosimo, as Cosimo himself had ordered. Cosimo, Vasari proclaims, wanted Donatello to be near him in death, just as he had been near him in life. Vasari's words are generally accepted as fact—even though we might reasonably suppose that these facts are, in the Latin sense of "facta," "made" in the imagination, that is, fictionalized. We believe Vasari, even though we know nothing of the exact personal relations between the artist and his patron. In his fiction, Vasari encourages us to see Donatello laid to rest in immediate proximity to Cosimo at Cosimo's request, as if he were one of Cosimo's own sons, as if his remains were in the family mausoleum.

Vasari does not stop here. He invents an elaborate state funeral for Donatello, like those for such important citizens as Cosimo himself. His funeral is invented out of the funeral of Michelangelo sponsored by the Medici, the decorations of which, created under Vasari's superintendency, stressed the way in which Michelangelo was taken into the Medici household, like an adopted son. Vasari says that Donatello's death caused great grief to his fellow citizens, as if Donatello were a noble citizen. He then imagines elaborate "obsequies" in the church, pretending that Donatello's body was accompanied to his grave not only by all the artists of the city but also by "nearly all the people." Reading Vasari's description of Donatello's funeral, one might think him writing about the death of Cosimo himself—understandably, because Vasari had made Donatello in a certain sense a "familiare" of Cosimo's house, a member of Cosimo's extended family.

Donatello's Relatives

In typical fashion, Vasari expands Donatello's family by claiming that a certain sculptor named Simone was his brother, even though there is no evidence that Donatello had any brothers. He pretends that when

Simone made the tomb of Pope Martin V, he called Donatello to Rome to assist him, and he further imagines that Donatello worked with his make-believe brother on the coronation of Emperor Sigismondo by Pope Eugenius—glorifying Donatello even more by virtue of his association with such august personages.

Vasari introduces other relatives or "parenti" of Donatello at the end of the artist's biography. He tells the story of how Donatello leaves a farm at Prato to a peasant who worked the land rather than to his "parenti." Although I have previously focused on this gift in relation to Donatello's loving and giving personality (rooted in his name from "donare"), here I wish to dwell on his antithetical relatives and what they stand for in family life. As Vasari says, these relatives "do not love unless it is useful to them"—by which he means that their love is fraudulent or insincere. In Vasari's portrayal of them, Donatello's "parenti" take their place along with Dante's Gianni Schicchi, seeking an inheritance they do not deserve. Whereas Donatello rewards the peasant who, in the spirit of the Gospels, brings forth good fruits and inherits the earth, his relatives personify the greedy relatives found in all Florentine families, whether those in Dante's poem, Boccaccio's stories, or in real life. In their greed, they are like Parri Spinelli's imaginary relatives who attack the artist over a disputed dowry, and they are like Taddeo Gaddi's prodigal son Agnolo, who is corrupted by money. Greed is a deadly sin that infects all families, not least those of artists' families. Donatello's imaginary "parenti" are a reminder of this fact; even if they are make-believe, they are true to life. They stand for all those relatives who dispute wills, who grasp after the wealth of others in their families.

Giuliano da Maiano's Father

Of all sculptors in the time of Donatello, Giuliano da Maiano was one of the most accomplished. In the biography of Giuliano, Vasari articulates one of the central themes of his book, his credo about wise fathers. He begins by saying that "those fathers of families" who do not allow their children to follow their natural inclination commit "no small error." In other words, wise fathers, whatever their own wishes,

allow their sons to pursue their inclinations in art. The first father of an artist we encountered, Cimabue's father, was such a wise father because (although he wanted his son to study grammar) he allowed him, finally, to study painting. Giuliano's father, himself a stonecutter, thought this craft too laborious and unprofitable, and so he sent his son to school, hoping to make him into a notary. This did not come to pass, however, because Giuliano was often truant and did not make progress in his studies. Having his mind set on sculpture, Giuliano in fact became a sculptor. His father had committed an error of judgment in not allowing Giuliano to pursue his art. There is no mention here of a "conversion" on the part of his father, as there was in the story of Cimabue, whose father finally acceded to his son's wishes. Giuliano's desire to work in stone brings to mind Michelangelo's humorous claim that he took in the tools of his art with the milk of his wet nurse, who was wed to a stonecutter. Vasari is saying that Giuliano similarly has his inclination to stonework through his ancestry, which bound him to the quarries of Maiano, notwithstanding his father's ambitions.

Although imaginary, Giuliano's father is the type of all real fathers who resist their sons' inclination to art. We have only to recall Cellini's father, protesting his son's training in art and, more to the point, Michelangelo's father, reacting violently to his son's drawing, since his father thought sculpture to be ignoble. Vasari tells us at one point in the life of Signorelli (discussed below) that his own father did not discourage him from drawing as a child, although he had Giorgio schooled in letters, but later, in his own autobiography, he more explicitly insists that his father "lovingly" put him on the path to art. What are the facts of Vasari's own relations to his father? Was his father like the idealized father of Cimabue, who respected his son's wishes and eventually gave his blessing to him without strife or conflict, or was his father in fact like Giuliano's (Michelangelo's and Cellini's) father, actively resistant to his son's desires? Whatever the answer to this question might be, Vasari, in making up the fiction of Giuliano's father's error, speaks of the reality of tensions between artists and their fathers—a tension born of the paternal conviction that art was not sufficiently suitable, dignified, or profitable. Vasari's story of Giuliano's father, an old and enduring one as we have seen, lies at the heart of Vasari's book, and it may well reflect, in some indeterminable way, on Vasari's own autobiography.

Piero della Francesca's Metaphorical Father

Vasari's fathers are for the most part literal, if imaginary; in at least one case, however, he introduces a metaphorical father, that of Piero della Francesca. Vasari begins his biography of Piero by observing that Piero took his mother's name (Francesca) because his father died when she was still pregnant with him. She brought up Piero, helping him to attain the rank that fortune held out to him. Although he never knew his father and did not bear his name, Piero did have a "father" of sorts—a "father" introduced as part of the larger theme of his life. Vasari says that sometimes an artist is robbed of his glory by another, who is like an ass dressed in lion skins. He here introduces the story of how Fra Luca Pacioli sought to "annihilate Piero's name" by publishing Piero's work on mathematics under his own name. Time, however, uncovered this deceit, revealing the glory of Piero. Inverting the classical adage "Truth is the daughter of time," Vasari says that time is the "father of truth," and it is probably no accident that he introduces it here, directly before saying that Piero had no father and that he took his mother's name. Although Piero did not know his father, as Vasari says, his father returns, we might say, in the form of Father Time, who preserves the glory of his son's achievement and of his maternal name.

It is perhaps no accident that Piero's life concludes with the touching story of a painter-father. This is the fiction about Piero's disciple Lorentino. When the painter's children begged him to kill a pig for carnival, he explained that he had no money to buy the pig. He was then asked to paint a figure of Saint Martin by a peasant who, not having money, paid with a pig. Thus the children's wishes were fulfilled by their father. The story tells us many things—above all, about the intervention of a saint in answer to a family's prayers.

Vasari's fable also takes on significance in terms of the relations between fathers and children. Even if we do not read the story through the sentimentalized fiction of Dickens (but how can we not?), we find in it a memorable domestic pathos. "If we do not have the money," the children sorrowfully ask, "how will we buy the pig, Daddy?" With faith (and this is fundamental to Vasari's story), the

painter replies: "Some saint will help us." When, in a sense, the saint does intervene, Vasari does not describe the response of the children but leaves us to imagine their joy. Through his devotion and good work the father fulfills the wishes of his children. He is the ideal father, the perfect father, who appears most pointedly, if not poignantly, in the life of the fatherless Piero.

The Most Noble House of the Alberti

Vasari's *Lives* range from the stories of humble artists, like Lorentino, to the tales of those artists who were wealthy or noble. The trajectory of the *Lives* socially is always toward nobility, and the life of Leon Battista Alberti provides Vasari with the opportunity to celebrate an artist who belonged to a very noble house—"la nobilissima famiglia degli Alberti." By saying that Alberti was born in Florence (rather than in Genoa, where he was in fact born), Vasari avoids an unpleasant fact, since, when he was born, the Alberti were in exile. Vasari chooses to dwell on Alberti's place "nella patria" rather than note the unpleasantness that resulted in his family's exile from their "patria."

Vasari dwells on Alberti's accomplishments as both artist and "man of letters," saying that he undertook the facade of Santa Maria Novella for his "very good friend" Giovanni Rucellai. Alberti is thus a patrician among patricians. He is, in Vasari's portrayal of the son of a noble house, "a person of most civilized and praiseworthy behavior, a friend of virtuosi, most liberal and truly courteous with all." For this reason he lived in honor as a "gentiluomo."

Alberti was, we might say, a lord among lords. Himself a "uomo illustre," he worked for such illustrious patrons as the Lord of Rimini and the Marquis of Mantua, making monuments to his own glory as well as theirs. Like other artists, Alberti extended what we might speak of metaphorically, in the language of politics, as the "domain of art." Vasari says that while in Mantua Salvestro Fancelli executed many projects according to the "wish" of Alberti. Speaking of the imaginary Salvestro, Vasari is thinking of Luca Fancelli, and it is clear that he has Luca in mind because, having referred to Fancelli, he

then refers to another Luca, a certain "Luca Fiorentino." This artist, living then and always in Mantua, left his name to the family of the Luchi, who are, Vasari says, still there. What Vasari has done is to create a fictional Doppelgänger of Luca Fancelli, a Luca Fiorentino, whom he then transforms into a sort of Luca Mantovano, founder of the house of the Luchi. He thus traces here the origins of a family in Mantua, much as he had discerned the origins of the Capanni family of Assisi, traced from Puccio Capanna.

Vasari's Luca is "a faithful and loving executor" of Alberti, as if he were a servant to his lord. Alberti becomes implicitly a lord, like the ruler of Mantua himself. By tracing the family of the Luchi from Alberti's faithful servant Luca, Vasari expands the dominion of art. Doing so, he plays on Alberti's noble origins and his relations to his noble patrons, seeing his quasi-fictive disciple as, in a sense, a servant in the court of art. Pretending that Luca was the ancestor of the Luchi, he creates another fictive genealogy, in which the artist is a patriarch, the founder of a house in the extended court of art.

Vasari's Illustrious Family

Vasari has a vested interest in celebrating artists either born of noble families or who attain nobility through their art, for these noble artists are mirror images of himself. Having written of Alberti, born of a most noble family, Vasari presents his own family in proximity to it, glorifying his family in the fictional account of his ancestor Lazzaro Vasari. Lazzaro is the father of Giorgio, the father of Antonio, the father of our hero Giorgio. Reading of Lazzaro's life in Vasari's aggrandized family romance, we might do well to recall Piero della Francesca's impoverished disciple who was too poor to buy a pig. We are reminded that the origins of artists' families, as ultimately of all families, are humble. Lazzaro was, as the documents tell us, a simple saddle-maker—a certain Lazzaro di Niccolò de' Taldi da Cortona. Let us see, however, what Vasari makes him into, extolling his own ancestry and family glory in the process of writing fictionalized biography.

Vasari begins grandly by saying that it is a pleasure for those who belong to a family in which the ancestors have applied themselves in some "noble exercise," be it arms, letters, or painting. He is speak-

ing here of his own family of "uomini illustri," since his ancestor
Lazzaro was, as Giorgio vaunts outrageously and shamelessly, "one
of the most famous painters of his day." Vasari is proud to be of his
bloodline—"nato dal sangue suo." Although Lazzaro was not born
"noble," he was the founder of a house that attained nobility through
the virtue of art.

Vasari goes on to pretend that Lazzaro was a "very great friend" and
collaborator of Piero della Francesca. Whereas Piero's assistant Loren-
tino (the poor painter) was rather humble, Lazzaro was a grand figure.
One could hardly distinguish his figures, Vasari claims, from Piero's.
Vasari further pretends that in his very first work, in the second
chapel on the left in San Domenico in Arezzo, Lazzaro painted under
a San Vincenzio the portraits of himself and his son Giorgio kneeling.
The fresco, in the manner of Lorentino, is still preserved, although it
is damaged and the donors are not present. Since Lazzaro was not a
painter, we can only conclude that Vasari's attribution of the fresco to
him and his embellished description of it is fiction. Vasari poetically
extends his description of the fresco when he pretends that Lazzaro
and Giorgio were shown dressed in "honorable vestments" of their
times. We can almost imagine them in dress like that of Tommaso
Marzi, Piero Traditi, Donato Rossello, and Giuliano Nardi, the
"cittadini aretini" supposedly portrayed by Lorentino in one of his
Aretine frescoes.

Vasari does not stop here in his description of the imaginary por-
traits. He says that Lazzaro portrayed himself and his son recommend-
ing themselves to the saints because the boy had cut his face with a
knife. Vasari claims that, although there is no inscription on the work,
certain memories of old men "in our house" as well as the presence in
the fresco of the family "arms" enable him to believe with certainty in
the connection of this work with Lazzaro. When Vasari says "without
doubt," we hear him covering his tracks, trying to conceal his fiction.
We note too that although he had not previously spoken of his family
as "nobles" he introduces the suggestion of their nobility by referring
to their arms. We cannot help recalling Sacchetti's story, retold in the
life of Giotto, in which Giotto mocked a patron who ridiculously
wanted his arms painted as if he were a noble. This impulse to glorify
one's own family was present everywhere in Renaissance society, and
we find it here in Vasari's own fictionalized family history. After de-
scribing the fresco in San Domenico, Vasari perhaps comes closest to

Lazzaro's origins as saddle-maker when he next remarks that Lazzaro painted bards or "bardi" of horses. Perhaps as saddle-maker Lazzaro did paint saddles?

Vasari fleshes out the story of his family by telling us that Lazzaro's brothers in Cortona also worked on vases, and he says that Lazzaro took into his house his sister's son Luca Signorelli of Cortona, whom he placed with Piero della Francesca. This fiction exalts Lazzaro as a wise and knowing patriarch of art, who oversees the education of his family in art, and it is later woven into Vasari's own autobiography, in which Signorelli appears as himself a patriarch in art. In old age Signorelli visits the Vasari household and encourages Vasari's father to let Giorgio learn drawing as well as letters. The memory of the patriarchal Signorelli (real or imaginary) is central to Vasari's story of his own formation in art.

In the life of Lazzaro, Vasari also discusses the work of Lazzaro's son, Giorgio, who was Vasari's grandfather. He tells us that his namesake occupied himself with ancient Aretino vases of terracotta, adding that in the time of Gentile of Urbino, bishop of the city, Giorgio rediscovered the ancient method of giving black and red coloring to vases like those in Arezzo from the times of King Porsena. Vasari made large vases (hence his name from "vasaio"), and many of these vases "are still in his house." We note that if Giorgio was a vase-maker, like his relatives in Cortona, Lazzaro was not; Vasari thus projected his name "Vasari" back onto his ancestor. Continuing his story of Giorgio, Vasari says that he found the remains of ancient furnaces at Calciarella and the baked remains of ancient vases, which were given, through the Bishop of Arezzo, to the Magnificent Lorenzo de' Medici during a visit to Arezzo. These vases, Vasari concludes, were the source and origin of his grandfather's entering "into the service of that most exalted family, in which he remained ever afterward." Vasari rose, we might say, from his humble origins in the clay with which his ancestors made pots to become himself a "familiare" of the Medici (like his grandfather)—becoming a part of their house, which stood at the summit of society.

Vasari's account of the life of Giorgio is generally accepted, but is it, we might ask, true? Is it any less fictional than the life of Lazzaro? Did Giorgio really make these archaeological discoveries of ancient ovens and techniques, or did Vasari invent this tale to exalt his grandfather by virtue of his revival of antiquity? Similarly, we might ask whether

Giorgio really made the gift of vases to Lorenzo and entered into his service, or did Vasari invent this story to memorialize the place of the Vasari in the service of the Medici—to place his namesake in their service as a prophecy of his own future devotion to that great house?

Vasari does not fail to mention that his grandfather Giorgio had five sons, all of whom followed him in his craft. Two of them, Lazzaro and Bernardo, were "good craftsmen," but Bernardo died at an early age in Rome. Giorgio was buried, Vasari adds, along with Lazzaro in the Pieve of Arezzo. Vasari invents a Latin epitaph for Lazzaro, invoking Callicrates to associate the Vasari further with the ancients. Vasari concludes by speaking of his own restoration of the family tomb in the Pieve, where his mother and father were buried as well. Making a "new tomb," Vasari exhibits his own filial piety, his devotion to his family, his reverence for his ancestors—his celebration of the illustrious house of the Vasari. All the fictions concerning the devotion to family in Vasari's lives of thirteenth- and fourteenth-century artists can be seen as projections of Vasari's own family story—foretelling Vasari's own practices and piety.

Against the Will of Baldovinetti's Father

Vasari's *Lives*, as we have seen, is the story of two kinds of fathers— those who resist the inclinations of their sons toward art and those who encourage them in pursuing their inclination. Vasari returns to this theme in the life of Alesso Baldovinetti. He begins by saying that the "noble art of painting" has such force that many "noble men" who "could have been rich" chose to follow their natural inclinations and went "against the wishes of their fathers." Vasari continues by saying that "virtù" brings "treasures" other than gold and silver—greater than the "earthly treasures" foolishly esteemed by men at more than their real value. Baldovinetti, in exemplary fashion, abandoned a career in commerce, the profession in which his relatives had occupied themselves honorably, living as "noble citizens." Instead, he devoted himself to painting, "against the wish of his father," who wanted him to enter into business. There is in this account perhaps an

echo of Saint Francis repudiating the wealth of his father. In the end the conflict resolves itself, because Baldovinetti made so much progress that his father was content to allow him to follow his natural bent toward art. Vasari speaks of Baldovinetti's progress as "profit," subverting the economic sense of the word, just as he did when referring to the "treasures" of art. To underscore his point that Baldovinetti turned away from the acquisition of wealth for the treasures of art, he begins his account of Baldovinetti's works by saying that he made a fresco of the Holy Trinity for Gherardo and Bongianni Gianfigliazzi, "most honored and very rich gentlemen." Baldovinetti's wealth is measured in terms other than gold and silver, as is suggested by the divine subject of his painting.

Eventually, after an illustrious career in art, Baldovinetti becomes an aged patriarch. Vasari says that Baldovinetti died at the venerable age of eighty, observing that Ghirlandaio portrayed him as "old" Joachim driven from the temple. We thus remember Baldovinetti in old age, as Vasari pictures him, by identifying him as the aged Joachim. Vasari then concludes his little parable on the treasures of art by describing Baldovinetti's final days. He claims that in old age the artist retired to the Hospital of Saint Paul's, bringing with him a "cassone," seemingly full of money, in order to be accepted there. Believing that Baldovinetti would leave the money to the hospital, the director and officers treated him well until his death. When they opened the money box, however, they discovered not money but drawings and a little book on the art of mosaics. These, Vasari is saying, are the "treasures" or riches of art.

Vasari's parable ultimately harks back to the Bible, where Christ preaches to the rich young ruler of the treasure in heaven. Christ, in Vasari's preaching, is the true father or master, whose will Baldovinetti has done in the pursuit of his art. Although Baldovinetti's biography is therefore deeply spiritual and moralizing, it is not without its humor. The artist is the "ingannatore" or deceiver par excellence in his illusionism, and Baldovinetti is such an "ingannatore," bringing with him to the hospital a "cassone," which seems to hold money but does not. Perhaps the officers of the hospital are self-deceivers, expecting the box to contain money. Or, to put the point differently, they are further disparaged when they discover the drawings, not appreciating that such treasures are more valuable than money.

Vasari concludes by saying that "some said" ("si disse") that the

reason there was no money in the box was that Baldovinetti had given it to his friends. In this respect, he was like the saintly Masaccio, who did not collect his debts, like the saintly Donatello, who gave his money to others, and like the saintly Brunelleschi, who gave to the poor. Born to wealth and commerce, Baldovinetti, like Saint Francis, repudiated his patrimony for the treasures of art, which are the treasures of heaven.

A Family's Vendetta Against Lippi

If Baldovinetti was born to wealth and good fortune, according to Vasari's fiction, Fra Filippo Lippi's beginnings were less fortunate, for he was orphaned shortly after birth. When his mother and father died, he was placed in the hands of his aunt, Mona Lapaccia, the sister of his father. She raised him until he was eight years old, Vasari continues, then placed him in the monastery of the Carmine. Lippi was given the rudiments of grammar, but he did not do much other than fill his books with drawings of figures. Being at the Carmine, however, he fell under the spell of Masaccio's work there; indeed, "the spirit of Masaccio entered the body of Fra Filippo." Thus began the career of this distinguished painter.

The fiction of Lippi's lusty ways while in the household of Cosimo de' Medici is so well known, thanks to Vasari, that we need not dwell on it here. There is one statement about his lust, however, that repays our attention. Before describing Lippi's escapades—that is, his escapes from Cosimo's palace to indulge his sexual appetites—Vasari says ("it is said") that Lippi was so amorous, "venereo," that seeing women who pleased him, he would give them everything he had to possess them and, if this failed, he would paint their portraits and cool the flame of his passion by reasoning with himself. We might almost say that the story suggests the manner in which Lippi possessed women by making their images. The story is about "the power of images," about their venereal or erotic character.

The principal woman in Lippi's life was Lucrezia, the daughter of Francesco Buti, who was a ward or novice at Santa Margherita. Seeing her, Lippi was taken by her beauty and grace, and he eventually received permission to paint her portrait. This was not enough to

temper his passion, however, for falling in love with her he took her from the nuns—on the very day that she is said to have gone to see the Girdle of Our Lady. By pretending that this abduction took place when Lucrezia venerated the symbol of chastity, Vasari magnifies her loss of virginity.

The nuns, Vasari continues, were embarrassed and "her father was never happy again," doing everything in his means to have her back— or so Vasari pretends, for Francesco was already dead at this time. Vasari is once again playing with the facts, poetically ornamenting a family's history. He goes on to say that Lucrezia stayed with Lippi and bore him a child, Filippino, also a painter. Pope Eugenius offered Lippi a dispensation so that he could take Lucrezia as his wife, but Lippi refused because he wanted free rein to satisfy his appetites. Vasari further pretends that at his death both Eugenius and Cosimo de' Medici (in fact both already dead!) grieved his loss. Vasari then tells the well-known story of how Lorenzo de' Medici later sought to bring Lippi's body back to Florence, mentioning Poliziano's epitaph for the painter.

There is one detail in Vasari's account of Lippi's story that is often overlooked—an episode foreshadowed by Vasari's fiction that after Lucrezia's abduction her father was never happy again. This detail speaks of a family dishonored, of a disgrace that needed to be avenged, like that of the family of Lucrezia's ancient Roman name-sake. In his fictional account of Lippi's death, Vasari claims that, according to some accounts, in consequence of his "blessed loves," certain relatives or "parenti" of his "beloved" poisoned him. In this version, the family of the lady he had loved took their revenge in a murderous vendetta. Although Vasari's story is make-believe, it once again is true to life, true to all the histories of Italian families who violently avenged themselves on those who dishonored their houses.

A Case of Fratricide

Even more legendary than the fictionalized story of Lippi's abduction of Lucrezia is Vasari's tale of Domenico Veneziano's death at the hands of the brutal Andrea del Castagno. No artist in all of Vasari's pages is so brutal, vicious, violent, and evil as Castagno. He is the very antithe-

sis of his friend Domenico Veneziano, who, affectionate and gentle, loves Castagno. In competition with Veneziano, however, Castagno becomes envious of his friend—blind in the root sense of envy ("accecato dall'invidia"). He then plots an attack on the unsuspecting Domenico, before falling upon him and bashing his head in. Domenico, not knowing who his attacker was, survives for a brief time, and when Castagno, who had fled the scene of the crime, hears the commotion, he returns, as if innocent, to his dying companion. Holding his victim in his arms, Castagno cries out, "Oh my brother, oh my brother," before Veneziano breathes his final breath. Not even in confession, Vasari pretends, did Castagno reveal his duplicitous crime. When Vasari has Castagno use the word "brother," feigning fraternal feelings for Domenico, he invokes the murder of Abel by Cain. As Vasari says, describing Ghiberti's reliefs on the Gates of Paradise, Cain, filled with hatred or "odio," murdered Abel, and Castagno, the very personation of "rancore," is similarly motivated to kill his "brother." Using the word "brother" metaphorically, Vasari recreates the biblical story of fratricide.

Castagno is not only a murderer of his "brother" but a traitor. In Dante's *Inferno* fraudulence is a greater crime than homicide, and Castagno belongs in Vasari's Dantesque vision with the fraudulent, with the traitors, at the very bottom of hell. He belongs with Lucifer, to whom he likens Castagno, by saying that he is "diabolical," and he belongs with Judas, whom, Vasari pretends, Castagno painted in his own image. Castagno is to be seen in relation to Ugolino, who betrayed his "patria." The pathos of Ugolino's dying sons is evoked by that of the dying Veneziano. Castagno is a traitor to the family of art, to his brother in art, whom he should have loved with "fratellanza."

The Deaths of Talented Sons

Some lives in Vasari's book are never read, except by the specialists. The biographies of Pesello and Pesellino are a case in point. This account of two relatively shadowy fifteenth-century painters is largely a list of miscellaneous works, but the final words are of general interest because they once again touch on family relations. Vasari says here

that, having taken a wife, Pesello had a son, appropriately named Pesellino. In fact, Pesellino was not Pesello's son but his nephew, son of his sister and of a painter named Stefano. As usual, it is not the facts that matter but what Vasari makes of them. Vasari says that when Pesellino died at the age of thirty-one, his father, Pesello, was left in grief, "dolente," and followed him to the grave a short time later at the age of seventy-seven. In fact, Pesello died nearly ten years before his imaginary son. Vasari wants us to ponder the sorrow of a father who outlives his son, the pathos of a son's premature death. This grief is so great, Vasari seems to be suggesting, that when the father follows his son to the grave only a short time later, he dies of sorrow. We read Vasari too briskly if we miss this detail and what it tells us of the vicissitudes of family life and emotion. It belongs to the larger elegiac theme of Vasari's book.

A fiction similar to that of Pesello's death is told in the life of Desiderio da Settignano. Vasari says that the artist's life was cut short at the age of twenty-eight years and that many, stunned by this loss, were filled with sorrow that the artist's genius would never ripen in old age. On this occasion, Vasari remarks, many poems and epitaphs were written in praise of the artist, and he quotes one of these (actually of his own invention). According to this poem, Nature, shocked by the beauty and spirit of Desiderio's art, which gave life to cold stones ("freddi marmi") and which therefore obscured her glory, cut short Desiderio's life—but in vain, for if he gave eternal life to his marbles, they gave eternal life to him. Despite the "glory" of his works, Desiderio's death was mourned, Vasari says, by the many friends and relatives or "parenti" who accompanied his body to the church.

The early deaths of Desiderio and Pesellino bring to mind the death of Vasari's own relative, Bernardo, the son of his grandfather Giorgio, who died in Rome during his youth. As Vasari says of Bernardo's death (and he could be speaking here of all young artists who die in their youth): "If death had not snatched him so prematurely from his house, he would have brought honor to his native place." The death of a talented person is met universally with grief, but nowhere more deeply, Vasari says over and over again, than in the dead artist's family or "casa" by the deceased's father and relatives, by his "padre" and "parenti."

The Pollaiuolo Brothers: From Poverty to Wealth

Vasari, as we have seen, writes of artists who are brothers or who are like brothers; of artists who are fathers or sons of other artists, or who are like fathers and sons to each other. If Antonio and Bernardo Rossellino are in fact brothers, Ercole Ferrarese is like a brother, "come fratello," to his teacher. No less is Ercole like a son, "come figliuolo," to his mentor. The relations of artists, we have seen, are those of fraternity and affiliation, in the root sense of the latter term, "affiliatus," adopted as a son. We need to recall that Vasari's sense of these relations between artists recalls those of the families that employed them. When he speaks in the life of Mino da Fiesole of the tomb of il Magnifico Bernardo Cavaliere di Giugni, he says that the deceased was "honorable" and "esteemed" and merited "this memory by his brothers," who commissioned the monument. It is precisely this kind of fraternal feeling that informs Vasari's accounts of his fellow artists, whose memories he honors over and over with accounts, often imaginary, of funerals and epitaphs and poems, such as those mentioned in the life of Desiderio, whose death was mourned by his "relatives." The brothers of Giugni, in Vasari's report, are exemplary; they are like all the artists who honor the memories of their brothers, fathers, and forefathers.

Vasari rarely misses an opportunity to honor such relations and their memories, whether in fact, fiction, or error. Although he mistakenly calls Giuliano da Maiano the "uncle" of Benedetto da Maiano (who was Giuliano's younger brother), he links them in common cause by pretending that Benedetto continued the work of his "uncle" in the Cathedral. Family connections, even if inaccurately recorded, are nonetheless maintained and celebrated. Such relations are celebrated in fiction because they run deep in fact. Let us turn to the lives of two distinguished contemporaries of Benedetto da Maiano, the brothers Antonio and Piero del Pollaiuolo, for another family story.

In the lives of these brothers, in which fact and fiction interpenetrate, we encounter once again the story of a family's rise to "glory" and good fortune. Antonio and Piero were born to a father of low station, "il padre assai basso," but through their "industry and labor,"

through the "force" and "valor" of their art, they ascended to glory. Vasari pretends that Antonio got his start with Bartoluccio, father of Lorenzo Ghiberti. Although Bartoluccio was a craftsman, we recall that virtually nothing is known of his activity; as we have also seen, Vasari establishes him as a quasi-mythic forefather of art, who guided his son in art. Now Vasari pretends that Bartoluccio trained Antonio, even though Bartoluccio had been dead ten years when his latest disciple was baptized. By reviving Bartoluccio, Vasari keeps before us one of the great patriarchs of art—a fifteenth-century equivalent to Iacopo Tedesco or Lapo, father of Arnolfo.

After departing from the shop of Bartoluccio and his son Lorenzo, Antonio opened a "bottega," which, Vasari says, was "magnificent" and "honored." Vasari is using here to describe the shop of craftsmen the language ordinarily employed to characterize the palaces or tombs of noble families—of the Medici or Strozzi. If Antonio and Piero came from a humble father, Vasari boldly proclaims that when they died, one immediately after the other, they were "rich." Their wealth was a measure of their social ascent and success. The story of their rise from poverty to wealth (a familiar story in Vasari's pages) is to be seen in counterpoint to those stories told of artists who either turn away from the wealth of their fathers or who are corrupted by it. All these stories, interrelated, are part of a larger story. They speak of the complex ambivalence in Christian society between the aspiration to personal and family wealth and the fear and rejection of avarice as a deadly sin. These stories do not conflict with each other because they mirror the larger conflict within Florentine society regarding the meaning of wealth. In the particular story of the Pollaiuolo, however, Vasari is, for the moment, celebrating the success of those sons of a simple and poor father who bring glory to their father and his family.

Cecca in the Time of Our Fathers

When Vasari writes about the Baptistry, "il bel San Giovanni," as Dante calls it, he speaks of one of the focal points of Florentine communal life: the place where all Florentines were baptized and thus entered into the church. Whether discussing the mosaics by Tafi for this venerable structure or the splendid doors by Andrea Pisano

and Ghiberti, Vasari is writing about civic history, not just art history. The biblical stories illustrated both within and without are exemplary; they are models of patriarchy and piety to the Florentines—the very patriarchy and piety mirrored, Vasari avows, in the life of Ghiberti, who worked at the Baptistry.

The Baptistry is the center of one of the most extraordinary and least read of all of Vasari's *Lives*, that of a certain Francesco d'Angelo di Giovanni, known as Cecca, the great engineer. "Ingegno" and "ingegnoso" are the key words in the life of Cecca, who is said to have invented many marvelous machines and devices, reminding us that our word "engineer" comes from "ingenium." Cecca began his career, we are told, as a carpenter, and he was perhaps responsible for some of the works that Vasari attributes to him. In all likelihood, he becomes a sort of fictional or quasi-mythic personality to whom Vasari attaches all sorts of inventions. As an inventor of machines for processions and religious spectacles, of war machines and fortifications, he belongs to that proud line of Florentine engineers from Brunelleschi to Michelangelo, including Benedetto da Maiano and the San Gallo.

Vasari dwells on Cecca's accomplishments in relation to his "patria." His works, which were "useful to the patria," brought "honor," "fame," and "glory" to his city. Although Vasari says that some of Cecca's inventions had fallen into disuse, his tradition was still alive in the festival decorations of Tribolo, Buontalenti, and Vasari himself. Cecca was one of the ancestors of art, and so Vasari wants to preserve the memory of an artist who labored "in the time of our forefathers"— "al tempo de' padri nostri." When Vasari writes that these festivities were organized by various "companies" or "fraternities" of gentlemen, he again gives us a vivid sense of how such art served the community.

Nowhere did this community express itself more fully than in the festival of San Giovanni, which took place in the space between the Baptistry and the Cathedral, in front of the Gates of Paradise. Cecca made an elaborate blue or heavenly canopy to cover the piazza, filled with the "arms" of the Florentines, both lions and lilies. No wonder Vasari said that Cecca "served the people." If the Baptistry was a major symbol of the commune, Cecca was the personification of that very community. Vasari goes on to describe such decorations further, saying that they were filled with heavenly images of saints and cherubim among clouds, and he also speaks of men on stilts, who dressed as giants like those described by the romantic poets. There were also

men who danced high above on ropes, and there were chariots or "carri" (antecedents of those of Piero di Cosimo, Pontormo, and Vasari himself). Vasari notes in particular that the "carro" of the Florentine Mint was made under Cecca's direction.

Vasari rounds out his account of Cecca by observing that he built a structure for the restoration of the mosaics of the Baptistry. We make much of our own restorations today, often forgetting how such renovations of venerable monuments already were undertaken in Vasari's own day. This contribution to the Baptistry mosaics, which was important to Vasari, earned Cecca a "very great reputation."

The documents indicate that Cecca was wounded in the head after the Siege of Piancaldoli. He died, Vasari says, when he stuck his head out from the Florentine defenses in order to take some measurements. Vasari claims that a priest, who, like his other enemies, feared Cecca's genius, was the enemy who delivered the mortal blow. By invoking the fear of his genius and by imagining that Cecca was killed by a priest, Vasari perhaps alludes here (as in the life of Leonardo) to that sense within Christian thought of the engineer as a type of "magus" or magician at odds with Christianity. In any event, the death of "this poor fellow" was a blow to the Florentines, who mourned his death. His remains were sent back to Florence, where he was given an honorable burial, as Vasari imagines, "by his sisters." Vasari magnifies their role in the funeral by inventing an epitaph that identifies the "pious sisters," who honored their brother. Thus ends the life of a legendary artist, who served the commune in the days of Vasari's forefathers—the life of one of Vasari's ancestors or "padri" in art.

The Rise of the House of Ghirlandaio

As we have observed repeatedly, Vasari sees the art of the past necessarily from the perspective of his own day. He is continuously in search of his own forefathers in art. (Lapo, father of Arnolfo, is such a forefather, Cecca another.) Nowhere is this more true than in the lives of the Ghirlandaio, a family of artists that proliferated and was alive in Vasari's day.

This clan descends from Tommaso del Ghirlandaio, whose name, Vasari says, is based on his invention of the "ghirlande" worn by Florentine girls. These garlands were of such beauty, Vasari says, that none satisfied, except those that came from Tommaso's shop. This is a fiction, according to which Vasari makes Tommaso into an "orefice," whereas in fact he was a broker. Like many of Vasari's artists, Tommaso's son was not encouraged to pursue his natural inclination, which was to be a painter. Instead, his father, a goldsmith, sent Domenico to work as a goldsmith, but in time Domenico demonstrated such skill as a draftsman that he became a painter. Once again the will of art, the Vasarian (not Hegelian) "Kunstwollen" wins out.

Domenico was not alone among Tommaso's progeny. He had two brothers who were painters, David and Benedetto, and he also had a sister, who married his assistant Bastiano. Thus a disciple of Ghirlandaio's, united to him in "friendship," was now linked to him "in parentado"—as a member of his family. Vasari takes advantage of Ghirlandaio's family story to tell a tale that demonstrates fraternal devotion. When he and his brother-in-law are painting at Passignano, David flies into a rage because they are not being fed properly by their clerical patrons. David turns the soup over on the priest, insisting that the virtue of his brother Domenico, who is about to arrive in Passignano, is greater than that of all the "abbot pigs" who ever lived in the monastery. In the end, the patrons of the Ghirlandaio recognize their error and treat them as "valenti uomini." The story has a happy ending, because one brother has come to the defense of another.

Like Michelozzo in the household of the Medici, Domenico Ghirlandaio was on terms of "familiarità" with the "rich merchant" Giovanni Tornabuoni, of whom he was a "very great friend," or so Vasari imagines. Vasari says that Domenico honored his brother David and his brother-in-law Bastiano by painting their portraits in the chapel of Tornabuoni, among "the true effigies of many important people." In Vasari's fiction, the artist's own family appears among the family of the patriciate. Vasari pretends further that when Ghirlandaio was dying the Tornabuoni, "in friendship," made a donation to him for his services to them. In like fashion, Vasari portrays Domenico as himself a patron or patrician of sorts, saying that Domenico paid Bastiano "liberally" for his labors, for working in his "service." The artist thus presides over his shop as a patron does over his artists. In both cases, these relations are those of "familiarità." Through his association with the Tornabuoni,

Domenico Ghirlandaio becomes a patriarch. Aspiring to paint all of the city's walls, Ghirlandaio not only harbors grandiose, Michelangelesque ambitions, but he aspires to adorn the very walls that protect the commune—that protect the wealthy and illustrious families with whom he is associated. The sheer grandiosity of his vision of decorating these walls is epic in scale. No less is it biblical in scope, evoking the monumentality of King Solomon's vision of Jerusalem.

Domenico's life ends with great pathos and family grief, as Vasari imagines it, for his son Ridolfo and his brothers David and Benedetto shed "many tears" and made "many sighs of piety" on the occasion of the artist's burial in Santa Maria Novella. Vasari elaborates on the death of this hero and patriarch of art by saying that the loss of so great a man caused much grief and that many excellent painters from outside the commune, hearing of his death, wrote to his relatives lamenting his untimely demise. In Vasari's fiction, Ghirlandaio is almost like a prince or monarch. When Vasari says that Domenico left many disciples—David, Benedetto, Bastiano, Michelangelo, Granacci, and Baccio Bandinelli, among others—he describes the departure of a great lord of a house, a grand patriarch taking leave of those who served his memory through their own works.

The Decline and Revival of a Great Family

Vasari continues the story of the Ghirlandaio in the "lives" of Ridolfo, Benedetto, and David Ghirlandaio. He comments at the outset of this biography that some brothers and sons do not follow the excellence of singular artists, because they lack "liveliness of spirit." This is the case with David and Benedetto, who, although endowed with "very good genius," were no longer capable of following the example of Domenico after his death, for they now strayed from the path of good work. Thus the artistic fortunes of the Ghirlandaio declined.

Such a falling off of the Ghirlandaio was only temporary, since Domenico's son Ridolfo breathed new spirit into the family's art or, as we might say, into the family of art. Vasari describes Ridolfo's paintings of San Zenobius's miracles, including the scene in which the saint

"restores" a dead boy to life, causing amazement in those who witness this "resuscitation." Seeing these works, Ridolfo's uncle David is content and thanks God that he has lived long enough to see the virtue of Domenico come back to life ("risorgere") in Ridolfo. Vasari is here playing on the relation between the resurgence of art in Ridolfo and the resuscitation that is the very subject of Ridolfo's painting. He is referring as well to the other miracle of Saint Zenobius painted by Ridolfo, in which the dry tree puts forth green leaves when touched by the coffin of the saint. Uncle David's remark on the revival of art in the Ghirlandaio family plays on the revival of the family tree—made green again in a manner resembling the revival of the Medici "broncone" or stump, which takes leaf upon their return to power.

Vasari continues by celebrating Ridolfo's works, extending the family's history further by saying that Ridolfo took on a protégé named Michele, to whom he showed paternal love. Ridolfo and Michele, Vasari says, loved each other as father and son. Finally, Ridolfo, living into old age (like David, but in contrast to Domenico), saw his daughters married and sons successful in commercial affairs in both Ferrara and in France. Thus ends the life of the aged patriarch, who, Vasari insists, loved art very much and succeeded commercially, we might add, like the Tornabuoni family for whom the Ghirlandaio worked earlier. In the final scene of Ridolfo's life, Vasari describes the artist carried into the Palazzo Vecchio, now the Medici residence, impressed by all the renovations. Pleased by what he sees, he exclaims, like Simeon in the temple: "I can die content and bring news to artists in the other world of what I have seen—that is, what was dead, ugly, and old is restored to life, beautiful, and become young once more."

Ridolfo's pronouncement echoes that of David, but whereas David was speaking of Ridolfo's art, Ridolfo is speaking of the building that stands for the entire Florentine community of art united under the Medici. Begun by Arnolfo, the son of Iacopo, it was transformed by Michelozzo and countless others before Vasari gave it final form for his Medici patron. Now the aged patriarch, who himself worked in the Palazzo Vecchio, passes judgment on the renewal of art of the entire community parallel to the renewal that he had effected earlier in the artistic life of his own family. Ridolfo is commenting on the revival in the family of art descending from Arnolfo's father Iacopo, the "Jacob" in the "Domus Jacob" of Florentine art—reminding us that the Florentine patrician society is always envisioned in deeply familial terms.

Iacopo Bellini, Venetian Patriarch

Just as the works of the Ghirlandaio contributed to the fame of Florence, so did the paintings of Iacopo Bellini and his family redound to the glory of Venice. Vasari's story of Iacopo Bellini's ascendancy is again the tale of an artist who rises from a modest beginning ("basso e vile") to the "summit of glory." The founder of a family of painters, Iacopo Bellini, as his name suggests, is another Jacob figure in Vasari's story of artists as patriarchs. His fortune and that of his family are bound up with the glory of his "patria." The family is a deep theme in the lives of the Bellini. Iacopo named his son after Gentile da Fabriano, Vasari says, because he had a "sweet memory" of his master, who was a "loving father" to him. We might almost say that Gentile plays the Abraham to Bellini's Jacob. This fiction sets the stage for the deeper theme of family and civic love that runs through the entire biography of the Bellini.

As a loving father, Iacopo diligently taught his sons the rudiments of drawing, and hoping that Giovanni would surpass him in art, he also hoped that Gentile would surpass them both. He was gratified when indeed both of them did excel. Iacopo worked with the aid of both his sons, who would later go on to paint scenes celebrating the glory of Venice, bringing fame to themselves and their house. As time passed, Iacopo withdrew into himself, and Giovanni and Gentile went off to live by themselves. They nevertheless continued to have "great reverence" for each other and for their father. Gentile went to Constantinople, where he was received with "great honor" by the sultan, who gave him a gold chain, which, Vasari adds, "is still with his descendants" in Venice. Gentile's trip is part of the triumph of Venice, of Venetian art, and of his family. Upon his return to Venice from this "most happy journey," Gentile was joyously received by "nearly the entire city," including his brother Giovanni. It is as if Gentile were an ambassador serving his state to the glory of his family. Reaching the venerable age of eighty years, Gentile, himself now a patriarch of art, died, and he was given an honorable burial by his brother, who "loved him most tenderly." The theme of brotherly love continues to run deep.

Giovanni then introduced to Venice the practice of making for all the houses of the city portraits of the fathers ("padri") and ancestors

("avi"), up to the fourth generation. In some more noble houses, Vasari says, the portraits go back even further. This practice, which existed among the ancients, as Vasari insists, is worthy of praise. "Who," he asks, "does not feel infinite pleasure and contentment, not to speak of the honor and adornment they confer, at seeing the images of their ancestors—particularly if they have been famous and illustrious for their part in governing their republic, for their noble deeds performed in war and peace, or for having any other notable and distinguished talent?" Vasari recalls that it was to precisely this end—to kindle in their successors a love of excellence and glory—that the ancients set up images of great men in public places. The portraits by Giovanni Bellini not only celebrate the Venetian patriciate, they also bring glory to the illustrious house of Iacopo Bellini.

Vasari's hymn to the efficacy of the portraits of forefathers also brings to mind his practice of identifying great citizens, statesmen, poets, and artists—even when they are not really there—in frescoes and altarpieces. The portraits of artists that accompany the *Lives*, which are often imaginatively adopted from works of art, were intended, like the *Lives* itself, as exemplary images of excellence and glory. The making of portraits and the writing of biography in Vasari, as elsewhere, are intended to celebrate the glory of the individual, but this individual fame is inseparable from that of the family and "patria." All the "portraits of gentlemen" that fill the houses of Venice glorify not only their sitters but their exalted houses and the state.

Making such images, artists participate in the glory of their subjects, achieving a glory of their own that depends on the virtue of their art. Vasari's stirring history of artistic, familial, and patriotic glory in the lives of the Bellini ends with the death of Giovanni at the age of ninety. Buried next to his brother, Bellini left the "eternal memory" of his name in Venice through his works, helping make his own family illustrious in his "patria." An aged patriarch at the end of his career, as Gentile had been, Giovanni contributed to the fame of the "Domus Jacob," founded by their father Iacopo.

The Marriage of Illustrious Houses

The life of Andrea Mantegna is a parallel and more than parallel life to that of Iacopo Bellini. Like Bellini, who rose from humble stock to distinction, Mantegna rose from modest beginnings, through his virtue and good fortune, to become "preux chevalier." In his youth Mantegna grazed herds before being taken to study painting with Squarcione. High hopes were held for his future success as an artist, whence Iacopo Bellini contrived to get Mantegna to marry his daughter, the sister of Giovanni and Gentile. Mantegna would go on to succeed splendidly in his art, for which Pope Innocent VIII made him a "cavaliere." Flourishing and prosperous, he then built "a very beautiful house" in Mantua—a symbol of his elevated status. Mantegna was a man of "gentle manners," a perfect knight.

Vasari's story is again one of the social ascendancy of the artist, but one in which two illustrious houses in art are joined. We could say that Mantegna became part of the Bellini clan, just as the less distinguished Bastiano became part of the Ghirlandaio extended family. The marriage of Mantegna into the house of the Bellini is reflected in the marriage of his style to that of the Bellini—a subject that is part of the very history of Renaissance style.

The story cuts deeper. The marriage is the source of a family rift. Mantegna was the "adopted son" or "figliuolo addottivo" of Squarcione, who took him into his house. Bellini was a rival of Squarcione, who in a sense lured Squarcione's son away from his home. Marrying the daughter of his rival, Mantegna betrayed his father in art. The story of marriage is thus also the tale of a family clash. Embittered that his son had betrayed him, Squarcione, who formerly praised Mantegna, now denounced him, criticizing his work publicly, saying that his painted figures, instead of looking like flesh-and-blood people, resembled sculptures in stone. Such criticism, which has become part of the story of Mantegna's highly sculptural style, is apt since his paintings, which reflect his study of Donatello and of classical statuary, do indeed have a sculptural hardness of form. We forget, however, that Squarcione's famous denunciation of his son is placed in the broader context of family history—that is, Mantegna's wedding to the

daughter of his father's rival. Vasari reminds us through this fiction that artistic competition is sometimes also related to social conflict.

Vasari concludes his detailed account of Squarcione's denunciation of Mantegna by saying that the latter nevertheless painted the portrait of Squarcione in a fresco, depicting him with a lance and sword in hand. Is Vasari not leaving us with this final image of Squarcione in order to fix in our memory the combativeness and fury of a betrayed father?

Medici Forefathers in Wax, Plaster, and Porphyry

It would be tedious to list all the portraits, both real and imaginary, that Vasari sees in frescoes. Nevertheless, these portraits are sufficiently important to Vasari's social history of art to warrant some further remarks, especially about the portraits of the Medici, whom he serves. Both portraits in history paintings and portraits as such are, Vasari recognizes, memorials to the dead. He sees these effigies of the dead, for example, vivified in Botticelli's *Nativity* for Santa Maria Novella, which portrays the Medici as the Three Kings. As memorials, these portraits have a function comparable to that of tombs.

Made of marble, bronze, and even porphyry, tombs are more enduring than paintings. Verrocchio's tomb of Giovanni and Piero de' Medici is a case in point, for it is a "cassa di porfido." Vasari is particularly interested in the very hardness of porphyry since the material caused technical problems. He plays on this feature of the stone when he refers to Perugino's obdurate resistance to religion, saying that no preaching penetrated his brain of porphyry or "cervello di porfido." So hard was porphyry, used here maliciously to memorialize Perugino in a word-portrait, that it could not be effectively carved until Francesco del Tadda developed a technique for making portraits from it, notably his portrait of Cosimo il Vecchio de' Medici. This technical breakthrough was of such magnitude that Michelangelo was much impressed, Vasari notes, when he learned of it. Now, thanks to his technique of carving portraits from porphyry, not only the resting

place of glorious individuals but their very images could be rendered in this most durable, indeed eternal, stone.

By contrast to these eternal images, Verrocchio made, Vasari tells us, plaster effigies, which were cheap and thus could be seen in every house—over chimney pieces, doors, windows, and cornices. Such portraits, he adds, continue to be made. He suggests that for this invention Verrocchio should be praised. Although he does not say so explicitly, Vasari sees these portraits in plaster, like the painted effigies of the Bellini, as images of illustrious citizens from illustrious houses or families. Not surprisingly, he dwells on those made for the Medici, introducing yet another kind of portrait when he speaks of the wax votive portraits made by a certain Orsino in collaboration with Verrocchio. Vasari's descriptions of these images are in the form of a panegyric to the family he served. He focuses on the life-size votive images of Lorenzo de' Medici made after the Pazzi conspiracy, in which Lorenzo was wounded in the cathedral and his brother Giuliano murdered. These images were set up to render thanks to God for his deliverance, since Lorenzo escaped from the cathedral with his life. One of these, sent to Assisi, was placed in the church of the Servi and another in a church in Via San Gallo. In the latter the figure of Lorenzo was clothed as he was when he appeared, wounded and in bandages, at the window of his house before the eyes of those who flooded there in the hope of seeing him alive or, if he were dead, of avenging him. By thus describing this image, Vasari seeks to kindle the memory of the glorious Medici forefather, hoping to ignite in his reader a sympathy for this great citizen of Florence who dominated the political and cultural life of his city, restoring, as Vasari says elsewhere, the "age of gold."

Vasari is suggestive when he says that the practice of such wax effigies has declined in his own day, wondering whether it is on account of diminished devotion or for some other reason. It is in this very context of Vasari's sense of a possible declining reverence for one's forefathers that we must place his own celebrations of the city's fathers—a celebration based on the devotion or piety that is one of the animating themes of the *Lives*.

Vasari's Illustrious Relative

The second part of the *Lives* concludes with the biography of Luca Signorelli. Like the biographies of the Bellini and the Ghirlandaio, this biography is part of the story of the artist's extended family—in this case Vasari's own. We read here of one of the great fathers of Vasari's own house, since Signorelli, as we should recall, was related to "the house of Lazzaro Vasari," being married to Lazzaro's niece. Signorelli was an "excellent" and "famous" painter, whose art was praised by Michelangelo. Like Mantegna, Signorelli was a gentleman, loved for his "gentilezza." Courteous and loving with his friends, sweet and pleasing in conversation, Signorelli was the perfect courtier. He lived splendidly and dressed well, and for all his good qualities (Vasari brags), he was always venerated in his "patria." Vasari is more than pleased to venerate this illustrious relative.

The climax of Signorelli's biography is the moment, already alluded to, in Vasari's childhood when the "old man" was brought on the shoulders of men (triumphantly?) from Cortona to Arezzo because he wanted to see "his friends and relatives." Vasari recalls that Signorelli encouraged his father to let him draw, telling his father that this activity would bring honor to him. Signorelli's words are almost recorded as a prophecy of Vasari's later accomplishment. Vasari fixes for his reader the graphic image of his forefather, his distinguished relative, an honored courtly gentleman, giving his paternal blessing to Vasari. Vasari exclaims that Signorelli gave his advice to his father, Antonio, because Vasari was always drawing when in school—an old story in the pages of Vasari. Were those artists of the past said to have drawn when they were sent to school projections of Vasari's own story? Is it possible, as we have already asked, that Signorelli is introduced to give his blessing because Vasari's father resisted his study of art—even though Vasari later claims that his father set him on the path of art? Could Vasari's father have been like those fathers who were set against the natural tendencies of their sons toward art? Whatever the exact facts of Vasari's own life may be, the memory of Signorelli, of this "good old man," this benevolent forefather, remained "fixed for eternity in his soul."

Signorelli stands for all the patriarchs in the history of art, all the fathers or paternal figures who wisely encouraged their sons in art.

He felicitously and triumphantly takes his place at the end of the second part of the history of art as one who helped pave the way to the "perfection" of art. Vasari's patriarchal relative not only in a sense foretold and blessed Giorgio's future success, but he also prefigured the advent of that artist who, inspired by Signorelli, was to become the greatest patriarch in the family of art—Michelangelo Buonarroti. In the metaphorical sense of family, Michelangelo descends from the extended family of Vasari.

Correggio's Family Misery

Not all the lives of the artists are so exalted as those of Luca Signorelli, Andrea Mantegna, or Giovanni Bellini. Take the case of Correggio. We usually recall Vasari's high praise of Correggio's color, the "vaghezza" and "morbidezza" of his "colorito," which is the central theme of Vasari's biography. But what of Correggio's personality and the "facts" of his life? His is a rather sad story.

Correggio was, Vasari claims, both "timid" and "melancholic." He ties this characterization to the portrayal of an artist always hard at work, seeking to fulfill family obligations that were an aggravation— "lo aggravava," they quite literally weighed him down. This presumably fictional portrait at the beginning of the biography is filled out in the conclusion, where, Vasari insists, Correggio was "aggravated by the family," by which he means its financial needs. No doubt this was a real issue for any artist. Vasari says that Correggio, continuously trying to save money for his family, became a "miser," ending his life miserably.

"It is said," Vasari writes, that having received in Parma a payment of fourteen "scudi" and wishing to return to his hometown in order to meet certain needs, Correggio set out on the journey. It was very hot under the sun and, overheated, the painter drank water to refresh himself before taking to bed with a high fever, from which he never recovered. Our final image of the miserable Correggio is thus the sad one of the painter perishing as he seeks to fulfill financial obligations to his family.

Vasari's fiction is perhaps keyed to the portrayal of Andrea del Sarto's servitude to his wife, whose greed put enormous strain on the

painter. In this context, we recall that Sarto's friend Franciabigio warned against the difficulties of having a wife, that both Raphael and Taddeo Zuccaro resisted marriage and its responsibilities. We also recall Vasari's description of the fresco that he says he painted of a wife, as a joke (but a serious one), the point of which is that the wife consumes the husband's very house. No doubt the responsibility of having a wife and family was a problem for Vasari and for other artists. His sad fiction of Correggio's end, when he was weighed down by family pressures, is a poignant reminder of this very real concern. Vasari's portrayal of Correggio dying in misery, seeking to fulfill his obligations to his family, is one of considerable pathos, intended to inspire the reader's deepest sympathies.

Leonardo's Enterprising Father

If Correggio's story is a sad one, that of his contemporary Leonardo is exalted, indeed triumphant. Leonardo da Vinci was the son of Piero da Vinci. Taken as a young child from his true mother Caterina, he was placed in the care of his father's wife Albiera. Without going into any of these details, Vasari says simply that the "celestial" artist was the son of Ser Piero da Vinci. Piero was the perfect father of the artist. When Leonardo did not get much out of school, he studied mathematics and played the lyre, singing beautifully. Piero observed, however, that Leonardo never abandoned drawing and making reliefs and, recognizing the heights of Leonardo's genius, he took some of his son's works to "his friend" Verrocchio in order to ask whether Leonardo could profit from study in art. Stupefied by what he saw, Verrocchio encouraged Piero to have him pursue the study of art, and Piero next "ordered" his son to study with Verrocchio. Leonardo, the perfect son, did this "willingly," following his father's command.

Leonardo's father next plays a prominent role in the well-known story of the *Medusa* that the young Leonardo painted on a buckler for a peasant. Let us take a close look at this fiction because it tells us many things, not the least about Leonardo's enterprising father. Once upon a time, when Piero was at his farm in the country, a peasant came to him with a "rotella," a round piece of wood cut from a fig tree, hoping to have it painted. Piero was very happy to do this because the

peasant fished and hunted for him. Piero then brought the piece of wood to his son in Florence and asked him to paint it. Seeing that the piece of wood was badly worked, Leonardo straightened it and, giving it to a turner, had it planed down. Leonardo next prepared the buckler for painting with a coat of gesso. Pondering what he might paint, he decided upon a head of Medusa, which would terrify anybody who beheld it. Leonardo studied various lizards, crickets, butterflies, serpents, and other "strange creatures," inventing out of these a most frightening beast with poisonous breath, which turned the air to flame. So absorbed was Leonardo in his work that he took no notice of the stench from the dead animals he studied in order to make this monster.

When Leonardo had finished the painting, he told his father that he could send for the buckler whenever he wanted. One morning Ser Piero, ready to examine the work, arrived in Florence and knocked at Leonardo's door. Opening it, Leonardo told his father to wait a minute. He then went to his room and placed the buckler in a good light near a window before going to invite his father in. Taken by surprise when he saw the painted Medusa, Piero gave a start, thinking that what he saw was real, not painted. Piero told Leonardo that the painting served its purpose. Indeed, he thought the work a "miracle" and praised Leonardo's ingenuity. Piero did not, however, bring this painting to the peasant who requested it. Instead, he bought another buckler covered with the painting of a heart penetrated by an arrow and gave this work to the peasant, who remained obligated to him ever after. Piero then secretly sold Leonardo's buckler to some merchants for one hundred "scudi." A short time later the painting came into the hands of the Duke of Milan, who bought it for three hundred "scudi" from the very merchants who bought it from Piero at one-third that price. So ends Vasari's tale.

It seems not unlikely that Vasari invented this story as a variation on Sacchetti's "novella" about Giotto painting a shield for the "simple little man." Vasari's fiction illustrates the "terribilità" of Leonardo's art and the "fantasia" that informs his "maniera alla grottesca." Although fictional, Vasari's tale is told in such detail that it becomes almost credible. Reading it we readily suspend disbelief, especially since the tale is true to Leonardo's art. A clue to its fictional character is perhaps found in its resemblance to the story of Michelangelo's *Sleeping Cupid.* Like Michelangelo's sculpture, also made during the artist's

youth, the youthful work of Leonardo was resold at a considerable profit at a price much higher than that for which it was originally purchased. Since the *Cupid* was misrepresented as an antique work, it had two identities, as a work of Michelangelo and as a classical sculpture. These two sculptures, so to speak, are parallel to the two shields. In both stories there is the important element of deception, that of Piero fooling the peasant with another buckler and that of the individual who pretends that the *Cupid* is an ancient sculpture. When Vasari concludes that the buckler eventually went to the Duke of Milan, he is suggestive, giving us a clue to his fiction. Is it merely coincidental that the court of Milan was the buckler's final destiny, since it was there that Leonardo would later work?

Vasari's story is almost as much about Leonardo's father as patron as it is about Leonardo as artist. Appreciative of the excellence of his son's work, of his skill and virtuosity, he also recognizes the painting's potential monetary value. His deception of the peasant, when Piero gives him another buckler, is strikingly parallel to the deception of his son's highly illusionistic work that had indeed fooled Piero. To invert the cliché, "Like son, like father." If we remember Leonardo as the youthful prodigy of Vasari's story, let us also recall his father as the clever and pragmatic businessman who, seeing the opportunity to use his son's art for his own financial gain, exploits it in a commercial "inganno." Doing so, Vasari reminds us that Florence was not only a capital of art but a business center, where men like Piero da Vinci were forever using their wits and guile to turn huge profits. Leonardo's discerning father stands in Vasari's fiction for all those Florentines of acumen, cunning, and entrepreneurial "virtue" who made Florence prosperous. Vasari's story reminds us that the stories of art and financial prosperity are inextricably related.

The Rise of the San Gallo Dynasty

In Florence, in the time of Leonardo, there flourished an architect of major accomplishment and reputation named Giuliano da San Gallo. Said to be the son of Francesco di Paolo Giamberti, an architect in the period of Cosimo de' Medici, Giuliano "lovingly entered the service of the Medici." He built for Lorenzo the splendid villa at Poggio a

Caiano and was also responsible for a number of important buildings in Rome and Naples.

Although born of the Giamberti, Giuliano took the name San Gallo, from his work on a convent outside the Porta San Gallo. According to the tale told by Vasari and still usually accepted at face value, Lorenzo gave Giuliano his name, calling him "da San Gallo," because of his work near the San Gallo gate. When Giuliano objected to Lorenzo that by calling him "San Gallo" he lost the name of his "ancient house," Lorenzo replied that, thanks to the virtue of his art, Giuliano was now the founder of a "new house"—as the founder of the artistic dynasty of the San Gallo.

Giuliano's younger brother Antonio was also an architect, whose works Vasari praises, and Giuliano's son Francesco was an accomplished sculptor as well. Giuliano had a nephew named Antonio, who would later become a distinguished architect, and Antonio's brother Battista Gobbo was his collaborator. Two other nephews of Giuliano, Aristotile and Giovan Francesco da San Gallo, also brought honor to the house and, like Antonio the Younger, Aristotile is the subject of one of Vasari's biographies. The San Gallo dynasty is thus exceptionally the subject of three biographies in Vasari's book.

By pretending that Lorenzo il Magnifico gave Giuliano his name, Vasari magnifies Giuliano's own magnificence. He also does this by telling another story about Giuliano and his patron immediately before the fiction of Giuliano's name. Vasari says that Lorenzo recommended Giuliano to the King of Naples. When Giuliano asked license from the king to return to Florence, he was given a number of presents to take back to Lorenzo—horses, clothes, and money—but Giuliano refused these gifts, saying that Lorenzo, his "padrone," had no need of money. If the king wanted to give Lorenzo a present, Giuliano said, he could give him some antiquities of his choice. For the love of Lorenzo and of the virtue of Giuliano, the king gave Giuliano a head of the Emperor Hadrian, a nude female figure, and a *Sleeping Cupid*. Giuliano presented them to Lorenzo, who was overjoyed by the presents and never stopped praising the "most magnificent" architect, who refused gold and would only accept art— something few people would do. In his munificence and love of art above money, Giuliano emerges as himself princely and magnificent, like il Magnifico himself.

Appropriately, Vasari concludes the biography of Giuliano by saying

that the "inheritance" of Giuliano and his brother was their art, adding that the San Gallo houses were filled with "an infinity of beautiful ancient marbles." The San Gallo thus became lordly collectors of art, like their Medici patrons. When Vasari later brags about the works of art in his own houses, he makes himself, like the San Gallo, into a princely "padrone" of art. The history of Vasari's book is increasingly the story of how artists, in their wealth and virtue, are like their patrons, the story of how artists' families resemble those of their patrons—eventually becoming princely.

Raphael's Princely Family

Of all artistic families, perhaps none dominates the pages of Vasari in its sheer extent as that of Raphael. Raphael's father, as Vasari tells us, was the painter Giovanni Santi of Urbino, who set his son on the good path of art. Giovanni, Vasari says, did not want his son sent to a wet nurse; he wanted him to be nursed by his own mother. Wet nurses were of plebeian or peasant stock, of rough manners, in contrast to the "gentle manners" of mothers. So Vasari insists in this family romance. Raphael's legendary "gentilezza" depended on the nurturing received at the breast of his mother, which in turn reflected the original paternal decision. Vasari fills out this fable of maternal love by saying that when Raphael left home for Perugia, his mother, "who loved him tenderly, shed many tears."

Vasari's fable of Raphael's mother is a poetical explanation of the tender, loving attitudes of the Holy Mother in his paintings. Having received the gentle love of his mother, nourished tenderly at her breast, he informed his own images of the Holy Mother with this very love and tenderness. Vasari's family idyll is a reminder of the fact that the eighteenth century did not invent modern sentimentality "ex nihilo." That we still respond to such fictions is a further reminder that in our unromantic modern world such sentimentality is not dead. It is not unlikely that Vasari invented this touching fiction of maternal love as a variation on Michelangelo's famous remark that he took in with the milk of his wet nurse the very hammers and chisels of his sculpture. The point of the antithesis is that whereas Michelangelo's feeding at the breast resulted in the marmoreal hardness of his works,

Raphael's infancy at his mother's breast led to the softness and tender grace of his art.

Vasari embellishes Raphael's family history by imagining that Bramante, also from Urbino, who encouraged the pope to invite Raphael to Rome to paint, was Raphael's "parente" or relative. Raphael eventually achieved great stature in Rome, working for the princes of the church Julius II and Leo X, with a huge shop consisting of Giulio Romano, Perino del Vaga, Giovanfrancesco Penni, and countless others. These protégés were Raphael's progeny, his sons in art, and Vasari explicitly says that he loved Giulio and Perino as if they were his own sons. These family relations become more than metaphorical, because, as Vasari tells us, Giulio married the sister of Raphael's disciple Lorenzetto and Perino married the sister of Penni. The shop of Raphael was indeed an extended family. When Vasari says that Raphael was like a prince to whom nearly fifty artists were connected, he presents the picture of a paterfamilias, presiding over the domain of art. Raphael's disciples, like the intermarried children of the courts of Italy, are part of the dynasty that he established.

Raphael's progeny, in turn, become themselves paternal figures. Perino, who achieved immortality through his great works for Andrea Doria and who was a dominating figure in Rome in Vasari's own day, was, in Vasari's words, the "father of the arts," and Giulio Romano, as Vasari himself proclaimed in a speech to the Lord of Mantua, was like a "padrone" of the city. The princely Raphael presided over a house whose sons became great patriarchs of art, princely figures, who like their father-in-art, Raphael, dominated the world of art. Raphael established a great "casato" of art, a dynasty of artists who extended the dominion of his family, honoring the memory of his "padri," Giovanni Santi and Bramante.

Timoteo Viti in the Clan of Raphael

Vasari links Raphael to other families in art. He says that when Raphael came to Florence he had close friendships with Ridolfo Ghirlandaio and Aristotile da San Gallo, both of whom, as we have seen,

belonged to large artistic families. Whereas Ridolfo never left Florence, not wanting to lose sight of the Cupola of the Cathedral, Raphael left his native Urbino not only for Florence but eventually, and finally, for Rome. Urbino and Rome are the axes of the life of Timoteo Viti, a protégé of Raphael's, whose life is virtually written by Vasari out of Raphael's biography, as an extension of it.

Like Raphael, Timoteo was born in Urbino. His mother Calliope was the daughter of Antonio Alberto da Ferrara, "a rather good painter," as Vasari says, whose works are to be found in Urbino and elsewhere. Timoteo's father died when he was still a child, and he remained in the care of his mother—a good augury, Vasari observes, since Calliope was one of the nine Muses, who presided over painting as well as poetry. A "prudent mother," she raised Timoteo, Vasari says, evoking Raphael's mother. Whereas Raphael's father instructed his son in art, it was Timoteo's mother who brought him to the study of painting. Eventually Timoteo was called to Bologna by his elder brother Piero Antonio, who was studying there. It was hoped that Timoteo would follow his brother in art, but he stayed in Bologna only briefly before returning to Urbino. Timoteo was then invited to Rome by Raphael (as Raphael was brought to Rome by Bramante), and there received with loving kindness. While in Rome, Timoteo prospered and, as a good son, sent money home to his family—or so Vasari imagines in this familiar tale of filial piety.

Finally, Timoteo could no longer endure his separation from his "patria," especially because he was continuously urged by his friends and mother, now aged, to return to Urbino, and this he did, much to the displeasure of Raphael, who loved him dearly. Not long after, Timoteo took a wife in Urbino at the suggestion of his relatives and began to raise his own family. Greatly honored in his "patria," Timoteo resolved never to leave home again, even though Raphael entreated him with letters.

If Timoteo was fatherless in infancy, he had found a father in Raphael—like all of Raphael's disciples, whom their master loved as sons. Working with his newfound father, however, Timoteo missed his "patria," his mother, and friends. When he finally established his own family in Urbino, Timoteo responded to a family tension—the conflict between loyalties to the artist's real family in his "patria" and to his adopted father Raphael in Rome. At first Timoteo was like Raphael, who left his "patria" of Urbino, but when he could no longer stay

away, he was like Raphael's friend Ridolfo of the Ghirlandaio family, who could never leave his "patria." To leave one's "patria" was to leave one's family behind.

Images of the Family in Renaissance Art

W. H. Auden once wrote that the old masters knew a great deal about suffering, and Renaissance paintings often depicted such suffering in scenes of immense pathos. Vasari's descriptions of art suggest the relations of these images to life. Speaking of Ghirlandaio's *Massacre of the Innocents*, he describes the soldiers who, ignoring the mothers, murder their "poor little children." With great sympathy he describes the little child with a slit throat who drinks in blood rather than the mother's milk, and he describes the mother seeking to reclaim her murdered child from the soldier who has killed him. When Vasari describes Verrocchio's sculpture reenacting Francesca Tornabuoni's death in childbirth, he is not just describing a funerary monument. He is speaking of a family tragedy, of the loss of the husband who loved his wife very much—"il marito . . . molto l'amata l'aveva." He is speaking of grief, of the pain and suffering that is part of family life.

Nowhere do we find the sense of family sorrow more vividly expressed than in Vasari's description of Raphael's *Entombment of Christ*, the picture painted for Atalanta Baglione as a monument to her murdered son. Echoing the language of Dante, Vasari says that the painting had the power to move the "hardest soul to pity." He says that Raphael has painted in this picture "the sorrow of the most loving relatives, who carry the body of the dearest person, in whom consists the well-being, honor, and utility of an entire family." Vasari is not only talking about the sorrow of the holy personages who respond to Christ's death. He is suggesting that their sorrow is exemplary of how a particular family dutifully responds to a death in the family, to the death of a son. Knowing that the painting was made for Atalanta Baglione, Vasari may well have known the circumstances of the commission and understood that the painting was a memorial to the patron's murdered son.

Not only religious subjects but also classical themes have familial implications in Vasari's descriptions of works of art. Speaking of Raphael's *Fire in the Borgo* for Pope Leo X, Vasari says that the painter rendered here a young man carrying an old man from the fire "in the manner of Virgil." He is of course referring to the passage in Book II of the *Aeneid* describing the Fall of Troy, where Aeneas carries his father from the burning city.

Vasari tells us that he had a deep knowledge of the poem, and we cannot fail to observe what this Virgilian theme meant to him. Just before Aeneas took Anchises upon his shoulders, his father prayed to the gods of his fathers to preserve his house, to protect his grandsons. Aeneas then says to his wife that they should flee separately and reunite at a funeral mound preserved for many years by their father's piety. Raphael's figures evoke the larger context of Virgil's poem, in which the sense of family and filial piety is a dominant theme. For Vasari the image of pious Aeneas carrying Anchises upon his shoulders crystallized a major theme of his book—that is, the devotion of the numerous sons to their fathers and forefathers.

The piety shown by Aeneas to his father and ancestors is thus exemplary. Like the "pietà" of the "family" of those who mourned Christ's death in Raphael's *Entombment,* which represented the death of a son, the piety of the Virgilian passage in Raphael's classicizing fresco would have struck a deep chord in Vasari. The Virgilian detail in Raphael's fresco can be seen as an icon of Vasari's own piety. Although this piety is classical in origin, it is infused in Vasari's culture and experience with Christianity. Vasari showed such a sense of duty when he restored the Pieve of Arezzo, which housed the remains of his fathers. Rebuilding their tomb, Vasari showed a filial piety like that of Aeneas, only Vasari's piety was now a "pietà cristiana."

Andrea Sansovino, Patrician

The ideals of antiquity are reflected elsewhere in Vasari's family histories, for example, in the story of Andrea Sansovino and his family. Andrea was born, Vasari says, the son of Domenico Contucci dal Monte Sansovino, a "very poor father," who was a tiller of the soil. The young Andrea was raised as a shepherd, but, like Giotto, he drew

all day in the sand. One day, Simone Vespucci, "podestà" of Monte Sansovino, saw the boy drawing and modeling in clay. Recognizing Andrea's talent, he sought to promote it. He then asked Andrea's father to let his son be trained in art, and Domenico "graciously granted his request." For a moment in Vasari's fiction Domenico's social status seemingly changes, for the humble tiller of the soil becomes courtly, responding "graziosamente." Did Simone Vespucci really take Andrea from his father, as Vasari claims, or was Vasari flattering the Vespucci family, with whom he lived when he first came to Florence, by presenting one of them as a wise connoisseur?

Vasari next pretends that Simone Vespucci placed Andrea with Antonio Pollaiuolo—an impossibility, for the latter had long before left Florence for Rome. Andrea's work and career are described with special emphasis on their classical subjects and style. Vasari tells us that Sansovino made portrait medallions of the emperors Nero and Galba based on classical models before he describes the sculptor's highly classicizing work in the vestibule to the sacristry of Santo Spirito. Speaking of its coffered vaulting, Vasari adds that he "heard from some old friends" of Sansovino's that the artist justified his practice in making the vault by saying that he followed the authoritative example of the Pantheon. The classical character of Sansovino's art, as we will see presently, is also related to his very public self and life as Vasari presents them.

Andrea prospered, Vasari writes, and was eventually able to build for himself a comfortable house in his "patria" of Monte Sansovino. He was now able to take a four-month holiday each year, enjoying a "most tranquil repose." He spent his time in agriculture and with his relatives and friends. Honored in his "patria," he acted prudently and discoursed well. A friend of learned men, he was a "philosopher" of natural gifts. In short, Vasari's portrayal of Sansovino is that of a learned patrician who, like the famous models of antiquity, like Pliny or Cicero, with whom he is implicitly associated, enjoyed a life of "otium" or leisure in the company of like-minded friends, cultivating his garden as well as himself. The extent of this classicizing of the self is seen in Andrea's choosing to name one of his three sons, "all'antica," Muzio Camillo. Himself a man of letters, Muzio was a humanist, whose death, Vasari writes, was a source of sorrow to his "family" and friends.

Sansovino's story is another example of the rise of the artist from

humble beginnings to prosperity and class. Indeed, as we have seen, his classicism, reflected in his art and culture, contributed to his status, giving definition to his very "class." A patrician, who enjoyed the "otium" of his country life, like the ancients at their country villas, he fathered a son, who reflected this culture. Sansovino thus brought glory to his family and "patria," for which he was appropriately honored.

The Extended Family of the Pollaiuolo

Recalling Vasari's fiction that Simone Vespucci placed Andrea Sansovino in the shop of Antonio Pollaiuolo (who was not in Florence at that time), we saw how Vasari imaginatively places the artist's formation in relation to that of an older master. Vasari followed this practice earlier, we further recall, when he claimed that Pollaiuolo had first trained under the shadowy Bartoluccio Ghiberti at the Baptistry. As we look retrospectively through the *Lives*, we see how Vasari weaves his imaginary "lives" into a seamless whole: Bartoluccio begat Pollaiuolo who begat Sansovino. Vasari later tells us that Andrea Sansovino in fact trained Iacopo Tatti, who took Sansovino's name. Becoming himself a patriarch of art, above all in Venice, Iacopo Sansovino took his place in this fictionalized genealogy of art. Vasari could thus see Iacopo Sansovino's splendid bronze doors at San Marco as descending through the family of art from the work of the quasi-mythic Bartoluccio at the Baptistry.

Pollaiuolo is a key figure in the emergence of the delightful character of Cronaca, or so Vasari imagines. Born Simone del Pollaiolo, Cronaca worked on the Palazzo Strozzi and later in the great "salone" of the Palazzo Vecchio, the hall completed by Vasari himself. Cronaca is remembered as a partisan of Savonarola's, the very patron of the great hall in which Cronaca worked. Cronaca took his name, Vasari says, because he was a good talker, a good "chronicler" of all the marvels that he had seen when he went to Rome.

Why did Cronaca go to Rome in the first place? Vasari pretends that Cronaca (that is, Simone di Tommaso del Pollaiolo) was a relative of

Antonio Pollaiuolo, who was then at work on the tombs of Saint Peter's, and that Simone, fleeing from Florence on account of a brawl, went to Rome to visit his "relative." As a result of his trip, Simone was inspired by the antiquities that he saw there and of which he took measurements. Thus, he returned to his "patria" as a "chronicler" of the marvels of Rome. The story allows Vasari to imagine Simone's formation as an artist in the classical tradition. He takes advantage of the fact that Simone's name is Pollaiolo, letting him claim that he was a relation of Pollaiuolo, though in fact he was not at all related to his illustrious namesake. Vasari's make-believe extension of the family of Antonio Pollaiuolo into a larger clan, including Simone, is consistent with his knowledge of the actual extended families of art—for example, that of the Ghirlandaio.

Because biography is for Vasari inseparable from family history, he also mentions that Cronaca had a brother, the short-lived Matteo, who was a talented sculptor, trained under Rossellino. There is a certain pathos in Vasari's notice of Matteo, who, dying at the age of nineteen, never finished any work. This reference to Matteo comes after Vasari's quotation of an epitaph by Giovanbattista Strozzi for Cronaca: "I live for thousands and thousands and thousands of years still, on account of my living palaces and churches; beautiful Rome will endure, thanks to me, in the soul of Florence." Vasari's allusion to Matteo's early death after the celebration of Cronaca's immortality is pointed, decidedly elegiac in tone. It puts us in mind of all those other artists mentioned by Vasari who died in their youth before they could realize their talents. Although only briefly mentioned, Matteo joins Simone as part of the imaginary family of Antonio and Piero Pollaiuolo, thereby extending an illustrious family in art.

The Ill-Fortune of the Peruzzi Family

Vasari's *Lives*, like all lives, moves between fortune and ill-fortune— whether the glory of Cronaca, whose works will endure for thousands of years, or the sad, early death of his brother Matteo. The biography of Baldassare Peruzzi is the story of both extremes, for, although he

achieved glory, which Vasari compares to that of Homer, both he and his family suffered much bad fortune. The life of his father Antonio, a "noble citizen of Florence," is a prelude to the tribulations of Peruzzi's own life. Harassed by the civic discord in his native Florence, Antonio fled to Volterra, but, when that city was sacked, he was forced to fly to Siena and live there in poverty, having lost almost everything he had. Not long after Antonio died, Baldassare took up painting, earning enough to maintain himself, his mother, and his sister.

The situation grew even worse, because although Baldassare went on to distinguish himself as an architect and painter in Rome, the ill-fortunes of war were visited upon him during the "cruel Sack" of Rome. Destitute and maltreated, he disguised himself as a prelate, but was unmasked by the "impious barbarians." He eventually slipped away from them and took ship to Porto Ercole and from there traveled to Siena. On the way he was robbed of everything and reached his "patria" with only his shirt. Honored and clothed by his friends, he then worked for the commune on the city's fortifications. Baldassare lived on in his native city, Vasari adds, raising two children. Peruzzi never prospered, however, because, Vasari claims, his patrons—popes, cardinals, and others—who should have been liberal were miserly. In his last years Baldassare lived in poverty, Vasari imagines, weighed down by his family. Although Vasari tells us of Peruzzi's many important works, which brought glory to him, he sets Peruzzi's accomplishment in relief against the misfortunes of financial hardship and war, above all the Sack of Rome.

Did Antonio's life of war and poverty really parallel his son's or did Vasari invent it in order to enhance the story of Baldassare's own bad luck and financial strain? Were Peruzzi's financial problems really as severe as Vasari imagines? It is particularly worth noting that Vasari dwells on the bad fortunes of all those artists caught up in the horrors of the Sack of Rome, no doubt to magnify what was in fact a horrible event. Vasari, as we will see when we consider these other artists, makes the Sack the central event in lives that were filled with ill-fortune. Peruzzi's life, as Vasari pictures it, ends with great pathos. When Peruzzi fell ill, Paul III, recognizing that he was losing a great man, sent Peruzzi a present of one hundred "scudi." The present came too late, and Peruzzi died, "very unwilling to give up his life, more on account of his poor family than for his own sake." So ends the doleful story of an artist who, Vasari says, was "much lamented by his

children and friends." So ends the story of an artist of virtue, whose life was filled with misfortune. Peruzzi's story, as Vasari presents it, is also the history of the suffering of an entire family—from the hardships of Peruzzi's father through the sorrow and poverty of Peruzzi's children.

The Sack of Rome and Family Turmoil

All those artists, including Peruzzi, who were in Rome during the Sack—Rosso, Parmigianino, and Polidoro—not only suffered there but eventually met cruel or unfortunate ends. Rosso, who was gentle of manner, handsome, well spoken, and gracious, was imprisoned during the Sack and maltreated. Vasari gives us a vivid image of "poor Rosso," stripped of his clothing, imprisoned, and enchained in weights. The artist managed to escape, but his life continued to be one of bad luck. He was forced to flee from Tuscany after a brawl with priests and, although he went on to distinguish himself in France, he falsely accused a fellow artist of robbing him and, for this, he was in turn charged with making a false accusation. Not able to clear himself, his honor stained, Rosso took his own life—or so Vasari says.

Similarly, Parmigianino's "virtue" was not enough to overcome the downward turn of the wheel of fortune. Like Peruzzi, he lost his father during his youth. Raised by his uncle, also a painter, Parmigianino became a young man of good manners and piety, a "uomo cristiano e civile." Like the young Rosso, he was gracious and courteous, "gentile e grazioso." Like Rosso, he was also unfortunately a victim of the Sack, taken prisoner by soldiers who forced him to pay a ransom of the little money he had. His uncle, grieved by this news, came to Rome in order to bring him back to Parma. If the story of Rosso makes no reference to family, the biography of Parmigianino is one of family loyalty. Again, like Rosso's life, that of Parmigianino after the Sack was filled with bad fortune. His companion Antonio da Trento robbed him of all his engravings, woodcuts, and drawings and, although Parmigianino recovered the prints, he never saw the drawings again. Parmigianino was betrayed by a fellow artist, who should,

according to Vasari's ideals of "fratellanza," have demonstrated brotherly love.

Parmigianino's last years were very grim. Vasari adopts the fiction that the painter turned to alchemy, neglecting his art. (No doubt this fiction, "true" to the artist's work, depends on the use of gold in his work at the Steccata and on the distinctive golden tonalities of his panels.) Vasari dwells on Parmigianino's decline, portraying an artist once "gentle" and "delicate" who became "a savage man."

Vasari's gallery of star-crossed artists who suffered during the Sack includes the portrait of Polidoro. Working in the "age of gold," revived by Pope Leo X, Polidoro collaborated with his companion Maturino, making works "all'antica." All their facades, filled with friezes, trophies, triumphs, and classical myths, seemingly re-created Rome in its former glory. Polidoro and Maturino decided, like brothers, to live and die together. They were the modern equivalents of Romulus and Remus, the founders of a new Rome. Then came the Sack, and, "like thousands of friends and relatives," Polidoro and Maturino were separated from each other. The separation of these "fratelli" in art stands for the more general chaos of the "family of art." As brothers, Polidoro and Maturino belong to those families, including Peruzzi's and Parmigianino's, deeply affected by the catastrophe of the Sack.

Fleeing Rome, Polidoro next took the road to Naples and from there went on to Palermo. Although he later wanted to return to Rome, Vasari says, he remained in Sicily on account of his love for an unnamed woman. Then an assistant, who loved Polidoro's money more than his master, had him strangled and stabbed while he slept. The assistant next went to the house of a certain count, who was a friend of Polidoro's, and told him, as if innocent, of this heinous crime. This fiction, a variation on the tale of Castagno's murder of Veneziano and of his contrived "false piety," also puts us in mind of how Parmigianino was betrayed by his companion Antonio da Trento. Eventually, however, the assistant was himself the victim of fortune. Seized by the count, he confessed and was executed—torn with red-hot pincers and then quartered.

What is striking about the lives of Peruzzi, Rosso, Parmigianino, and Polidoro, all victims of the Sack, is the similiar pattern of violence and betrayal. Whatever the facts of each biography might be, Vasari fictionalizes these lives to bring out their common misfortune, consequent in all cases upon the "cruel Sack." The tale of Polidoro's murder

at the hands of his assistant is invented to form the antithesis to the fraternal love, before the Sack, between Polidoro and Maturino. Since the assistants of artists are supposed to be like loving sons to their teachers, the murder of Polidoro is a form of patricide. This harrowing account of murder poetically embellishes the story of the interruption of friendship resulting from the dissolution of society brought about by the Sack. The story of Polidoro's murder prompted by greed is also keyed to the account of Polidoro and Maturino sharing their money. The "commune concordia" of these two artists stands for the ideal community of artists during the "age of gold" before the Sack, which, Vasari says, was prompted by "invidia." This earlier community has its antecedents, we recall, in the community of Florentine artists Masaccio, Brunelleschi, and Donatello, and earlier still in the loving brotherhood of Cimabue, Tafi, and Gaddi. Vasari is forever placing the catastrophes of the present in relation to such love and "concordia" of the past. He pictures this "concord" in the trecento fresco of "faith," attributed to Simone Martini, envisioning its eventual rebirth in his own Accademia del Disegno.

After the Sack, as Vasari later says, Rome remained dormant for some time, for there was little work there in the wake of such destruction and disruption of society. Vasari's biographies, based on facts but always spruced up rhetorically, are attempts to explain artistic decline. These biographies, as we have seen, are inseparable from family histories—both real and imaginary, both real and metaphorical. They recall Vasari's history of the rise and fall of the Gaddi family, as an attempt to explain the general rise and decline of trecento art. Vasari's fictionalized biographies, still often taken too literally, are so powerful as to have played no small role in the subsequent arthistorical view of sixteenth-century art—a historical view that has ignored the high degree of rhetoric and sheer artifice that inform Vasari's stories.

Sarto's Heartless Wife

In Vasari's colorful history, the Siege of Florence takes its place along with the Sack of Rome as a catastrophe of enormous magnitude. The effects of the Siege are felt throughout the *Lives,* for Vasari is forever

noting with great pathos all those works damaged or destroyed during its barbarous assault. The Siege plays a particularly important, indeed fatal, role in the life of Andrea del Sarto, which is the story of an artist and his cruel wife.

Sarto's wife, thanks to Vasari, is legendary. She stands with Shakespeare's Kate as one of the great shrews in history, but, unlike Kate, she was never tamed. Sometimes historians have sought to correct Vasari's distorted view of her, but to do so is to miss the point. Not unlike Vasari's Castagno, Lucrezia is a fictionalized character in Vasari's historical novel. She tells us a great deal about Vasari's view of women. As we have already seen, Vasari dwells on the tension between the artist's professional ambitions and his family responsibilities. It is no accident that he puts into the mouth of Sarto's companion Franciabigio the words, "He who takes a wife takes on troubles and suffering," for this is the exaggerated point of Vasari's cautionary tale of Lucrezia.

Very imperious, "imperiosissima," Lucrezia is a domineering figure. She urges Sarto to disregard his pledge to the King of France to return to France, where the artist had been flourishing. Repudiating his vow, Sarto is thus dishonored. Sarto then squanders the money earned during his time in France, and there is in Vasari's account the suggestion of his wife's contribution to his prodigality—a suggestion taken up in Browning's poem, which revivifies Vasari's portrayal of the fictionalized Lucrezia. Sinking from "the highest rung of the ladder to the very lowest," Sarto passed the time as best he could. Vasari's psychology of Sarto is bound to his interpretation of the painter's art, for he associates Sarto's timidity when confronting his wife with the lack of "fierceness" and "ardor" in his painting.

Sarto's biography is ultimately tied to the lives of those artists deeply affected by the Sack of Rome, since the course of his life was similarly determined by the Siege. The soldiers stationed in Florence during the barbarous attack on the city brought with them an infection, Vasari says, which Sarto contracted. Living an unregulated life, Sarto died from the disease. Some say, Vasari adds, that Sarto died without anybody knowing about his demise, since his wife stayed away from him, fearing the plague. There is in this description the sense that Sarto died not only because he did not look after himself but because his wife did not do what a wife should have done—that is, minister to her husband. It is the final image of a wife who stands

apart from the countless individuals who exhibit piety, devotion, and love of family in the pages of Vasari—the final image of a heartless wife.

Noble Wives

Sarto's wife has her antithesis in Margherita Acciaiuoli, whom we encounter in the life of Sarto's disciple Pontormo. When Vasari describes Sarto's death during the Siege, he mentions the capture of Giovanbattista della Palla. We often find Della Palla in Vasari's account of these years, above all in the life of Pontormo. Sarto had made paintings of the story of Joseph for the bed of Pierfrancesco Borgherini, and Pontormo contributed to this project. In his life of Pontormo, Vasari describes Margherita defending all of these paintings from Della Palla, who wished to despoil the bed by selling its paintings to the King of France.

Although I have previously written in some detail about Margherita, I want to focus on her again, now in the context of Vasari's family history. The paintings she defends illustrate the story of Joseph and his brothers, who are the tribes that are the nation of Israel. The artist's patrons, themselves patricians, are identified with biblical patriarchs. The paintings are part of the patrimony of the family and the "patria." Painted on and in proximity to a bed, they refer to the perpetuation of family and state.

In a moving, powerful, and heroic speech, the noble Margherita defends the bed and the honor of her father-in-law and husband against the greedy villain, whose desire to sell it is part of the very Siege of Florence. A modern Penelope and Lucretia, she says that she is willing to shed her very blood to protect the bed of her fathers and husband. Her noble speech (quoted in full and discussed in *Why Mona Lisa Smiles*) is exemplary of the bravery of a Florentine wife and daughter defending the honor of family and state. The heroic dignity of Margherita defending her bed (and the paintings on it) stands in marked contrast to the portrait of the imperious, selfish, heartless, and greedy wife of Sarto, who had himself contributed importantly to the bed.

Although on balance Vasari is suspicious of wives and their treacher-

ies or of the pressures they exert on painters, he presents one other instance of a truly noble wife. I am speaking of the rather obscure, probably imaginary, wife of Cola dell'Amatrice. Vasari tells us that this painter was living happily with his good wife of "honored family," "endowed with singular virtue," when, during a siege, they were pursued by soldiers. Seeing no other way of saving her "honor" and her husband's life, she jumped from a high precipice to her death. At this, the soldiers left off their pursuit of Cola, whose life was spared thanks to his wife's sacrifice. Nonetheless, after her death, the painter lived unhappily ever after. As Vasari says, this unnamed woman is worthy of eternal praise, "degna d'eterna lode." Almost in the manner of ancient history (and surely this story is fiction), she sacrificed her life for her painter-husband. Her selflessness and heroism, linked to Margherita's, reminds us again of the antithetical Lucrezia, who selfishly and heartlessly left her husband to die by himself.

Family Trees and Tribulations of Verona

One of the most interesting, if cumbersome, parts of the *Lives* is the "Life of Fra Giocondo and of Other Veronesi," a series of nearly two dozen biographies packed into one "vita." It is Vasari's attempt to bring together the biographies of almost all the principal artists of a city by writing a compressed history of its art. His references range from Stefano da Verona (whose life he previously recounted) to Paolo Cavazzuola, from Fra Giocondo to Falconetto.

This "vita" is one of those biographies in the *Lives* that becomes a list or catalogue—not only of artists and their works but also of writers or literary figures related, either directly or indirectly, to these artists. Poliziano, Scaliger, Sannazaro, Fracastoro, and Budé are among the well-known literary figures mentioned here. A library of the works by these and other authors mentioned in relation to the Veronese artists, including Calderino and Paolo Emilio, would give the reader a substantial knowledge of Renaissance humanism. Vasari's point here, as elsewhere, is to show the close relations of artists to literati.

Vasari observes that the location of Verona is very similar to that of

Florence. Playing on words, on the floral implication of Florence, as he always does, he adds that many "beautiful geniuses" flourished ("son fioriti") in Verona as in Florence. His compressed history of Veronese art is like that of Florence—a history of artists' families and, in a few cases, of their tribulations. First let us briefly note these family relations, then their occasional troubles.

Vasari is forever going back to Stefano da Verona, the "pater patriae" of Veronese painting. In the life of Falconetto, he says that Stefano had a brother named Giovanni Antonio, also a painter, who had a son, the painter Iacopo, whose sons, Antonio and Giovanmaria (Falconetto) were also artists. Giovanmaria, in turn, had two sons who were artists, Ottaviano and Provolo. We also learn that Liberale da Verona taught Giovanfrancesco Caroto, whose brother Giovanni, also a painter, "followed the style" of Giovanfrancesco. Liberale's other protégé, Francesco Torbido (more about whom presently), had a son Battista del Moro, who was similarly a painter. One of the major families of Veronese artists is that of the Monsignori. Francesco, who was encouraged to pursue his art by his father, a dilettante painter, had three brothers, two of whom were painters: Fra Cherubino, a miniaturist, and Fra Girolamo, a "reasonable" artist. The Morone are another such family of artists. Domenico, said to have learned his art from disciples of Stefano, had a son Francesco, whom he trained as a painter. Francesco was like a "brother" to Girolamo dai Libri, the miniaturist, who was trained by his own father, Francesco Vecchio dai Libri.

Whereas Vasari speaks of these artists living, for the most part, "happily" or "without trouble," there are exceptions. He tells us, for example, that Francesco dai Libri was drawn away ("sviato") from the path of art by his mother's brother, a very rich man without sons, who brought him to Vicenza to attend to his glass furnace. Unfortunately, Francesco spent the best years of his life in this business, losing the chance to succeed in his art. In the meantime, when the wife of his uncle died, his uncle remarried and had children of his own, and so Francesco did not even become the heir to his uncle's estate, as he had expected.

Even more bitter perhaps is the story of Liberale da Verona. When he was eighty-four years old or older (is Vasari not exaggerating again?), Liberale placed himself in the care of his relatives, particularly of his married daughter, who (sharper than a serpent's tooth)

treated him "very badly." Despite the pathos of filial betrayal, the story has a reasonably happy ending. Liberale took things into his own hands, placing himself in the care of his protégé Torbido, who was devoted to him. Liberale went to live with Torbido, to whom he left his house and gardens, choosing to leave his property to one who loved virtue rather than to those who treated their next of kin badly. Forever moralizing, Vasari here rewrites the tale of Donatello's giving his property to a man of virtue rather than to greedy, undeserving relatives. These family stories may be fictions, but they are based on the facts of family life. If make-believe, they are true to life.

Perino del Vaga: Orphan and Father

Vasari's history of Veronese art as a series of closely related family histories is a reflection of the reality of Italian art history—that is, art, like other crafts and trades, remains in the family. Fathers teach their sons, older brothers train their younger brothers. The architect Baccio d'Agnolo, whose life precedes that of the Veronese artists, trained his sons Giuliano and Domenico. Although Giuliano enjoyed a distinguished career, the life of his younger brother was cut short. With characteristic pathos Vasari concludes that if Domenico had not died so early, he would have surpassed both his brother and his father.

The life of Perino del Vaga is the story of both extreme misfortune and great success. His is one of those lives notable for the absence of fathers. It resembles the life of the orphaned Lippi and has affinities with that of the fatherless Piero della Francesca. If Piero was eventually vindicated by a metaphorical father, Perino was, as we will see, also succored and protected by a double metaphor, both father and mother.

Born of a "poor father," Perino was "abandoned" as a child, but he was governed and guided, Vasari says, by the "virtue" of his art. Perino's story is a dramatic account of ascendancy from humble beginnings or "bassezza" to the "summit of greatness," for he eventually achieved a great name on account of his works. Perino was the son of a soldier, Giovanni Buonaccorsi, who fought, Vasari imagines, in the

time of King Charles VIII of France. His mother died of the plague when he was just two months old, and he was taken in great misery to a farm, where, Vasari says in a mythologizing mode, he was suckled by a goat until his father returned for him. Having taken a second wife, whose husband and children had also died in the plague, Perino's father left him with relatives because he lacked the means or the will to accept the burden of raising his child. Perino was then placed with an apothecary in the hope that he would learn that trade, but, not caring for it, he was taken as a shop boy to the painter Andrea de' Ceri. So began Perino's career in art.

Although Perino would eventually achieve great success in Rome and elsewhere, his life was not without continued difficulty. Having taken as a wife the sister of the painter Penni, he found himself and his family among the "infortunati" during the Sack of Rome. Caught in the turmoil, he ran from place to place with his wife, who held their baby in her arms. Seeking to save his family from the conflagration, Perino was like a Trojan during the Sack of Troy—a not implausible connotation of his tribulation, given that his future success is associated with his paintings from the *Aeneid* for Andrea Doria. Eventually, Perino was captured (joining, in a sense, Rosso, Peruzzi, Parmigianino, and Polidoro, who supposedly suffered similar fates during the Sack of Rome), and he had to pay a ransom to secure his release—or so Vasari says. After putting his affairs in order, Perino left his wife in the care of his relatives in Rome before traveling to Genoa, where he distinguished himself in the employ of Andrea Doria.

Perino became, Vasari insists, one of the "universal painters" of his time. Indeed, Vasari continues, "one can say that he has been the father ('il padre') of these most noble arts, his virtue residing in them." Speaking of Perino as a father in art, Vasari evokes Perino's humble beginnings when, abandoned by his own father, he was fatherless. Vasari says that Perino's "virtue" lived in the noble arts, and we recall Vasari's earlier assertion that when Perino was abandoned by his parents he was guided and governed by the "virtue" of his art, which he always recognized and continuously honored as his "true mother"—"legittima madre."

The pathos and glory of Perino's life are also part of the larger story of the clan of Raphael, for (as we noted) Perino married the sister of Giovanfrancesco Penni, his companion in Raphael's shop. Achieving "parentado" with Penni, Perino also found a father in Raphael, who

loved Perino "like his own son." The previously abandoned Perino served his new father-in-art "with obedience"—that is, as a good son. Despite the downward turn of the wheel of fortune—abandonment in infancy and hardship during the Sack—Perino rose to become, like the patriarchal Raphael, a great father in art. He did so thanks to his "true mother," virtue. Perino's life story, a legend of sorts, is one in which the metaphors of paternity and maternity loom large. It is yet another of Vasari's stories of the ideal family of art.

Domenico da Prato as Penitent Son

Journeying deeply into Vasari or down certain paths that lead away from the central story of art, we encounter some touching family histories. Take, for example, the case of Niccolò Soggi, who was loving to all. Vasari should know, because he tells us that Niccolò showed him great kindness, influencing patrons to turn a commission over to the young Vasari, who needed it more than Niccolò did. Niccolò kept in his house Domenico Zampalocchi da Prato, whom he trained with much love. When he approached old age, he hoped that Domenico would return to him in his final years what he had given Domenico with so much love and effort. But this is not how things turned out.

In another tale of great pathos, Vasari tells us that Domenico went off to Milan, where he prospered, becoming very rich. When he received news of Domenico, Niccolò was old and needy, without work. He then went to Domenico, hoping that Domenico would help him in his old age and misery, as he had helped Domenico in the latter's youth. He hoped in particular that Domenico would avail himself of his services. Instead, he discovered that expecting too much from others we are deceived, for when the conditions of men change, so often do their temperament and will. "Oft expectation fails," as Shakespeare wrote, "and oft there where most it promises." When Niccolò arrived in Milan, he found the exalted Domenico and told his former student of all his difficulties, beseeching Domenico to help him by hiring him. Not remembering or wanting to remember with what loving kindness he had been treated by Niccolò, "as if he

were his own son," Domenico gave Niccolò a miserly sum of money and got rid of him as soon as he could. The story concludes painfully, for Niccolò returned to Arezzo full of heartache, seeing that the boy whom he raised with great labor and expense as his own son was now little less than an enemy.

The story does not quite end here, however. After describing the death of Niccolò, repulsed by one who should have helped him, Vasari returns to the story of Domenico. The latter returned to Prato from Milan, but, not finding relatives or friends, he repented of having behaved ungratefully to Niccolò. His greed and cruelty were now transformed into love and charity, and Domenico left to his native city ten thousand "scudi" to establish a fund with which a number of students could maintain their studies. In gratitude for this devotion, the city fathers placed in the Council Chamber of Prato the image of Domenico, who was worthy of eternal remembrance. Having learned from his sinfulness toward his "father" Niccolò, Domenico became, in the end, like his "father," one who helped others. Once again Vasari writes a parable, the story of conversion and charity. The story of a metaphorical family—of father and son—becomes part of the history of the artist's "patria," in this case Prato.

Pierino da Vinci and the Family of Leonardo

In the life of Pierino da Vinci, Vasari speaks of the fame of the young artist, of the reputation of his very name. Having executed a number of important works, Pierino died after being exhausted and broken by a sea voyage. He had barely reached the age of twenty-three. In the sonnet by Benedetto Varchi with which he concludes Pierino's life, Vasari speaks of the "secondo Vinci."

In the elegiac "proemio" to Pierino's life, Vasari says that an artist should not be deprived of praise just because he died in the first bloom of life. Vasari's manner of magnifying Pierino's glory is, not surprisingly, through the artist's distinguished relative, Leonardo. He begins by telling us that in the town of Vinci there lived Piero, father to the most famous of all painters, Leonardo. Piero also had a son

named Bartolomeo, who, when he had grown to manhood, was desirous of having a male child. Bartolomeo often spoke to his wife, Vasari imagines, of the great genius of his brother Leonardo, praying to God that he should make her worthy of bearing "another Leonardo." Soon after this imaginary conversation a child was born. Bartolomeo wanted the boy to be named Leonardo, but his relatives recommended that the child be named after Leonardo's father, Piero. Perhaps evoking the beauteous Leonardo, Vasari says that the young Pierino had a beautiful countenance. Vasari then says—and is this not another of his dramatic fictions?—that the astrologer Giuliano del Carmine and a priest, expert in chiromancy, came to Bartolomeo's house and, after examining the child, both pronounced upon his genius and predicted that his life would be short. (As Perino del Vaga suckled by a goat evokes baby Jupiter, so does the prediction of Pierino's early death suggest Achilles.) The young Pierino demonstrated in his first works the genius that had been foretold, and Bartolomeo concluded that his prayer to God had been heard. He believed that his brother had been restored to him in his son. Thus ends the introduction to the short life of Pierino, whose glory is enhanced by association with his illustrious uncle—kept in our memory by Vasari's account of Leonardo's brother praying to God for a son of Leonardo's genius.

There is one other aspect of family history touched upon in the life of Pierino, and it should not be passed by too quickly. It is not a detail from Pierino's own life—rather a reference to the notorious family story that is the subject of one of his best-known works. I am speaking of Pierino's relief depicting the death of Count Ugolino and his sons, made after some suggestions of Luca Martini, who wrote a commentary on the *Divine Comedy*. The very mention of this famous subject from Dante should have sent a shudder through Vasari's readers, who would have been made to recall the horrible death by starvation of Ugolino's sons, who suffered along with Ugolino. Vasari revives his reader's memory of Dante's account by describing Pierino's relief, in which one son is already dead, while another, overcome by hunger, is near his end. Although Ugolino is in the bottom of hell for his betrayal of his "patria," he is shown, Vasari says movingly, "in a pitiful and miserable attitude, overcome by and heavy with grief, reaching over the pathetic bodies of his sons stretched upon the ground." It is a

scene to inspire pity in any reader—a classic scene of a father's grief over the death of a child.

The Death of Bandinelli's Son

Vasari, as we have observed, often comments on the pathos of a father losing a son, and he does so again in the life of Pierino da Vinci's teacher, Baccio Bandinelli. Baccio had a son whom he named Clemente, after the Medici pope who was his patron. Clemente was a gifted sculptor who helped finish "the works of his father." When Bandinelli made the sculpture of a *Pietà* for his own tomb, Clemente assisted him, executing, Vasari claims, the very figure of Christ. Bandinelli himself wrote in his memoir or *Memoriale*, as it has come to be called, "The Pietà for my sepulcher was made in part with the help of my son Clemente." Bandinelli does not specify exactly what Clemente did on the work. In any event, Clemente's participation in the preparation of his father's tomb was, we might say, an act of filial piety. Was Clemente in fact specifically responsible for the figure of Christ, as Vasari claims? Clemente no doubt helped his father with this figure, as with the entire work (as his father says), but why would Vasari associate the son with Christ? There is, I believe, an explanation.

Vasari relates that when Baccio saw that Duke Cosimo no longer wanted his service, he was filled with "great displeasure" and "sorrow." Both at home and elsewhere he became very "strange," treating his son Clemente "very strangely." For this reason—that is, the strangeness of his father—Clemente asked leave of the duke and left Florence for Rome. At the time of his son's departure, however, Baccio gave him nothing, even though Clemente had been a great help to him, being his father's right-hand man—"le braccia di Baccio." A short time later Clemente died in Rome and, as Vasari adds, the *Pietà* for his father's tomb was still unfinished. To see what Vasari is getting at, let us recall that Bandinelli portrayed himself in this work as the figure of Nicodemus holding up Christ's body. Vasari dwells on the fact that Clemente's death was a "great loss" to Baccio. By emphasizing Clemente's presumed sole responsibility for the fig-

ure of Christ, Vasari associates Clemente with Christ. In other words, Bandinelli in the guise of Nicodemus holds up the figure of Christ, who stands for his own dead son. Vasari implicitly turns the sculpture into a *Pietà* in which Baccio grieves the death of Clemente.

Baccio's *Pietà* is thus in family terms a double *Pietà*—that of his devoted son, who exhibited filial piety by assisting his father in making the sculpture of the Son of God, and that of Baccio, who now allegorically holds in his arms the body of the Son of God, who stands for his own dead son. The familial associations of the *Pietà* should remind us of Vasari's description of Raphael's *Entombment* (made to honor the death of a son)—in which the mourners are likened to a "famiglia." For Vasari and his contemporaries works of art infused with deep personal feelings of piety are not merely symbolic. When he says on occasion in the language of Dante that a work of art would move the hardest heart to pity, Vasari reminds us of such real feelings as he projects into the account of Bandinelli's *Pietà*, imagining the artist's grief at the death of his son. Contemplating Baccio as Nicodemus, holding the figure that stands for his son in his very arms, we come to see the pathos in Vasari's purposeful description of Clemente, who had been his father's very arms—"le braccia di Baccio."

Bandinelli's Father

Vasari's biography of Bandinelli is the story of three generations of artists, for just as Baccio trained his son Clemente, so did Baccio's father educate him in art. Bandinelli's father was in the service of the Medici, as Vasari's grandfather supposedly was, and, like Baccio's rival Michelangelo, Baccio's father (also named Michelangelo) was on terms of "familiarità" with the sons of Lorenzo il Magnifico. We are reminded once again of the ways in which the family histories of artists are intertwined with those of their "padroni" or patrons. In a certain sense, when Baccio named his son Clemente after his Medici patron Clement, he linked his family to that of the Medici, as if his Medici patron, the Holy Father, were a family forefather after whom a descendant was now named.

Baccio's father, Michelangelo, was a leading "orefice" or jeweler in Florence and, desirous of leaving his son heir or "erede" to his craft,

he took him into his shop. Baccio's impulse, however, was to work on a large scale—an ambition reflected, for example, in the giant snow-man he made in imitation of the ancient statue, *Marforio*. Eventually, Bandinelli's father, seeing "the desire of his son" to become a sculptor rather than a craftsman, changed his plan ("mutò . . . pensiero") and placed Bandinelli with the sculptor Rustici. Thus Michelangelo Bandinelli joined the company of the numerous other wise fathers previously lauded by Vasari for letting their sons follow their natural inclinations in art.

The biography of Bandinelli is one of the most interesting in the pages of *Lives* for its satire and for its reflections of the artist's rivalries with Michelangelo, Cellini, and Vasari himself. All these artists served the Medici family, assuming, in a sense, filial relations to their patrons. Vasari implies this relation when he says, speaking of the enmity between Baccio and Cellini, "As it happens that the potter is always the jealous enemy of the potter, and the sculptor the jealous enemy of the sculptor, Baccio was not able to suffer the favors shown to Benvenuto." The word for potter is "figulo," a word sufficiently close to "figliuolo" or son to remind us of the childish name-calling in the disputes between the two artists, Benvenuto and Baccio, before their "padrone" or "father" the duke. Both "figliuoli" turned to their "mother" as it were, when they went to the Duchess Eleonora, seeking her "matronage," we might almost say. The duchess favored Bandinelli, Vasari observes, and Cellini, writing in his *Autobiography* (more about which later), tells us a great deal about his dealings with the mother-figure Eleonora in the family of the court. Forever seeking the support of their patrons, forever envious of their rivals in art, such artists as Cellini, Bandinelli, and Vasari were like squabbling children—like "figuli" and "figliuoli" both.

We should not fail to note that Vasari's decision to compare Baccio's envy of Cellini to that of a "figulo" or potter who envies another potter may also have personal connotations, for Vasari, himself a fierce rival of Baccio's, who criticizes Baccio's work in the "salone" of the Palazzo Vecchio, is named after potters or "vasai." Perhaps Vasari, who plays on his name in the portrait of Lorenzo de' Medici with the emblematic inscription, VAS, implicitly associates himself, through his reference to pottery, with the rivals of Baccio?

In the end, after all the vicissitudes of his career, after all the triumphs and defeats, Baccio prepared his tomb in Santissima Annun-

ziata, where he put in place the *Pietà*, of which we have previously spoken. Baccio wished to be buried in his tomb, Vasari says, along with his wife and with the remains of his father, Michelangelo. This was the appropriate wish of an artist-son, devoted in piety to his artist-father.

Bandinelli's Father's Bones

Baccio's family story does not quite end with his preparation of the family tomb. Vasari says that, having built the altar of his family chapel, Baccio wanted to place the bones of his father in the tomb with his very own hands, whence it happened that either because he felt sorrow or shock in handling his father's bones or because he exerted himself excessively in transferring these bones himself, or for both reasons, he fell ill and died a few days later—after a lifetime perfectly free of illness. Just as Vasari implicated the story of Baccio's son's death in the story of the *Pietà* for the tomb, he now places his father's bones in the story of Baccio's own death. Indeed, Vasari is saying that Baccio was overwhelmed by filial piety or pity—that he died on account of the very depths of this piety. It is not beyond Vasari to fictionalize the biographies of his contemporaries. As in his "novelle" about the forefathers of art, he is poetically inventive in the lives of those artists whom he knew. Characteristically, he leaves us with a vivid, three-dimensional image of Baccio in his family chapel, holding his father's bones—stilled in grief for eternity. Baccio is like the figure of Nicodemus from the *Pietà* (in his own guise), holding the body of Christ (who in Vasari's account stands for Baccio's dead son); only now it is the remains of his father that Baccio holds. For all his hatred of Baccio, Vasari renders a vivid and moving account of the pathos of Bandinelli's family life.

Vasari records the epitaph to Bandinelli's tomb, which indicates that he was an "eques" or knight. In his own memoirs or "ricordi" Bandinelli dwells on his admission to the order of Saint James. This event is part of the larger story of Bandinelli's family's history and his place in it. Dictated to his son Cesare, Baccio's memoirs are a fascinating document that tell us a great deal about the "splendore della mia casa," the splendor of my house, as he boasts. We are given a full history of his noble family and of all his ancestors and immediate

relatives, an account that dwells on their nobility and accomplishments. For example, Baccio tells us that his uncle Giovanbattista, "a man of great valor," was for many years a soldier in the service of King Francis I and that his father entered into the "grace" of the Medici, serving them faithfully. Baccio is also proud to tell us that his wife Caterina was the daughter of Taddeo Ugolino, "nobile fiorentina."

Bandinelli occupies a central place in his own memoirs, of course, but his principal role, as he defines it, is that of restoring through his accomplishments the glory of his house. He writes in the eleventh part of the *Memoriale:* "Dear and most beloved sons, I pray that you keep in mind with no less fervor than that with which I have contrived to write this, the labors that your father endured to reacquire all that was lost over a century ago on account of bad fortune and the imprudence of your ancestors." Bandinelli's memoirs are very much a family history—the story of "la cura familiare della casa," the story of family responsibilities and sorrows as well as of triumphs. When he writes that he had many sons, some of whom are now dead, he mentions Alessandro, saying that tears come to his eyes, remembering his dead son, that he still carries the sorrow of his son's loss in his heart. His greatest loss, we recall, was Clemente, who was named after Pope Clement VII, whom Baccio served "as the son of old friends and servants of the house of the Medici." What finer way to memorialize such fidelity to the great Medici house than by giving the name of one of its most illustrious sons to that of one's child?

Vasari writes that Bandinelli left his sons and daughters many possessions in the form of land, houses, money, and drawings, which were still, he adds, in the hands of the family. (This is what Baccio meant when he wrote to his children of restoring his house— financially!) Bandinelli lists these holdings in his "ricordi," including "a beautiful house in the via de' Ginori," one at San Michele Visdomini, a house near the Pitti, another on the Renaio, a farm with an inn and fountain (with the family arms) called the Tre Pulzelle, a farm at San Gervasio called Malcantone, a farm near Remoli, two farms at Pinzi di Monte, etc. Bandinelli had done well in reestablishing his family financially, and he asks his children to remember "the great labors your father has undertaken to leave you in good state." Baccio is the modern equivalent of Vasari's Taddeo Gaddi, who had prospered and brought considerable wealth to his family.

In the long list of possessions left to his children, Bandinelli men-

tions his drawings (also noted by Vasari) and sonnets and the letters he wrote to and received from kings. These letters ennobled Baccio as similar letters ennobled Pietro Aretino. He also mentions a work on sculpture and "disegno"—oh, the pity it is lost!—called "Dialoghi con Giotto." After giving the full list of his writings, Baccio beseeches his children, by the very bowels of Jesus Christ ("le viscere di Giesù Christo"), that they show their obligation to him, their "benefactor," that they show the love they should have for their father, who has passed through the valley of miseries, by tending to his writings after his death, by transcribing and showing them to intelligent, literary persons. "Execute, therefore, this commandment of your father," he continues, asking them to "see that these writings are published." Finally, he begs his children to see that his tomb is completed, his *Pietà* placed there along with his family arms. He concludes by praying that God will bless his children on this earth, that they will be granted long, happy lives before returning to their "fathers" in heaven. Bandinelli is speaking of family "fathers" or ancestors, but, doing so, he reminds us of the "famiglia del cielo," the family of heaven of which Dante speaks—that divine family central to the hierarchy of Renaissance religion and art, presided over by "Dio Padre."

Bandinelli's memoirs are a mirror image of Vasari's account of artists' families. These memoirs not only show us that Vasari's fictionalized biography of Bandinelli is true to the artist's sense of family, but they help us to see that Vasari's sense of family is typical of the epoch in which he wrote. All the fictions in Vasari's biographies concerning families present and families past, concerning real families and imaginary families, concerning mythological and divine families, are born of the deep sentiments of devotion to one's house, of filial piety that men like Vasari and Bandinelli felt as they contemplated the bones of their fathers.

Bugiardini and the Memory of the Rucellai

The story of filial piety is sustained in the life of Giuliano Bugiardini, a close friend of Michelangelo's on terms of "familiarità" with the great

artist. Bugiardini's life affords Vasari an opportunity to return to the catastrophe of the Siege of Florence, which deeply affected the lives of all in the city at the time. We have noted only a few cases, in the lives of Sarto and Pontormo, of how Vasari registers the horrors of the Siege, but to read the entire *Lives* is to see the continuous, sustained references to this catastrophic event and its devastation.

Vasari says that, before the "assedio" or Siege in 1530, Florence had grown to such a degree that there were many citizens living in "borghi" outside the city gates. Filled with churches, monasteries, and hospitals, they formed another city, inhabited by many honorable persons and good craftsmen of all kinds who, less wealthy than those in the city, lived with fewer expenses and taxes. It was in one of these "borghi" outside the gates of Faenza that Giuliano Bugiardini was born. He lived there as his ancestors had done, Vasari says pointedly, until all the "borghi" were destroyed during the Siege.

After observing that Bugiardini studied in the Medici gardens, where he trained along with Michelangelo, Vasari tells us of the work done during the Siege. It was the custom before the Siege, Vasari says, at the burial of the dead, for good families to carry in front of the bier a string of pennons fixed around a panel that a porter bore upon his head. These pennons were afterward left in the church in memory of the dead in the family. When the aged Cosimo Rucellai died, Vasari continues, his sons Bernardo and Palla desired to have something new done in this fashion. (Vasari's account is jumbled, since Palla was the brother of Cosimo and both were the sons of Bernardo. But no matter.) The Rucellai sons wanted, instead of pennons, a large banner (four or five "braccia"), with pennons at the bottom containing the Rucellai arms. This banner with four large figures of Saints Cosmas, Damian, Peter, and Paul was the work of Giuliano and it was, Vasari insists, "truly beautiful."

Vasari's account is historically interesting for its references to the Siege. It is also significant as a description of another kind of memorializing, that of ephemeral art, like the wax portraits from Verrocchio's shop, which is part of the larger history of art, even though it no longer exists. The memorial banners are part of Vasari's story of how family members, in this case sons, left memorials of the dead of their families in churches—"per memoria del defunto della famiglia." In this case (although Vasari does not quite have the names straight), it is the Rucellai whose memory is preserved. Vasari helps to preserve

their family name by describing Bugiardini's work for them. It was the general practice of patricians in Florence to honor their families in chapels, tombs, altarpieces, portraits, and other works, of which the nearly forgotten pennons are a further example. Such family piety is the context in which Vasari celebrates the devotion of artists to their own families.

Pontormo and the Family of State

In the life of Pontormo, Vasari describes another of those lost funerary works, like Bugiardini's, through which members of the family honored the dead, including themselves. He tells us that Bartolomeo Ginori, anticipating his own death, commissioned Pontormo to paint a string of pennons, according to the Florentine custom. In the upper part of this work on white taffeta, Pontormo painted the Madonna and Child, along with the arms of the family, in the usual manner. At the center of more than twenty-four pennons, he made two of white taffeta, on which he painted figures of Ginori's name-saint Bartolomeo, each two "braccia" high. Vasari claims that this work was of extraordinary size and was the source of similar works made to these dimensions in his own day. Contemplating the history of Florentine art as fully as possible, we need to envision the cold, dark churches of the city filled not only with splendid frescoes and altarpieces and richly ornamented tombs but with brightly colored pennons—now all gone, alas—which were family memorials to their dead.

There are broader senses, as we have seen, in which Vasari speaks of the "family." He says that Pontormo painted for the nuns of Saint Anne at the Porta di San Friano a painting of Mary and Saint Anne with saints, the "predella" of which showed the "Signoria" of Florence as it used to go in procession with trumpet players, fifers, mace bearers, messengers, ushers, and the rest of its household, or what he calls "famiglia." This communal family is seen in relation to the Holy Family presided over by the matron saint of the city, Saint Anne. Pontormo made this painting, Vasari says, because this commission was given to him by the captain and "famiglia" of the palace. The history of Florence is, as historians teach us, the history of the political power and patronage of individual families united through mar-

riage. Vasari reminds us, however, that these families are united in the state, which is described as itself a "family"—for all the members of the household of the palace are the family of the state, to which all of the families of the commune are tied.

Fraternal Love in Vasari's Family

From biography to biography the features of Vasari's subjects are delineated in such a manner that their portraits, characters, and lives are inseparable from the stories of their families. It is the exceptional biography that contains no family history, real or imaginary. Family history is particularly important in Vasari's life of Cristofano Gherardi—a strange character, an eccentric, who, even if not well known today, is one of the most lovable figures in Vasari's pages.

I have already retold elsewhere several of the stories Vasari tells about this delightful eccentric, who was comically notable for his indifference to clothing. Cristofano was a disciple of Vasari's, and our biographer tells us that he treated Cristofano as if he were a brother— "se fusse stato suo fratello." Cristofano worked under Vasari's direction with a certain Stefano Veltroni dal Monte Sansovino, a "parente" or relative of Vasari's. (In fact, he was Giorgio's cousin.)

It is not Vasari's cousin, however, with whom we are concerned; rather, it is of Cristofano whom we must speak, the man who was like Vasari's brother. Vasari says that when Cristofano's true brother Borgognone died, Cristofano had to return to Borgo San Sepolcro. Vasari, who had kept most of Cristofano's salary for him, said, "I have your money; it is right that you take it and use it as you see fit." To this the good-hearted Cristofano replied, "I don't want the money, take it for yourself; it is enough for me to be fortunate enough to be with you, to live and die with you." Cristofano shows here his usual affection and lack of interest in things material. The dialogue continues. Vasari tells Cristofano that it is not his custom to profit from the labor of others. "If you will not take it," he insists, "I shall send it to your father." To this Cristofano replies, "you must not do this, for he would only waste it as he always does." After all Vasari's portraits of highly responsible and noble fathers, we encounter a father who squanders

his money. No doubt there were other such fathers of artists or other family members whose vices are otherwise obscured in Vasari's generally idealized portrayal of artists' families.

In the end, Cristofano took the money and went off to Borgo San Sepolcro, but he was in poor health and felt such sorrow at the death of his brother, whom he loved greatly, that he took ill and died a short time later—having distributed his money to his family and to the poor. So died an artist whom Vasari loved like a brother, an artist who died in part on account of the grief he experienced at the death of his real brother. If Cristofano did not exhibit the kind of filial piety that we associate with Vasari's artists, not wanting the money for his father, he does exhibit the typical devotion of one brother to another, both in his love of his real brother and of Vasari, to whom he was like a brother. With the vivid image of Cristofano's grief at the death of his own brother, a grief that supposedly hastened his own death, Vasari holds before us once again the ideal of fraternal love.

Contemplating such fraternal love and the numerous other examples of such love that we have previously found in the pages of Vasari's book, we do well to recall once again the broader social and religious ramifications of "fraternitas," the ideal brotherhood of the Apostles (as of Peter and Paul), of saints (Francis and Dominic), of the "frati" who make up the church, not to mention the fraternity of citizens in "fraternità," who contribute to the "famiglia" of the commune by giving to the poor, as Cristofano did. Such giving is not only civic but also is deeply religious, for it is charity, the demonstration of Christian love or brotherhood. The fraternal love between artists, as between Cristofano and Vasari himself, illustrates Vasari's larger vision of the ideal community of artists, one of "fratellanza," in which all envy and discord are purged. In such fraternity we cannot distinguish the civic from the religious, for Vasari envisions the commonwealth of art as the mirror image of the City of God.

The House of Genga and the Court of Urbino

The close relations of family to state are further delineated in Vasari's portrayal of Urbino and its artists. Urbino, we recall, is the city of Giovanni Santi, his son Raphael, Raphael's "relative" Bramante, and Raphael's protégé Timoteo Viti. Raphael became a princely figure, presiding over an extended family of artists as if he were a prince, the dominating figure in a court, like the very courts he served, both in Urbino and in Rome. Vasari extends this history of Urbino—as the intertwined stories of ruling families and artists' families—in the life of Girolamo Genga. Before we turn to the details of the artist's life, let us note that Vasari speaks of the "amicizia" or friendship that unites him and Genga's son, Bartolomeo, who was also an artist. If we had a "scudo" or "fiorino" for every artist to whom Vasari was united in friendship or fraternal love, we would have enough money to rebuild the Palazzo Vecchio stone by stone.

Now for Genga's story. Having worked with Timoteo da Urbino in the time of Duke Guidobaldo, Girolamo left for Rome, but after Guidobaldo's death, Francesco Maria, Duke of Urbino, ordered Girolamo to return to his native city. At this time the duke married Leonora Gonzaga, daughter of the Marquis of Mantua, and he required Genga to undertake the decorations necessary to make Urbino seem a "Roma trionfante." This work brought Genga great honor, but when the duke was exiled, going to Mantua, Girolamo, along with the exiles, left Urbino to seek his fortune, taking his family with him to Cesena. When the duke subsequently returned to Urbino, Girolamo also returned and restored the ducal palace. Vasari's account of the court of Urbino is one of family union through marriage, of political discord and exile followed by the return to power. The fortunes of Genga and his family are determined by these political conditions.

When Vasari concludes his account of Genga's life, he tells us that the artist was not only a good painter, sculptor, and architect but also a good musician. He spoke beautifully, Vasari adds, and was courteous and loving to friends and family alike. He was in his very universality and grace the epitome of the ideal courtier defined by Castiglione in the *Book of the Courtier*, a work set in Urbino. Vasari says elsewhere

that Castiglione was the "formator" of the perfect courtier. Describing Genga and artists like him, Vasari is himself the "formator" of the perfect artist-courtier.

Vasari rounds out Genga's biography, saying that he was "honorably buried" in Urbino and grieved by "his wife and sons." Genga's death was also mourned by all the artist's "relatives" and by all the citizens of Urbino. Once again the artist, his family, and the "patria" are closely interrelated in Vasari's vision. In death, as in life, Genga and his family are inseparable from the court of Urbino.

Vasari continues this family history of glory, saying that Genga "established the house of Genga of Urbino," leaving two sons who followed in his footsteps in architecture. One son died before he could demonstrate his talents fully, the other, Vasari adds, is still alive today, devoted to the "cares of the family." The latter, Bartolomeo, was born when his father went into exile, during the exile of the Duke of Urbino. Educated by his father, who recognized his son's inclination toward design rather than letters, Bartolomeo was sent to Florence, where he learned many things from his friend Vasari. Genga Junior went on to distinguish himself, working throughout Italy before his untimely death in Sicily, where he was hailed as "another Archimedes." When the duke heard of Bartolomeo's death, he showed his love to the artist's five sons by taking them under his protection. Like his father, Bartolomeo was well rounded, for he was a poet as well as an artist. We can imagine him along with his father at the court of Urbino, discoursing on the qualities of the perfect courtier.

Vasari rounds out the story of Genga's family by writing of his distinguished son-in-law Giovanni Battista Bellucci. Born of a good family and trained in letters, Bellucci pursued a career in commerce, first opening a wool business. Soon after his marriage, his wife died. He then went to Rome before marrying Genga's daughter, who bore him two sons before her own death. Trained in architecture by Genga, Bellucci, now in mid-life, took up a second career. He flourished, making fortifications for Duke Cosimo de' Medici; most important of all, he made a ground plan of Siena that was crucial to the duke during the Siege of Siena. Serving the duke as soldier, Bellucci, as valiant in the field as he was ingenious in architecture, died in battle. When his son Andrea went to kiss the duke's hand, he was received warmly on account of the ability and fidelity of his father. Thus ends the story of an artist's family that had begun as part of the story of

Urbino and then modulated into the history of the court of Florence. The scene shifts easily, because Vasari sees the court of Florence, for whom he worked, as the mirror image of the perfect court of Urbino—the court served so faithfully and well by the "house of Genga."

The San Michele Family of Verona

Vasari fills out the history of artists' families outside Florence, returning to Verona in the life of Michele San Michele. Trained in architecture by his father and uncle, he was sent to Rome to study, leaving behind two brothers: Iacopo, who devoted himself to the study of letters, and Don Camillo, a canon in the church. Michele achieved great fame for his works throughout Italy, but some of Michele's works ended badly. One of his projects, the Guareschi Chapel in San Bernardino, was left unfinished, either for reasons of avarice or bad judgment, Vasari observes, and Michele lived to see it botched by other artists before his very eyes. On another occasion Michele's design for the round temple of the Madonna di Campagna was destroyed on account of the parsimony or poor judgment of the wardens of the building, but in this case a relative of Michele's, Bernardino Brugnoli, intervened by making a new model, after which the building was completed. This happy ending to the story is another example of how art stays in the family.

Michele's family history includes the work of his "nipoti." The foremost of these, Gian Girolamo, son of Michele's cousin, Paolo, was judged to be not inferior to Michele himself. In old age, Michele gained much satisfaction from seeing the virtue of this nephew's work. When Gian Girolamo fell mortally ill, he gave all his drawings to Luigi Brugnoli, his kin by marriage, in the hope that he would carry out his projects. (Luigi in turn had two sons, who also practiced architecture; of these Bernardino excelled, giving proof, Vasari says, of the genius that came from the mother's side of the family.) At the death of Gian Girolamo, Michele was overcome by grief. He saw the house of San Michele become extinct, for he himself left no children. Although he sought to conceal his deep sorrow, he soon became ill and died shortly thereafter. Once again Vasari suggests that the death

of one family member contributes to that of another, overwhelmed by grief. Although it is no doubt fictional, this claim nonetheless reflects Vasari's ideal of family love, devotion, and reverence.

Vasari dwells on the loving, generous character of Michele. He tells us that Michele confessed to him that in his youth he had a liaison with the wife of a stonecutter, with whom he never corresponded. He had heard that she was left a widow, with a daughter now ready to marry, who was his own child. Michele then asked Vasari to deliver to her fifty "scudi" so that she might use the money as a proper dowry for her daughter. When Giorgio went to deliver the money, the woman observed that the daughter was not in fact Michele's child, but Vasari insisted that in obedience to Michele's command she take the fifty crowns, which, he adds, were as welcome to the poor woman as five hundred would have been to another.

Vasari also links himself to Michele by telling us that in Venice he once made for his friend a large drawing of the Angel Michael vanquishing Lucifer. Surely the drawing was emblematic, since the *San Michele* was made for Michele San Michele. It was the icon of an artist, who presided over one of the most distinguished families of art in his native Verona—an artist with whom Vasari was proud to be associated. Michele, Vasari remarks, "did nothing more at the time than thank Giorgio for it." When Vasari made a return trip to his "patria," however, he discovered that his mother had just received from San Michele a number of beautiful and magnificent presents, worthy of being the gifts from a very noble gentleman. San Michele sent them to Vasari's mother along with a letter, in which he honored her on account of his love for her son, whom he was thanking for the emblematic drawing. Recounting this episode, Vasari binds San Michele's life to the story of his own family.

The Noble Houses of Lombard Art

In the "Lives of Garofalo, Girolamo da Carpi, and other Lombards," Vasari continues his account of artists' families. Girolamo da Carpi, who trained with Garofalo, worked first under his father, who painted

houses. Girolamo Mazzuoli, no mean painter in his own right, was the cousin of Parmigianino. Cristofano and Stefano, painters from Brescia, were brothers. Baccaccio Boccaccino, a painter of note from Cremona, was the father of the gifted painter Camillo. Of all artists' families the Campi of Cremona were preeminent. The painter Galeazzo Campi had three sons, Giulio, Antonio, and Vincenzo, who were all painters.

As if for reasons of symmetry, Vasari introduces the three Campi brothers just before introducing the three Anguissola sisters, painters all. Until the mention of these three painters, Vasari had said little about women artists, writing only the life of Properzia de' Rossi. He also noted in passing that Uccello's daughter learned to draw, that Parri Spinelli's sister made embroideries from his designs, and that Valerio Vincentino's daughter practiced his craft as jeweler. Now Vasari celebrates the three sisters of Cremona, above all, Sofonisba, but also Lucia and Europa. He also adds that they had a fourth sister, Anna, still a little girl, who was beginning to study drawing. The "four noble and gifted sisters" made of Amilcare Anguissola a "most happy father of a virtuous and honored family"—"felicissimo padre d'onesta et onorata famiglia." His house seemed to Vasari "the very home of painting," that is, "of all virtue in art." Vasari concludes his account of this noble house of art by asking playfully, "Since women are able to produce living men, is it surprising that those who wish to are capable of creating them in painted form?"

Sodoma's Wife

We have seen that artists frequently move from one city to another, and this is the case in the life of Giovan Antonio Bazzi from Vercelli, in North Italy, the son of a shoemaker brought to Siena by merchants who worked for the Spannocchi family. One of the most extraordinary figures in all of Vasari's pages, Giovan Antonio was called Sodoma, because he kept company with boys and beardless youths. A "happy" and "licentious" fellow, Sodoma played a lute, wrote poetry, dressed smartly, and was also called Mataccio, the Fool. Vasari's account of the painter is legendary. He tells us of Sodoma's stable of horses, of his animals, the various birds he kept at home, especially the crow, who

imitated Sodoma whenever anybody knocked at the door. With all the squirrels, apes, jays, and doves within, his house was, Vasari says, like the very Ark of Noah. No doubt exaggerated, Vasari's description makes of Sodoma a painter "alla grottesca," in the sense that he was surrounded by creatures like those depicted in painted grotesques. Describing Sodoma, Vasari becomes himself a master of the literary grotesque.

Vasari's caricature of Sodoma is so vivid, especially the characterization of Sodoma's taste for young men, that we scarcely recall that the painter had a wife and family. "Sodoma had a wife?" you ask. Vasari says that when he was young and still in good repute, Sodoma took a wife, a Sienese girl of a very fine family. The documents indicate that he had by her two children, one of whom he suggestively named Apelles. Vasari, who clearly did not like Sodoma, imagines that because he was such a beast, his wife left him, living after that on her own earnings and on the interest from her dowry, tolerating only with great patience the follies and bestiality of her husband.

Sodoma's domestic life was probably in fact more conventional than Vasari imagines. He does tell us, in any case, that Sodoma's daughter married the painter Riccio, who became heir to all her father's possessions associated with art. For all the eccentricity or reputed eccentricity of Sodoma, the artist's story is a familiar one—that is, the story of art in the family that we have encountered repeatedly in Vasari's pages.

Salviati and the Social Solidarity of Art

Vasari's exaggerated account of Sodoma's bestiality, which is not without mocking humor, is part of the sustained moralizing purpose of his *Lives*—all of which are exemplary, of both virtues and vices. For Vasari, Sodoma's viciousness is ignoble and stands apart from the nobility of art that is his broader theme, nobility achieved either through birth in a noble house or through the demonstration of artistic "virtue." Whenever he can, Vasari tells us of the noble origins of artists, whether he is speaking of the "noble family" of Rustici or of

Titian. Sometimes, Vasari even suggests, families become noble or are ennobled by the art that they commission. Speaking of the "most noble painting" made for Domenico Canigiani by Raphael, Vasari says that in his day it was with the heirs of Canigiani, who kept it with the esteem that a work by Raphael should have. It is as if this inheritance, this very noble object, gave social status to the family that possessed it, ennobling the family.

Vasari's acute sense of nobility shines through splendidly in the life of his friend Francesco Salviati, whom he "loved like a brother." Salviati's father, we learn, was a good man, a weaver of velvets. Having many children to raise, he needed help, and he decided at all costs to have Francesco devote himself to his own calling of weaving. The young Francesco, who had turned to other things, did not care for this trade, although in the past it had been practiced by people who were rich. These individuals, Vasari adds pointedly, were not noble, "non dico nobili." Against his own will, Salviati, a good son, followed the will of his father—"il volere del padre." He thus belongs to that great tradition of Florentine artists from the time of Giotto who did what would bring contentment to their fathers—even if, in some cases, against their own will. Associating with the children of Domenico Naldini, an honorable citizen, Francesco, who was given to gentle and honorable ways ("costumi gentili et onorati"), was "much inclined to drawing." What is of special interest here is the way in which Vasari associates the art of drawing with gentility or nobility, as if to say here, as he does elsewhere, that art is noble.

At this time Francesco trained with his cousin Diacceto, a young goldsmith with a good knowledge of design, who not only taught Francesco all that he knew of his craft but also furnished Francesco with many drawings of various "valentuomini," which Francesco studied day and night, unbeknownst to his father. Although de Vere translated "valentuomini" as "able men," the term connotes much more, such as "valor" that one associates with "gentiluomini." Aware of Francesco's activity, Domenico Naldini (who, we recall, was an "honorable citizen") prevailed upon Francesco's father, Michelangelo, to place him in his uncle's shop to learn the goldsmith's art. Within just a few months' activity in his new art, Francesco made so much progress that all were astonished. This account is, as we have seen, typical of numerous such stories we have encountered in the pages of Vasari—that of the conflict between the "will" of the father and "natural inclination"

of the son toward art that is resolved by the son's success in art. Vasari inevitably explains this resolution by emphasizing the nobility of art.

Vasari further emphasizes this happy resolution by saying, "In that time a company of young goldsmiths and painters used to come together on feast days to make drawings of the most praised works in the city." None of these artists, Vasari says, worked harder or with more love than Francesco. In his company were Nanni di Prospero dalle Corniole, Francesco di Girolamo dal Prato, Nannoccio da San Giorgio, and many other youths, who all became "valentuomini" in their profession. Thus Francesco entered successfully into Florentine society, contributing to it in the shared goals of artists drawing monuments of their "patria" with love, achieving valor in their art as they paid honor to their city. A truly noble story, it is the tale of a successful son having resolved his conflict with his father by becoming part of a company of art, a sort of confraternity of art, whose glory is connected with that of Florence and its artistic patrimony.

Salviati's story is part of the larger story in Vasari of artists' companies or friendships, both real and imaginary, that bring glory to Florence—from the associations of Gaddo, Tafi, and Cimabue to Vasari's own establishment of the Accademia del Disegno, including all those groups of artists that gathered to study in the Brancacci Chapel or the cloister of the Scalzi, or who studied Michelangelo's cartoon for the *Battle of Cascina*. Vasari's description of Salviati and his companions studying with love the most highly praised works of Florence on feast days signifies their spiritual union in fraternity, which is part of their social solidarity. Family conflict (between father and son) thus resolves itself in the glory of the "patria," to which artists contribute through their noble work. Studying the greatest art in his city, Francesco venerated, "with love," the art of his forefathers.

Salviati and Vasari as Brothers

The story of Salviati's successful initiation into his noble profession modulates into Vasari's autobiography (as so many of the biographies do) because Vasari says that "at that time," when Francesco and his companions made drawings in Florence, he and Salviati became "very

great friends." Telling his own story in the third person, Vasari says that they met after Giorgio came to Florence with Cardinal Passerini of Cortona, who was a kinsman of Giorgio's father. Seeing that the boy was grounded in his studies by Antonio da Saccone and by Giovanni Pollastra, an excellent Aretine poet, seeing also that Giorgio had learned a great deal of the *Aeneid* by heart, which Vasari recited to him, and that Giorgio had learned to draw from Guglielmo da Marcillat, the cardinal urged Vasari's father to let him take Giorgio to Florence.

Vasari then says that in Florence he worked with Michelangelo—a claim often doubted by scholars, who justly suppose that Vasari is puffing himself by tracing his artistic roots to the divine Buonarroti. He further notes that this association came to the attention of Salviati, who was introduced to him by the "gentiluomo" Marco da Lodi, after which the two young artists became good friends. Vasari says that he "did not leave off the study of letters," for every day he took lessons from Piero Valentino along with Ippolito and Alessandro de' Medici. Although he pursued his art, his training was and his profession was to be in "letters"—perhaps, as it has been suggested, as a secretary to the Medici.

Vasari reports that he was with Michelangelo "some months" before he went to work with Sarto and then Bandinelli; all of this activity in art, he says, took place before the Siege of Florence and the exile of the Medici. During the Siege he and Salviati supposedly rescued three broken pieces of Michelangelo's *David* damaged during the hostilities. They did this, Vasari explains, without fear of danger to themselves. Perhaps Vasari and Salviati did rescue the fragments of the *David*, which was in fact broken, but perhaps Vasari is telling a tale that further links him to his supposed teacher, thus concluding the story-line of his fictionalized early years with Michelangelo. True or not, the story is another reflection of the catastrophe of the Siege, of heroism in the heat of battle. Vasari and Salviati are like Michelangelo himself, who defended the city at this time by building fortifications at San Miniato. Protecting the statue of David, they were defending the statue that, in Vasari's own words, personated the very "defense" of the city. The claim of his and Salviati's intervention here resonates with the earlier reference to Salviati and the other young artists making drawings of the "most praised works" in Florence. By

protecting the *David*, Vasari and Salviati were showing similar devotion to the artistic patrimony of the city—a devotion not without a certain patriotic significance.

This chapter in Vasari's life (or rather Francesco's, for it is Salviati's biography that Vasari has autobiographically invaded) concludes when Giorgio's father Antonio calls him back to Arezzo. His departure was a source of regret to both Francesco and Giorgio, who were forced to separate from each other, for they loved each other like brothers— "s'amavano come fratelli." Thus ends the chapter of youthful fraternal friendship in the lives of two loving fellow artists, who epitomize the very ideal of brotherly love that informs Vasari's history of art. Although he regrets leaving this brother in art, Vasari must heed the command of his father, returning from his adopted "patria" to his father and true "patria."

Vasari's Families

In his own biography at the end of the *Lives*, Vasari does not retell in any detail the events of his youth, since, as he says, he had already spoken of the "origins of my family," of how he was "lovingly set on the path of virtue and particularly of design" by his father Antonio. Since Vasari's training was primarily in letters, one wonders whether Vasari's gradual transition from letters to art was as smooth as he claims. Did Vasari invoke the authority earlier of Signorelli, who urged his father to let Giorgio learn to draw, and did he pretend to have trained under Michelangelo in order to justify an eventual career in art that did not exactly conform to his father's wishes? Perhaps, as I have suggested above, the previous stories of the tensions between fathers and sons in Vasari's history touch upon an aspect of Vasari's own biography and family history that is otherwise glossed over? In any event, Vasari tells us that shortly after he was called back to Arezzo by his father, Antonio, died of the plague.

Still in his teens, Vasari now took on the weighty responsibilities of his family; he had, as he observes, to help his three sisters and two brothers, all left to his care after the death of their father. Although he worked in Florence for a time and then Bologna, he wanted to see his

family and relatives again and so returned to Arezzo, he says, where his family affairs were diligently attended to by his uncle. Vasari dwells on his study of art at this time, when he worked both night and day (reminding us of all his artistic forefathers, who similarly toiled day and night), and he associates this intense labor with the needs of his family. He could not afford to shirk responsibility, to shrink from vigil, toil, and fatigue, for he had become, if prematurely, the paterfamilias.

Woven through the story he tells of his career as an artist are remarks about his family role. After receiving advance payments and gifts for his decoration in 1536 for Charles V, Vasari says that he used part of the money to pay for the marriage of one of his sisters and that he used some of it for another sister, who became a nun. Besides paying a "dote" or a dowry for the latter sister, he made an offering of a painting of the Annunciation to her convent. Vasari adds that on account of all his services to Duke Cosimo de' Medici, the ruler gave to his brother Piero a political office and showed favor to Vasari's relatives in Arezzo. Vasari also recalls once again the family tomb that he renovated in the Pieve of Arezzo, for he was, as he says, "padronato" of his "house."

In a similar fashion, Vasari speaks, in the language of family, of his place in the families of art, religion, and politics. When Pontormo gives Giorgio advice, addressing him as "figliuolo mio," we recall that the venerable painter was a patriarch among painters, identified with the biblical patriarch whose name he bore. Similarly, Michelangelo, whom Vasari served, was the greatest patriarch of art, and Vasari was devoted to him as to his other "padroni" or patrons. In particular, Vasari was dedicated to the "padri" at the monastery of Camaldoli, and he also worked extensively for the "Padri Santi" or popes. Of all family relations outside of his own, however, the deepest was that to the house of the Medici. With particular reverence, Vasari speaks of Ottaviano, who protected Vasari as long as he lived, treating him as a "son." Vasari insists: "I will always revere and remember him as my most loving father."

It is perhaps fitting that Vasari's autobiography should conclude with mention of his project for a "third sacristy" at San Lorenzo, similar to Michelangelo's, which would be a mausoleum for the remains of the duke, his children, his mother, and the duchess. Planning such a monument, Vasari demonstrated filial piety to the house he served, bringing honor to himself as to his "padroni."

Vasari's "Ricordi"

It has often been observed that Vasari's autobiography is not one of the more exciting or even interesting biographies of the *Lives*, and this is certainly so, since (as Vasari reminds us himself) he has already told much of his own story in the lives of others. As a straight record of the works he made, his autobiography is based on "ricordi." Such memoirs have an extensive background in the "records" kept by the Florentines since the fourteenth century, including the memoirs of Donato Velluti and later of Buonaccorso Pitti and Gregorio Dati. Whereas such family diaries focus on family finances, listing transactions, Vasari's memoirs catalogue works of art, which are his form of commerce. Vasari's records are like the memoirs of former merchants and bankers, recording events of family history, travel, and occasionally political and social events of larger historical significance.

Vasari's autobiography and the other contemporary autobiographical writings of Michelangelo, Bandinelli, and Cellini, from the years in the middle of the sixteenth century, all belong to the tradition of the Florentine diary. Vasari's fairly colorless autobiography is particularly like the straightforward account of career and family that Bandinelli dictated to his son, and both stand apart from the more grandiose, mythologizing lives of Michelangelo and Cellini. When Michelangelo dictated his autobiography to Condivi in the early 1550s, he was revising Vasari's biography of the artist, which was the culmination of the first edition of the *Lives* from 1550. As I have suggested previously, Vasari's biography of Michelangelo had already included a good deal of Michelangelo's colorful "autobiography"— that is, Vasari had already transcribed many things that Michelangelo had told him and wanted recorded.

Though Vasari's "vita," as he tells it at the end of the *Vite*, is a bit dull, the autobiography woven through the *Lives* is not. The sum of Vasari's proud moments in the "lives" of Lorenzetti, Signorelli, Lazzaro Vasari, Salviati, Michelangelo, and numerous others is an autobiography that, in its liveliness of incident, is linked to the autobiography of Michelangelo, as told to Condivi, and to that of Cellini as told to a young scribe. The relations of these three works are radical, because Michelangelo's autobiography revises the biography that Vasari had already written in response to what Michelangelo told him,

and Cellini's autobiography, as students of literature have remarked, depends in no small measure on the rhetoric of Vasari's *Vite* in the first edition. Like the autobiographical writings of Vasari and Bandinelli, those of Cellini and Michelangelo have much to tell us about the artist's identity in relation to his family's status. To look at Cellini's autobiography and Vasari's revised biography of Michelangelo in the second edition of the *Lives* in the light of the entire *Lives* and of Vasari's autobiography woven through the *Lives* deepens our under-standing of the artist's sense of family—both of Vasari's and that of the artists to whom he was closely tied in friendship and rivalry at the Medici Court, the extended family of the state, in which they are all sons.

Vasari and Cellini: Parallel Lives?

When we think of Cellini's swashbuckling autobiography, we recall the moments of adventure, the swordfights and battles at the Castel Sant'Angelo, his imprisonment at the castle and eventual liberation, his court intrigues in Rome, Florence, and France, the rivalry with Bandinelli, among others, the sexual exploits, and, finally, the heroic casting of the monumental *Perseus*—all of which, as Berlioz recog-nized, made of his life a Romantic opera. The incidents of Cellini's childhood and youth are also well known, especially his defiance of his father's wishes that he become a musician. These first experiences repay our close scrutiny, if we are to see in Cellini's "vita" the place of family in his own image, and if we are to recognize how Cellini's relations with his father contributed to the ways in which he gave form to his autobiography. No less than his exquisite jewelry and sculpture is Cellini's book a work of refined artifice, in which he develops his own highly wrought persona—a persona deeply in-formed by Cellini's sense of family.

The full story of how Cellini repeatedly defied his father by practic-ing his craft as goldsmith instead of his music, of how he was recon-ciled with his father, only to defy him again, has a bearing on the deep theme of Vasari's *Lives*—that of the complex relations between fa-thers and sons, which take us back to the various fictions concerning artists that we have previously examined. As I have suggested on

more than one occasion, Signorelli's intervention in Vasari's life—
when the patriarch tells Vasari's father to let his son draw because
drawing is as important as letters—may well suggest that Vasari's path
to art was not so smoothly paved by his father as he later claimed.
Vasari's father may well have had in mind for his son a more noble
career, principally in letters, just as Cellini's father foresaw for his son
a career in music. Cellini's story is a melodrama of paternal curses,
tears, recrimination, and vengeance, whereas Vasari's is a quiet one of
accommodation, in which conflict is resolved. Even so, given differ-
ences of style, Cellini's autobiography and Vasari's tales of artists and
their fathers are more closely linked than we might initially have
supposed. Let us consider the issue by turning back to Cellini's *Vita*
and reading its family history, while bearing in mind the autobiogra-
phy and family fictions of Vasari's *Lives*.

Cellini's Ancestry

Like Vasari writing the history of his own family, especially in the life
of Lazzaro Vasari, Cellini celebrates his ancestors. Although Vasari
himself does not come from a noble house, he is quick to claim noble
origins for various artists. We recall in this regard the fiction of
Arnolfo born of the noble Lapi Ficozzi. (We recall too that both Mi-
chelangelo and Bandinelli stressed their noble origins.) Cellini's fam-
ily line, he says, descends from "virtuous and ancient peoples." His
ancestors came from Ravenna, "the oldest city in the world." They
also lived in Pisa and the Val d'Ambra, where they devoted them-
selves to arms. His own skill in arms or that of his brave soldier-
brother Cecchino are thus traced back to knightly origins. Discussing
his own origins in art (as Vasari does), Cellini observes that his grand-
father Andrea was an architect, whereas in fact he was but a "mura-
tore" or mason.

The supreme fiction in Cellini's autobiography, however, concerns
his ultimate ancestor. Vasari's story of his vase-making grandfather
Giorgio, who supposedly rediscovered the ancient technique of mak-
ing earthenware, is a modest fiction in comparison with Cellini's ac-
count of his first ancestor, whom he traces back to antiquity itself.
Exploiting the histories of Florence, according to which Florence was

founded by the ancient Romans, he says that Julius Caesar, along with several Roman nobles, was determined to build a city in which each would be responsible for one of its principal buildings. Among Caesar's leading and bravest captains was Cellini's ancestor named Fiorino da Cellino. Playing on Fiorino's name, all the soldiers would say, when visiting him, "Let's go to Florence"—"Andiamo a Fiorenza." Since this name seemed beautiful to Caesar, he decided to name the city "Fiorenza"—although Cellini adds that the name was also derived from the abundant quantity of flowers in the city.

"Names are the consequences of things," Dante said, and Vasari played on his own family name using the emblematic inscription VIRTUTUM OMNIUM VAS, just as Michelangelo did when he invented an emblematic device of three intersecting circles, or "buone rote." In Rabelaisian fashion, Cellini carries this "philosophy of nomenclature" to a new pitch when he gives his ancestor the name of his great city, implying that the city is named after his family. Just as Michelangelo identified himself with David, defender of the "patria," Cellini makes his fictional ancestor a soldier, who is the "figura" of his very self. In Cellini's family fiction, all of Florence in a sense descends from the Cellini family, from Fiorino da Cellino. The very idea of the family of the "patria" is carried to new heights, as Cellini's imaginary forefather becomes the ultimate patriarch of the "patria."

Although Cellini does not say so—and he does not have to—his ancestor's name is that of the Florentine coin, the "fiorino." In fact, we see that Cellini has taken his ancestor's name from this currency, making new capital of it. The "fiorino" or florin has on it the symbolic lily, the "fiore" that no doubt encourages Cellini to say that the city is doubly named after both Fiorino and the city's "fiori." Cellini embellishes this wordplay in a sonnet placed at the beginning of his autobiography, saying, "I descended, Welcome ['Benvenuto'] in the flower ['fiore'] of this worthy Tuscan terrain." His language not only evokes Vasari's biblical description of Michelangelo sent down from heaven to Florence, but the play on "fiore" is reminiscent of Vasari's references to Florence, as Flora, goddess of flowers, and his locution, "fiorirono in Fiorenza," "there flourished in Florence." We might say in the language of Cellini that his ancestor Fiorino was the first flower of Florence, that he, Benvenuto, was its final flower. The flowering of the Cellini family is inseparable from the very flowering of the city of flowers.

Cellini's Fathers

If Cellini's family origins are classical, that is "all'antica," they are also biblical. These biblical resonances are found in the description of his birth and naming, which echo events in the life of the "Holy Family" as told in the Gospel of Saint Luke. Cellini writes of his advent: "It happened that I was born on the night after All Saints at half past four." The wet nurse, who knew that Cellini's parents expected a girl, wrapped him in beautiful white draperies and brought him to his father, named Giovanni, and said: "I bring you a beautiful gift, which you did not expect." Beholding his unexpected gift, Cellini's father raised his eyes to heaven, saying, "Lord, I thank you with all my heart for this child, who is most dear to me and who is welcome [benvenuto]." All those who were present asked him what name he gave to his son, and Giovanni said, "He is Benvenuto." The matter resolved, Cellini was baptized and, as he says, "thus I live in the grace of God."

Giovanni Cellini's very name encourages Benvenuto to see his birth and the response to it in relation to the birth and naming of John in Luke. Cellini's mother, who had not borne a child in nearly twenty years, was like Elizabeth, who was barren before John's birth. When Zacharias wrote the name of John (which means "has favored"), all present marveled, and Zacharias praised God for this gift of grace, speaking in the mouth of the holy prophets. Cellini's father similarly gives his son a name of deep significance and thanks God for this gift of his son. The joy of those present at Cellini's birth recalls the "joy and gladness" of those who rejoiced in John's birth. Cellini later describes his father as a prophet, further linking him to the prophetic Zacharias. Cellini's description of himself as a "gift" also evokes the biblical language of the "gift of gifts," of grace, which is Luke's very theme. It reminds us too of the ways in which Vasari spoke of the great artists as "gifts" from heaven, similarly echoing the language of the Bible. Cellini's name, like the names in Vasari, also has hagiographical significance, recalling an episode in the life of Saint Buonaventura. When the saint fell ill as a child, Saint Francis intervened to heal him, at which the saint's mother cried out "o buona ventura"—"oh good fortune," whence the saint's name Buonaventura.

Cellini's father's father was still alive when Cellini was born, just as the aged Simeon lived long enough to behold Jesus. Cellini tells us

that his grandfather was over one hundred years old at this time, when in fact he was eighty. Cellini is like Vasari, who is always exaggerating the ages of his subjects, making them into great patriarchs.

Cellini's father figures prominently in two fictions from his childhood. At the age of three, Cellini came running to Giovanni holding a scorpion, which he thought was a little crab. His father took the creature away from Benvenuto and cut off its poisonous tail before it could harm his son. His father took this liberation from death as a sign of good fortune, a "buon aurio." Again Cellini may still be thinking of the birth of John, which was also a "buon aurio," an "augury" of the birth of Jesus. In any event, this "buon aurio" resonates with "buona ventura" and "benvenuto." The second signal event from Cellini's childhood occurred when he was five years old. While playing the violin, Cellini's father saw a lizard running around in the fire. He called Cellini and his sister to him, then gave Benvenuto a slap, saying that Benvenuto had done no wrong. "I hit you," he said, "so that you will never forget the lizard you saw in the fire, which is a salamander, and as far as I know, no one has seen one before." The second tale suggests the visionary powers of both Cellini and his father. But what else does it imply?

Cellini's fiction introduces the theme of music, which was a curse to Cellini, a source of deep conflict between him and his father. Second, the unforgettable slap that his father gives him evokes the very violence of his father's subsequent responses to Cellini's defiance of paternal will. Third, the eternal salamander is a suggestion of the emblem of the King of France, Cellini's future patron, who called Cellini (or so he says) "mon ami." We might say that Cellini appropriates the royal emblem as his own in the vision of his future glory in France. If the story of Cellini's birth harks back to the Bible, the fictions of his childhood prophesy his future success.

A Paternal Curse

Cellini's father Giovanni served the Medici by playing the pipes for Lorenzo il Magnifico and his son Piero, and he was also well treated by Pope Leo X. Cellini tells us that before the return of the Medici under Leo, his father, who was a prophet, wrote prophetically of the

Medici arms lacking the sacred mantle of Peter. Read throughout Florence, his prophecy came to pass with the ascendancy of Leo X to the papal mantle. Cellini thus attaches his family's history to the Medici, as Vasari, Michelangelo, and Bandinelli all had done. Not only did Giovanni's service to the Medici foretell Cellini's own, but his prophecies, which reflected the "divine," as Cellini says, also foreshadowed Benvenuto's own prophetic powers. Giovanni's prophecies, visions, and dreams, as well as Benvenuto's, are also part of the dramatic story Cellini tells about the conflict between father and son. Few stories of such conflict between paternal will and filial desire are so vivid and dramatic as that told by Cellini. It is a story that throws into relief the very conflict of which Vasari writes so often.

Whereas Giovanni Cellini hoped that his son would follow him, pursuing a career in music, Benvenuto resisted the "damned playing" and persisted in working as a goldsmith. A student of Giovanni's named Piero told Cellini's father, "Your son Benvenuto will achieve more honor as a goldsmith than as a fifer." Cellini's father flew into a rage, making a pprophecy that in due course Piero would pay for these words, for his lack of gratitude. In biblical language appropriate to his divine persona (linked, we recall, to the Holy Family), he says to Piero that "no bad tree ever bore good fruit," prophesying that Piero's children would come to his sons begging charity. Less than a month later, Piero repeated Cellini's father's words of prophecy of ill-fortune, at which time God showed his hand and the floor of Piero's house collapsed. Stones and bricks rained down on Piero, breaking both his legs, and a short time later he died from the accident. In accord with Giovanni's prophecy, Piero's son later came to beg charity of Benvenuto. Cellini insists that his father's prophecy should not be mocked, because through Giovanni the "voice of God" spoke.

The story, real or imaginary (and it is likely fictional), comments not only on Piero's lack of gratitude to Giovanni and the curse on Piero's family but also on Benvenuto's sense of not having fulfilled his father's wishes. Whereas Piero had not been like a good son to Giovanni, Benvenuto insists that he was a "good son." Although he practiced his art against his father's wishes in Pisa, Lucca, and Rome, he tells us (expiating his sin?) that he always sent money home to his "poor afflicted father." Nevertheless, Cellini's father expressed his "sorrow," hoping that Benvenuto would not "rob" his house of its honor. Cellini adds that, although he had stopped playing the flute while practicing

his art in Pisa, he became ill and returned home, and his father received him with caresses, nursing him to health. Shades of the parable of the Prodigal Son?

The freight of Benvenuto's father's suffering, his love for him and his pleas to Cellini's sense of honor, is enormous and graphically detailed in dialogue. So deep was the conflict between father and son and so powerful were the feelings this conflict aroused that Benvenuto had a dream while in Rome in which his father cried affectionately to him, begging him for the love of God to set out on a new path. When Cellini refused, his father, assuming a terrible shape, replied, "If you do not, you will know a father's curse, but if you follow his will, you will receive blessings." Again the language is biblical, for it is as if Cellini had deviated from the way of God. His father's warning is like that of Jesus to the faithful, likened to children, who will either be redeemed or punished in hell. When Cellini awoke from the dream, he went to his father, telling him about the dream. Miraculously, his father replied that he too had had the very same dream—the warning of a paternal curse.

Not long after having the dream of paternal malediction Cellini traveled to Mantua. When he returned to Florence, he had an experience that one might speak of as visionary—as if it were one of the horrors of hell. When he arrived at his home, he beheld at a window a perverse old hunchback, who cursed him. A neighbor then arrived to inform him that his father and everyone in his household had been killed by the plague. Although he found his sister and brother alive, the image of the infernal hag and the news of his father's demise are tinged with the kind of horror that Cellini experienced in his dream of his horrific father. It is as if the perverse hag were in some way associated with Cellini's father, her curse being an extension of his father's.

Even after his father's death, the threat of the paternal curse did not diminish. When he became gravely ill in Rome and nearly died of the fever, Benvenuto had visions of an old man, whom he identifies as Dante's Charon, as if the boatman had come to drag him down into hell. Is this not the hellish imagery of curses harking back to Giovanni's curse of Piero, to Cellini's dream of paternal malediction, in which his father had assumed a horrible form, like that of the hag who subsequently cursed him, another image of the father seeking to punish his son for his waywardness? We might ask whether the subse-

quent stories of Cellini's conflicts with his "padroni" or patrons were not a playing out of this primordial conflict with his father. When Cellini wrote a poem on his liberation from the Castel Sant'Angelo, he described an angel appearing to him who said that he liberated him "in the grace of the Father on Earth as in Heaven." Did God the Father finally liberate Cellini from his paternal malediction?

Although Cellini insists throughout his autobiography, down to the very end, that God is on his side, we are not convinced that he has found peace, liberated from this curse, for his has been, as he says, a "cruel destiny." Cellini is sure to tell us that he is in Duke Cosimo's good graces, that the duke says he will do anything that pleases him. He does not convince us, however, that this is so, that he is pleased, as he puts it, to have had the burden of the *Neptune* commission removed from him. Surely Cellini's inability to secure the commission to carve the *Neptune* for the duke was a disappointment, indeed a failure in his mind. Cellini's autobiography ends as he prepares to ride off to Pisa to see the duke after the death of the duke's son, who had been his "right eye." Perhaps Cellini sees the duke's loss as a curse justly delivered on the "padrone" who had not properly appreciated Cellini's virtues. For all his successes and triumphs, Cellini is still under the indictment of the paternal malediction. Without reducing the sheer richness and variety of Cellini's vivid life story to a single factor, we can say that his autobiography is profoundly informed by the enduring sense that, having abandoned music for art, he had not shown adequate "pietà" to his "povero padre." The conflict with his father, as with his "padroni," is the leitmotiv of his life beyond music.

Cellini's Brother

The story that Cellini tells of his brother Cecchino is not unrelated to his own. Although their father encouraged him in the study of letters, Cecchino was naturally inclined toward arms, and he subsequently distinguished himself as a soldier, fighting in the army of Giovanni delle Bande Nere, the father of Duke Cosimo de' Medici. In the end, however, Cecchino was murdered, and Benvenuto, demonstrating his love of his brother, both honored him and avenged his death.

According to the story Cellini tells, when Cecchino heard of the murder of Bertolo Aldobrandi, he let out a roar that could be heard for miles away. He then captured the murderer, running his sword forcefully through the belly of the villain with "ferocious energy." One of the murderer's friends, however, mortally wounded Cecchino in the leg. The story that unfolds is one of Cellini's own rage, comparable to that of his brother. When Cellini later caught up with his brother's assassin, he plunged his dagger into him with enormous force, killing him at once.

Before this act of vengeance, Cellini honored his brother with a tombstone, for which "learned men of letters, who knew Cecchino, wrote the epitaph in Latin." Cellini had all the letters of Cecchino's name broken, except the first and last. The broken letters, he explains, stood for his brother's broken body; the first letter was left entire in memory of the gift given to his brother by God of a soul that was never broken; and the second whole letter stood for Cecchino's glory and fame. Cellini also added the arms of his family, which originally included, he says, the rampant lion with a lily in its paw. Although Cellini pretends that his arms are derived from those of his ancestors in Ravenna, he in fact adopts the "marzocco" or Florentine lion and the Florentine "giglio" or lily, as seen in Donatello's *Marzocco*, which appears with the lily upon its shield. (The appropriation of Florentine symbolism here recalls Cellini's invention of his ancestor Fiorino, from the "fiorino.") Cellini modified the family arms by showing the lion with an axe rather than a lily in its paw in order to remind himself, he says, that he had to avenge his brother.

The artifice of Cellini's symbolic invention for his brother's tomb, which, he brags, was adopted by others, is an index of "bella maniera." Such artifice is not unrelated to that which informs his entire autobiography, shaping the biblical and Dantesque narrative, the hyperbole of his divine, highly wrought persona. The account of his devotion to his brother is also a vivid instance of fraternal devotion and piety that is part of the context in which we might recall Vasari's portrayal of "fratellanza" or brotherly love of artists who were in fact brothers or were united, like brothers, in love. We might recall here, in the light of Cellini's avenging his brother, the way in which David Ghirlandaio defended the honor of his brother Domenico at Passignano with violent rage—although admittedly the circumstances were different. We might recall, too, the story Vasari tells of how Giovanni

Bellini honorably buried his brother Gentile. Vasari presumably knew nothing of the circumstances of Gentile's funeral, but his account of Giovanni's honoring his brother rings true—especially when we place it in relation to Cellini's account of how he honored his brother. Cellini's description of his own devotion to his brother enables us to see that Vasari's stories of brotherly love, although often fictional, are nevertheless true to life.

Michelangelo's Family and Vasari's Families

Vasari's account of the "fratellanza" of artists is, as we have seen, highly idealized. His history of artists who were in fact brothers (the Cione, Ghirlandaio, Bellini), or who were like brothers (Gaddi and Martini, Polidoro and Maturino, Vasari and Salviati), is often purged of the kinds of tensions that generally exist in real families. In fact, we might well ask whether in real life, as opposed to his autobiography, Cellini's dealings with his own brother—given their fiery temperaments— were free of discord or rivalry. If we turn to the "carteggio" of Michelangelo, to the letters he wrote to his father Ludovico, to his brothers Giovansimone and Buonarroto, and to his nephew Leonardo, we discover a vivid image of family relations, filled with strain, particularly sibling tension, that is a corrective to the idealized family portrait in Vasari. In these letters, Michelangelo resents the requests for money from his brothers, speaks of his generosity to them, worries about his father's needs, and chides his nephew, whom he helps in business affairs. Dowries, a family shop, rentals, farm properties, a wool business—these are among the topics of letters brimming with financial concerns and anxieties, which are at the center of family life.

Michelangelo was often very nasty. He was suspicious and highly temperamental. His temper emerges in his letters. The vivid picture he gives us in them of the strains between himself and his brothers, especially Giovansimone, whom he calls a "beast," reminds us that, even if his relations with his siblings were particularly sour, the kinds of strains he refers to (largely financial) are those that existed in the "real lives" of all of Vasari's artists. They remind us that, although he

idealizes artists as loving brothers, Vasari also gives us examples of artists as sibling rivals. Such rivalry is particularly conspicuous in Vasari's own circle. In his memoirs, Bandinelli mocks Vasari for not knowing where his head is, and Vasari, in his biography of Bandinelli, ridicules Baccio for his pride and the various errors in his art. Bandinelli calls Cellini names, and Cellini replies by calling Baccio an ox. Cellini also mocks Vasari when he describes him scratching his flaking skin during an illness. All of these siblings go running to the "padrone" of their extended court family, Cosimo de' Medici, and they all invoke the fatherly authority of Michelangelo in judging their art. Cellini and Vasari brag that the paternal Michelangelo praised their works, whereas the proud Bandinelli actually admits that Michelangelo's criticisms of his sculpture were just.

Beyond these rivalries and other stories in Vasari of "invidia" between artists—antithetical to brotherly love—there are clues throughout the *Lives* to the kinds of real strains that Michelangelo's letters betray concerning family affairs. I refer to Vasari's fictionalized remarks about Giovanni da Ponte squandering his "patrimonio," Agnolo Gaddi greedily living a life of luxury, Donatello accusing his relatives of caring too much for money, and Liberale da Verona not trusting his daughter and other relatives to look after him properly in old age. When Vasari pretends that Correggio died a miser weighed down by the strains of family responsibility, he sums up this underside of family life, which is grounded in financial worries like those reflected in Michelangelo's letters to his relatives. The broadest reading of the *Lives* is one in which we recognize not only the serene family of artists united in love, of artists devoted to families, aspiring to the condition of the "Holy Family" itself, but also the real families of artists struggling under financial strain—paying their sisters' dowries, establishing their brothers or relatives in business, seeing to their parents' needs.

Michelangelo's Father and Vasari's Father

Although Michelangelo emerged as the major source of income in his family by the time he was working for Pope Julius II, he was still

accountable to his father. Indeed, we find him, for example, in a letter of 1507 from Bologna explaining defensively to his "revered father" why he let go his two assistants, Lapo, a "ne'er do well" and "scoundrel," and Ludovico. He even writes a letter to his brother Buonarroto in advance of the letter to his father, saying that if the two assistants come to their father, he will be able to justify his actions in releasing them. Michelangelo insists to his father that he has not sinned at all in this matter. After signing the letter, Michelangelo, still troubled that his father will not be placated by his explanation, writes a postscript, explaining "one more thing" in answer to Lapo's charge against him. It is less the details of this episode that interest us here than the fact that Michelangelo needs to justify himself to his father— to free himself of the accusation of sin, of his father's harsh judgment. Michelangelo's concerns are here not unlike those of Cellini, who lived in fear of paternal indictment or curse.

The episode of Lapo and Ludovico is not the only one of conflict between Michelangelo and his father. Born of an "honest and noble woman" and of Ludovico di Leonardo Buonarroti Simoni, Michelangelo was, Vasari says, of the "most noble and ancient house of the Counts of Canossa." It was expected therefore that he would behave according to his noble station. Sent to grammar school, Michelangelo was motivated, however, to draw secretly, consuming his time in this activity. For this drawing, Vasari tells us, he was screamed at and sometimes beaten by his father and elders, who did not appreciate the virtue of art, thinking it a "low thing not worthy of their ancient house." When Michelangelo went to work with Ghirlandaio, his desire to pursue his art increased daily, and Ludovico, seeing that he could not divert his son from his drawing, decided that there was no other remedy but to let him stay with Ghirlandaio. The conflict between paternal volition and filial inclination here puts us in mind of the similar conflict in the life of Cellini.

Just as the conflict with his father colored Cellini's imagination, so did the conflict with Ludovico inform Michelangelo's autobiography. After telling Condivi that he was beaten by his father and relatives, Michelangelo next told him that he made a copy after a print by Schongauer of the "torments" of Saint Anthony. The subject of Michelangelo's copy has many implications. It is an example of Michelangelo's art "alla grottesca" as well as of his artifice in counterfeiting a work of art, like that exhibited in his *Cupid* "all'antica." The image of

Saint Anthony is also an icon of Michelangelo himself, persecuted as he would be throughout his career. Identifying himself with saints, Michelangelo saw his own persecution as like theirs. What is most suggestive here, in the light of his beating at the hand of his father, is the juxtaposition of his "torments" with those of Saint Anthony. Michelangelo assimilates hagiography to his life's story as martyred saint, as Cellini would a short time later, following his very example.

Michelangelo's autobiography and its theme of conflict between father and son becomes, like Cellini's, even more interesting when we compare it to the rhetoric of Vasari, especially that in the life of Cimabue. Like Michelangelo, Cimabue is said to have been born of a noble house and, like Michelangelo, he was sent to study letters (with a "relative," Vasari adds, keeping the story in the family). Like Michelangelo, Cimabue consumed his time all day in drawing and, Vasari adds, fled his classes to watch artists at work. Here, however, the stories diverge. Whereas Michelangelo's father beat him because art was a low thing not worthy of his noble house, consenting to allow Michelangelo to study with Ghirlandaio only because nothing else could be done, Cimabue's father, seeing that Cimabue honored himself in art, apprenticed him to artists whom Cimabue soon surpassed. This is also Michelangelo's story, since he too soon surpassed his teacher Ghirlandaio. But the fictional life of Cimabue is the life of Michelangelo minus all the beatings of his father (and, for that matter, minus all the paternal tears and melodrama of Cellini's biography). Cimabue's father is the ideal father who allows his son to abandon his study of letters for painting. Cimabue's father is Vasari's idealized father, who, encouraged by Signorelli's patriarchal advice, lovingly led Vasari down the path of "disegno."

The Ghost of Michelangelo's "Father"

The more we pursue Michelangelo's story of his dealings with his father, the more we discover that it is as complex as Cellini's account of his relations to his father. Vasari says that after Michelangelo made the *Faun* for Lorenzo de' Medici, the latter asked Ludovico Buonar-

roti if he could take Michelangelo into his own home, saying that he wanted "to treat him as one of his own sons." The Magnifico gave the boy his own room, according to this account, and Michelangelo is said to have eaten at table with Lorenzo's children and other worthy and noble persons in Lorenzo's household. Michelangelo received a salary in order to help his father, and Lorenzo gave his father a place in the Customs House.

In the version of the story that Michelangelo gave to Condivi, there is more drama and tension. Lorenzo sends Michelangelo home with a message for his father that he wants to speak with him. When he hears this, Michelangelo's father guesses what is on Lorenzo's mind and complains that Lorenzo is leading his son astray by encouraging him in his art. Ludovico remains determined that his son will never become a mere stonecutter. When he finally goes to il Magnifico, he is asked what trade he pursues, to which he replies that he has no trade, that he lives on his meager income from his few possessions left by his ancestors. Lorenzo then asks Ludovico if there is anything he can do for him before he dismisses him. Michelangelo then enters into Lorenzo's household, receiving an income with which he can help his father, and later Lorenzo arranges to give Ludovico a job. Michelangelo's patron and new father exerts his powers of political patronage by looking after the needs of Michelangelo's father.

Thus Michelangelo passes from the house of his true father into that of his patron and new father, who treats him as one of his own sons. This event took place, we recall, after Michelangelo supposedly made the *Faun* for Lorenzo. As I have argued elsewhere, the *Faun* is a double icon of both Lorenzo and Michelangelo as Socratic satyrs, who, like Plato's Socrates, were well known for the contrast between their outward ugliness and inner virtue. In his physical attributes, that is, his ugliness, Michelangelo resembled his "padrone," as ugly children resemble their ugly fathers. When we think of patrons as fathers, we might consider that, just as Cellini's conflicts with "padroni" had in some degree to do with his unresolved conflict with his father over the practice of art, so were Michelangelo's storied, turbulent relations with the Holy Father Julius II related, in some measure, to the similarly unresolved tensions with his father.

Michelangelo told Condivi that after the death of his patron, Lorenzo il Magnifico, a certain Cardiere, in the employ of Lorenzo, had a vision in which Lorenzo appeared to him in a black habit, command-

ing him to tell his son Piero that he would be driven from his house, never to return. Cardiere, who improvised upon the lyre, emerges in this story as a type of Orpheus with visionary powers. It has recently been suggested that Cardiere's vision was actually Michelangelo's own. We might speculate further that the vision is a retrospective fiction in which Michelangelo comments on his filial ties to Lorenzo. Let us consider the rest of the story in order to see why this might be so.

According to what Michelangelo told Condivi, he urged Cardiere to tell Piero of this vision. Meeting Piero at Careggi, Cardiere then told Piero how he was visited by Lorenzo, to which Piero responded with a scornful jest. Cardinal Bibbiena said to Cardiere, "You are a madman. To whom do you think Lorenzo would be better disposed to appear than to his own son? Would he not prefer to appear to his son if that were possible rather than to anybody else?" Michelangelo, fearing that the vision did foretell the future exile of the Medici, then fled Florence, traveling to Bologna and then on to Venice before Piero was in fact banished. The significance of the story is that Michelangelo, like a good son, took the warning of the ghost of his "father" seriously, whereas his sibling of sorts, Piero, did not. In this story Michelangelo is faithful to his father, the epitome of filial piety. That Lorenzo had become his symbolic father here, as elsewhere, tells us something again about his troubled feelings regarding his own father. The image of Lorenzo appearing to Cardiere (and in a sense to Michelangelo) is a reminder of the less benevolent paternal apparitions that appeared to Cellini in dreams and visions.

Michelangelo as the "Pater Patriae" of Art

Becoming a member of the Medici household, becoming an adopted son of sorts to Lorenzo il Magnifico, Michelangelo exalted himself. He did not stop there, however, because, as I have previously explained, he even appropriated the Medici emblem, of three overlapping rings, adapting the three rings to his own emblem of three intertwined crowns, signifying the arts that he practiced. Imitating

the symbolism of the Medici, he saw himself as princely, like his very patrons, and Vasari elaborates this self-image as prince and, indeed, as "pater patriae."

In Michelangelo's funerary decorations superintended by Vasari, one of the paintings showed Michelangelo surrounded by and honored by artists young and old. For Vasari, Michelangelo was the "padre" and "capo" of the Accademia del Disegno; the funeral painting symbolized his patriarchal role in the "patria" of art, in which he was the "pater patriae." This idea was made explicit in another painting for the funeral, in which Michelangelo, as if in a school of art, was shown as a teacher giving instructions to young disciples. The Latin tag to this painting from Lucretius—"Tu pater, tu rerum inventor, tu patria nobis"—makes explicit Michelangelo's identification as the father of the "patria," following the example of Duke Cosimo's forebear Cosimo il Vecchio, who had died exactly one hundred years earlier. Surely Michelangelo's elaborate funeral was resonant with Cosimo's glory on, this, the centenary of his death. Buried by Vasari and his Academy, Michelangelo was honored by his family in art.

A further word should be said about this painting of Michelangelo giving instruction to other artists. Vasari says that it depicted Michelangelo "courteously" teaching the students who were part of his "scuola." The painting not only symbolized the Accademia of which Michelangelo was the "padre," but it also transformed Michelangelo into a type of Raphael, who was courteous with his disciples, by contrast to Michelangelo, who was in fact often irascible, nasty, and facetious with other artists. The image of Michelangelo is so dominant in the pages of Vasari that we sometimes forget that Raphael is that other principal figure in the *Lives* to whom Vasari points as model to his academic disciples. Vasari holds up to his students and to his readers the combined ideals of Michelangelo, unsurpassed in rendering the human form, and Raphael, supreme exponent of "variety" in art. Artists should, Vasari insists, synthesize the best features of both artists. In accord with this principle of "concordia Michelangeli et Raphaeli," Vasari conceived of Michelangelo giving instruction most courteously in the funeral painting as a similar synthesis—that is, of Michelangelo Raphaelized, made to appear like the Raphael who lovingly treated his disciples like sons. In Vasari's fiction, the real traits of Michelangelo, a harsh father of art, are softened into the more gracious attributes of Raphael, the other great patriarch of his book.

The images of the Raphaelized Michelangelo or of the loving Raphael
are also the mirror in which Vasari sees himself.

Conclusion:
The *Lives* as Social History

So ends Vasari's history of artists and their families, both real and
imaginary—a history that begins with the stories of Cimabue, whose
wise father gave his blessing to his son when he abandoned the study
of letters for art, and of Giotto, who dutifully asked his father's con-
sent before he went to study with Cimabue, and unfolds through
countless family stories, culminating almost mythopoetically with the
ascendancy of the Raphaelized Michelangelo, the supreme patriarch
in the family of art. Vasari's *Lives* is, as we have seen, highly fictional,
but this fact does not in any respect diminish its historical interest.
Vasari's book is a sustained meditation on family, on filial piety, on
family responsibility, on family glory. It is the graphic record of how a
particular individual, living in Arezzo, Florence, and Rome and travel-
ing elsewhere in Italy during the sixteenth century, defined himself
and others in relation to their families or the families for whom they
worked, of how Vasari's experiences and vision of the world were
shaped by the idea of family.

The concept of family permeates Vasari's thinking—from the notion
of "disegno" as the "father" of art to his description of families in
paintings, above all, the Holy Family. The glory of artists is the glory
of their families, just as the fame of their art reflects the fame of the
families for whom it was made. As Burckhardt dwelt over one hun-
dred and thirty years ago on the emergence of the individual in the
Renaissance, recent historians, in a sense turning Burckhardt inside
out, have focused on the subsumption of individuals into their fami-
lies and extended families, on the relations of family patronage to the
state, almost as if, in a cultural reversal or transformation, ontogeny
were recapitulating phylogeny.

Vasari's book, which should be one of the principal source books for
any scholar concerned with the social history of the Renaissance,
reminds us how concepts of family permeated religious life—for exam-

ple, the notion of brotherhood in the Church. We have seen how the religious ideal of "fraternitas," with its roots in Saint Paul, is part of Vasari's view of the "fratellanza" of artists. His book also reminds us that notions of family extend into the state, made up of great families or ruled by powerful families. The state or "patria" is ruled by the patriciate, the patricians who are its patrons, exerting power as they give shape to and protect its patrimony, as they preserve and extend their own family patrimony. The state is a patriarchy in which the fathers of families and their sons emerge as the dominating figures. The patriarchs of art in Vasari's story are a reflection of that political reality. In the end, the "pater patriae" is the paterfamilias presiding over the family of the state, and the supreme father of art, Michelangelo, presides over the "principato" of art in the same way that the Medici dominate Florence as fathers of the city and its domain.

Whether Vasari is telling Michelangelo's family story, which is the dramatic history of an adopted son of the Medici, who comes to be the "pater patriae," the glory of the Medici and of the "patria," whether he is writing of the rise of his own illustrious house and of his place in it, whether he is describing the glorious, noble patriarchs of art from the past, from Arnolfo, Cimabue, and Giotto to Signorelli, the Bellini, and Raphael, or whether he is speaking of the tribulations of family life—in the various anecdotes concerning financial strains, disputes over money, vendettas, and misery in the lives of Parri Spinelli, Filippo Lippi, Correggio, and others—Vasari is forever talking about the family, the family that gives form to the individual's concept of self, to society, to religion, to politics, and, not least of all, to his compendious book, itself a work of deep sympathy, love, and filial piety that might well be called *Le Vite degli Artefici e le loro Famiglie*. Can anyone dispute that his *Vite* is one of the deepest and most extensive accounts of the family from the Italian Renaissance available to us and that, as such, as a monument of social history, it is a book that we have scarcely begun to read in its cornucopian entirety?

BIBLIOGRAPHICAL NOTE

As in the earlier volumes of my Vasari trilogy, I have relied primarily on the edition of the *Lives* edited by Paola della Pergola, Luigi Grassi, and Giovanni Previtali (Novara, 1967), which is useful for its documentation and occasional observations on Vasari's literary purposes. Still fundamental is Milanesi's often reprinted edition (Florence, 1878–85), which is especially pertinent here since he includes many genealogies of artists' families that might well be looked at again in the light of recent historical scholarship. The most reliable complete translation of the *Lives* in English, which I have often consulted, is that of Gaston Du C. de Vere, reprinted in New York in 1979. George Bull's translations of selected *Lives* are also widely accessible in two Penguin editions (1965 and 1987), and a selection of Vasari, translated by Julia and Peter Bondanella, is scheduled for publication by Oxford University Press.

The history of the Renaissance has been conceived in recent years as the history of the family, and the literature on this subject, especially concerning Florentine families, is now vast beyond all measure. For an index of recent trends in the field and for an extensive bibliography, see David Herlihy and Christiane Klapisch-Zuber, *Tuscans and Their Families* (New Haven and London, 1985). Whereas scholars of Italian Renaissance art have studied for some time the families of the Florentine patriciate—that is, the patrons of art—recently they have focused more sharply on the families of the artists themselves. William Wallace's forthcoming *Michelangelo at San Lorenzo*, for example, examines the family finances and business deal-

ings of the artist, and Elizabeth Pilliod's current studies of Bronzino's household deepen our understanding of Bronzino's ties to the Allori family.

Although I have only alluded to Leon Battista Alberti's *Della Famiglia*, it is fundamental to our understanding of many of the familial ideals that inform Vasari's *Lives*. For the English translation of Alberti's book, see *The Family in Renaissance Florence*, trans. R. Watkins (Columbia, S.C., 1969). I have explored Vasari's fictionalized family histories of artists from the perspective of Vasari's own family history and that of his contemporaries Bandinelli, Cellini, and Michelangelo. For the details of Vasari's family, see T. S. R. Boase, *Giorgio Vasari: The Man and the Book* (Princeton, 1979), which can be supplemented by Patricia Rubin's important book *Giorgio Vasari: Art and History*, forthcoming from Yale University Press. Bandinelli's records for his family, called the *Memoriale*, give us deep insight into his highly idealized vision of the family. Although they were published by Arduino Colasanti (*Repertorium für Kunstwissenschaft*, vol. 28, 1905, 406–43), they are unavailable in a complete English translation. Cellini's *Autobiography* offers the reader a view of the artist's deep familial piety; it is available in George Bull's often reprinted translation from Penguin. Finally, Condivi's *Life of Michelangelo*, trans. A. Wohl (Baton Rouge, 1976), sheds light on Michelangelo's own familial ambitions.

Although this volume focuses on familial themes in the *Lives*, the idea of the family informs the earlier volumes of my trilogy. *Michelangelo's Nose* (University Park and London, 1990) explores some of the ways in which Michelangelo shaped his identity in relation to the Medici, and *Why Mona Lisa Smiles* (University Park; 1991) touches on various aspects of the family, especially in the account of Margherita Acciaiuoli's spirited defense of her marriage bed. Both of these books contain further bibliographies on Vasari.

INDEX